Forgetting Lot's Wife

Forgetting Lot's Wife

On Destructive Spectatorship

Martin Harries

FORDHAM UNIVERSITY PRESS NEW YORK 2007

Publication of this book has been aided by a grant from the Abraham and
Rebecca Stein Faculty Publication Fund of New York University,
Department of English.

Library of Congress Cataloging-in-Publication Data

Harries, Martin.
 Forgetting Lot's wife : on destructive spectatorship / Martin
Harries.—1st ed.
 p. cm.
 Includes bibliographical references and index.
 ISBN-13: 978-0-8232-2733-4 (cloth : alk. paper)
 ISBN-10: 0-8232-2733-2 (cloth : alk. paper)
 ISBN-13: 978-0-8232-2734-1 (pbk. : alk. paper)
 ISBN-10: 0-8232-2734-0 (pbk. : alk. paper)
 1. Influence (Psychology) 2. Violence. 3. Suffering 4. Audience—
Psychology. 5. Spectators—Psychology. 6. Memory. 7. Recollection
(Psychology) I. Title.
BF774.H37 2007
155.9′35—dc22

 2007014127

Printed in the United States of America
09 08 07 5 4 3 2 1
First edition

As things were in Lot's days, also: they ate and drank; they bought and sold; they planted and built; but the day Lot went out from Sodom, it rained fire and sulphur from the sky and made an end of them all—it will be like that on the day when the Son of Man is revealed.

On that day the man who is on the roof and his belongings in the house must not come down to pick them up; he, too, who is in the fields must not go back. Remember Lot's wife. Whoever seeks to save his life will lose it; and whoever loses it will save it, and live.

—Luke 17:28–33

The Scripture stories do not, like Homer's, court our favor, they do not flatter us that they may please us and enchant us—they seek to subject us, and if we refuse to be subjected we are rebels.

—Erich Auerbach, *Mimesis*

Contents

List of plates following page 106

Looking Back on Lot's Wife

As Lot's wife glanced back, she turned into a pillar of salt.

—Genesis 19:26

Forgetting Lot's Wife offers a theory and a fragmentary history of destructive spectatorship in the twentieth century. Its subject is the notion that the sight of historical catastrophe can destroy the spectator. The fragments of the history I trace here all lead back to a biblical story, however: Lot's wife, looking back at the destruction of the cities of Sodom and Gomorrah, turns into a pillar of salt. This biblical story of punishment and transformation—the nexus of a story about sexuality, sight, and cities—becomes the template for modern engagements with the idea that looking back at disaster can petrify the spectator.

Many remember the episode of Lot's wife looking back, but most do not know the circumstances that surround it. Therefore, this preface at once rehearses and rereads the story. The crucial elements for this book: Abraham has bargained with the Lord, and gotten him to agree that the city of Sodom will be saved if ten righteous men can be found there. Angels arrive in Sodom, presumably to canvass the city for righteous men, and take shelter with Lot; all the men of Sodom surround Lot's dwelling and threaten to rape the foreign angels; Lot offers his two daughters instead; the men refuse Lot's offer, threaten to break down Lot's door, and are blinded. The angels tell Lot and his family to flee Sodom, and neither to look back as they flee nor to stop anywhere on the Plain. His sons-in-law stay behind. Unable to escape to the mountains beyond the Plain, Lot pleads with the angels and they agree to save

biblical
story

a small city, Zoar. In flight, Lot's wife does look back, and is "turned into a pillar of salt." The next day, Abraham looks down onto the ruined cities from the spot where he bargained with the Lord. Meanwhile, Lot and his daughters find shelter in a cave; his daughters get Lot drunk, and each sleeps with him, one one night, the other the next; their children by their father become the Moabites and the Ammonites (Gen. 18.20–19.38).

In retelling the story, I have emphasized the elements that shape the modern responses: the moments of looking, and of punishment; the sexual transgressions that frame the story; and the spectacle of the ruined city.[1] These three elements coalesce in the punishment of Lot's wife. This punishment is resonant, and yet also, as is common in such biblical stories, opaque. Oddly, it forms part of a narrative that treats the possibility of bargaining with the Lord or with angels to escape punishment: Abraham bargains for the survival of the cities of the Plain, and Lot himself—always the slightly farcical revision of Abraham—arranges for the protection of the small village of Zoar from general destruction. Lot's bargain, indeed, shows that the commandment that condemns Lot's wife is not absolute. "Flee for your life!" the angels order Lot and his family. "Do not look behind you or stop anywhere in the Plain" (Gen. 19:17).[2] Lot wins the angels' consent to stop in the small town of Zoar, which lies on that forbidden Plain. Should Lot's wife, too, have bargained, have asked for permission for the backward glance?

The discrepancy between Lot's successful bargain and the fate of Lot's wife emphasizes the severity of her punishment. When the doomed men of Sodom crowd around Lot's house, demanding that he hand over his guests—those angels, in disguise—so that the men can have sex with them, the angels provisionally punish the men with blindness. Such a punishment might have "fit" Lot's wife's transgressive look back, but there is no such match between crime and punishment in this story. Sexual transgressions—the desires of the men of Sodom, the incestuous intercourse of Lot and his daughters—surround that of Lot's wife. The daughters' trick repeats Lot's hospitality. First, he does not know who his two guests are and, later, he does not know what company he keeps. His daughters' sex with their father also oddly inverts his offering of them to the men of Sodom as a substitute for the strangers they desire. (One imagines a different tale, in which the men of Sodom accept the bargain, and survive.) It is also unclear whether Lot's offer of his daughters is a sex crime in itself, or, as commentary often suggests, an inevitable, if extreme, extension of ancient hospitality.[3]

There are intimations of the sacrifice of Isaac in the punishment of Lot's wife: the faithful do not question the reasons for deaths demanded by the Lord. There is room to wonder whether one should call the death of Lot's

wife a death at all. The letter of the biblical account never specifies: "she turned into a pillar of salt." The Bible might include a notion of metamorphosis.[4] If one were to call this a "sacrifice," one would encounter in the narrative an ironic variant on the common ancient story where the sacrifice of the woman is the price for the maintenance or establishment of a people. The "sacrifice" of Lot's wife is the condition for the incestuous sex of Lot and his daughters that founds the Moabites and the Ammonites. Following this reading, the spectacular punishment of Lot's wife possesses not a *meaning*, but a *function*. Just as, after another disaster, the curse on Ham—the result of another crime of sight, that of seeing the patriarch naked—explains the establishment of the cursed Canaanites, so the punishment of Lot's wife leads to the establishment of Israel's enemies, the Moabites and the Ammonites.

This structural parallel with the story of Noah suggests, however, that the punishment of Lot's wife is not the arbitrary explanation for a landmark: its place in a structure of narrative repetition resonates. Ham sees Noah naked; Ham's brothers cover Noah without seeing him; Noah curses Ham when he discovers Ham has seen him. The crime of Lot's wife might, like Ham's, violate the taboo against seeing the nakedness of the patriarch.[5] The angels forbid Lot and his family to see the destruction of the cities on the Plain. One does not know why the taboo is at work here. It may be that the look back convicts Lot's wife of complicity with those who are destroyed, and that it is evidence of nostalgia for the life of Sodom and Gomorrah. The passage following the sentence describing the fate of Lot's wife echoes that sentence:

> Next morning, Abraham hurried back to the spot where he had stood before with Yahweh. As he looked down toward Sodom and Gomorrah and the whole area of the Plain, he could see only smoke over the land rising like fumes from a kiln. And so it was that, when God destroyed the cities of the Plain and overthrew the cities amidst which Lot had lived, God was mindful of Abraham by removing Lot from the midst of the upheaval. (Gen. 19:27–29)

The story establishes a contrast between Lot's wife's transgressive backward look and Abraham's sanctioned look down; indeed, Abraham is the privileged spectator of the whole story of Lot. (The Lord stages the story of Lot for Abraham: God thinks of Abraham while destroying the cities of the Plain.)[6] The narrative establishes a stark difference between the position from which Abraham can look down on the results of the catastrophe and the catastrophic look backward of Lot's wife. And, indeed, as the translation I have quoted above suggests, this act might be something less lingering than a look—simply a "glance." This difference between Lot's wife and Abraham here is temporal,

even historical. Lot's wife dares to look and is exiled not only from the world of the living, but from the human dead, becoming salt, a mineral associated with infertility and the destruction of cities.[7] The difference between the position of Lot's wife and that of Abraham suggests the commandment against graven images: the divine must not be seen, or even imitated. As E. A. Speiser puts it, "God's mysterious workings must not be looked at by man."[8] Abraham's retrospective look downward has divine sanction; Lot's wife's backward look is too close to the destruction she witnesses. The desire to see the spectacle of divine destruction as it is happening petrifies her.

I thank my interlocutors—colleagues, correspondents, students, friends—who have made this a better book: Oliver Arnold, R. Ward Bissell, Jennifer Cayer, Patricia Crain, Patrick Deer, Elin Diamond, Craig Dworkin, Elaine Freedgood, John Kleiner, Davis McCallum, Susan Maslan, Jeff Nunokawa, Yopie Prins, Laura Saltz, Jared Stark, Carolyn Williams, Michael Wood, Rishona Zimring. I delivered early versions of chapters as talks at Rutgers, Princeton, Columbia, New York University, Boston University, and at the Modernist Studies Association and American Comparative Literature Association conferences. Questions from these audiences have reverberated, sometimes over several years. Peggy Phelan and Joseph Roach were exemplary readers: their criticism was bracing, their enthusiasm encouraging. Nick Frankovich's wonderful supervision of production has been a thrill. I am fortunate once again to have Helen Tartar as editor; her sympathetic understanding makes all the difference.

Una Chaudhuri's unmatched spirit is such that I no longer know how to separate her scholarly encouragement from her friendship; all the same, I thank her for both. Margaret Bruzelius and Joanna Picciotto have passed along so many relevant passages from their wide reading and have been so close to the writing of this book that I feel I owe them another book as well, one that would attend to their many suggestions that I could not, in the end, follow. But they will find unnumbered passages where their e-mails, conversation, and friendship have proven invaluable. Where elective affinities feel like kinship, it is hard to know what to say: Stathis Gourgouris and Neni Panourgiá, Meredith McGill and Andrew Parker practice that rare art, conversation; they also feed me. My family continues to provide immeasurable support: Peter Harries and Lisa Harries-Schumann, and their families; Karsten Harries and Elizabeth Langhorne; Elizabeth Wanning Harries and Jennifer Whiting—words fail me. At home, Sadye and Walker remind me of the spice of life. And Jennie has truly read every word, so every word is dedicated to her with love.

Forgetting Lot's Wife

Introduction

ANONYMOUS

In 1936, this unnamed poem appeared in A. E. Housman's posthumous collection, *More Poems*:

> Half-way, for one commandment broken,
>> The woman made her endless halt;
> And she to-day, a glittering token,
>> Stands in the wilderness of salt.
> Behind, the vats of judgment brewing
>> Thundered, and thick the brimstone snowed;
> He to the hill of his undoing
>> Pursued his road.[1]

This laconic poem by a laconic poet encapsulates some of the difficulties of reading the figure of Lot's wife. The nameless poem does not name its subjects, Lot's wife and Lot; it requires that the reader recognize the "glittering token" and the man who pursues the road of his own undoing. This recognition is, however, the least of the interpretative difficulties the poem creates. We can name names: I begin this book, in the preface, with a reading and summary of the story of the family of Lot in Genesis, and I do this because I have found that the peculiar turns of the story are not part of the ready knowledge of many with whom I have spoken, any more than they were part of my own when I first became interested in the story's details. Such iconographic literacy, however, leads only to questions; as commentators have long been aware, the story is very odd, and odd from the start.[2] It takes on peculiar opacities in the twentieth-century revisions that are the subject of

this book. If, to return to one of my epigraphs, Auerbach is right to say that the "Scripture stories . . . seek to subject us," for the artists I discuss here the stories maintain their compelling force, and yet it is unclear what subjection to them would mean.[3] Indeed, Lot's wife's disobedience is legible as the refusal of subjection. The opacities and lacuna in biblical stories that Auerbach describes so acutely invite endless retelling. They are also reminders that the further we read these stories, the more opaque they might appear. The story of Lot's wife evokes things we may feel we cannot not know about—sex, remembrance, the spectacle of mass death—and yet it estranges them.

Housman's poem accentuates these opacities. The poem's two quatrains pair the transgression of Lot's wife with that of Lot; her "endless halt" and his "undoing," the poem implies, somehow rhyme. To summarize the poem in this way is, however, already to rush past description into interpretation. Much depends on how one reads the poem's first line. Does Housman write ". . . for one commandment broken" in order to stress the severity of the punishment, perhaps even to sympathize with this destroyed figure? A stress falls on "one," and this stress might emphasize the paltriness of the transgression that brings down such a strange and fierce, unjust punishment. This emphasis could also, however, be quite orthodox, suggesting that one broken commandment alone inspires divine wrath. The poem is about something like a judgment, the instantaneous transformation of Lot's wife; its own judgment of the events to which it alludes, however, remains shadowy.

What is most remarkable here, perhaps, is that Housman does not name either Lot's wife's backward look or Lot's sex with his daughters; he assumes but does not name these acts. The parallel between them does, however, have the intriguing result of producing a certain penumbra of agency around the stumbling and unaware Lot. The biblical text, so enigmatic about so much, carefully protects the patriarch when it comes to his knowledge of the incestuous schemes of his daughters: "That night, after they had plied their father with wine, the older one went in and lay with her father; he was not conscious of her lying down or her getting up" (Gen. 19:33); and with the younger, too, the following night, the text asserts again, he was neither "conscious of her lying down or her getting up" (Gen. 19:35). Whatever we may know of Lot's wife, it seems, we know she knows she should not look back; whatever we know of Lot, we know we cannot blame him for the two incestuous nights he sleeps through.[4] The conscious disobedience of Lot's wife contrasts with the unconsciousness of Lot himself. Housman's poem upsets this logic.

What I have loosely called the "rhyme" between Lot's wife's backward look and Lot's "undoing" in Housman's poem is especially clear in the relationship between its first and last lines. The last line enacts, so to speak, the first; it

Lot can't look back to see what she's become?

makes its "endless halt" after getting only "Half-way," ending abruptly after a mere four syllables in a poem where one expects another line of eight syllables. There is no place to go but back to the beginning of the poem, where the reader begins, once more, "Half-way." This doomed place in between is supposed to be the place of Lot's wife, but the truncated last line suggests that it is also—or more exactly—the place of her husband. This parallel between Lot and Lot's wife challenges the alibi of unconsciousness customarily granted to Lot. Lot actively "Pursued his road"; Housman withholds the standard exoneration. The unconscious patriarch becomes the aggressive agent of his own destruction, failing to contemplate the "glittering token" behind him. But unconsciousness—lack of knowledge—is also necessary. Lot cannot know what his wife has become. Contemplation would require looking back: Lot cannot contemplate a "token" he is forbidden to see.

That "glittering token" raises one last aspect crucial to the significance of Housman's poem. In describing Lot's wife "to-day," the poem, exceptionally, uses the present tense: "And she, to-day, a glittering token, / Stands in the wilderness of salt." On the one hand, Housman alludes to the just-so story that reads salt formations in the Middle East as the remains of Sodom and Gomorrah and of Lot's wife; this "to-day" has lasted since ancient times.[5] On the other, this gesture toward the present demands that the reader ponder what this "glittering token," standing in the "wilderness of salt," stands *for*. The "token" of Lot's wife signifies the rather questionable legibility of the poem itself; this reflexive movement inward, however, where the token or figure *in* the poem becomes a figure *for* the poem, also marks the poem's movement outward toward a social world that the poem can otherwise not acknowledge.

clear, transparent

In a passage from an essay that has informed my last paragraph, Theodor Adorno writes: "The elevated, poeticizing, subjectively violent moment in weak later lyric poetry is the price for its attempt to keep itself undisfigured, immaculate, objective; its false glitter is the complement to the disenchanted world from which it extricates itself."[6] All that glitters is salt: Housman's poem is about disfiguration, but it never names the process that causes disfiguration. If, that is, Housman's poem is what the lyric poem should be according to Adorno—"a philosophical sundial telling the time of history"— then it is through this combination of sly present-tense construction and the refusal to refer to the most often remembered elements in the story of Lot that Housman tells historical time.[7]

PICTURING LOT'S WIFE

In this study, the figure of Lot's wife appears as the measure of a particular set of historical concerns. I chart how Lot's wife becomes a figure for certain

modern conceptions of spectatorship. This is, then, neither an iconographic survey nor a study of Lot's wife as transhistorical sign.[8] A concatenation of concerns—about looking and disaster, about retrospection and desire—may shadow discussions of Lot's wife at all times, but these concerns are also changeable. In particular, Lot's wife becomes the nexus of a constellation of twentieth-century fantasies and fears about the potential for spectatorial damage. I follow these concerns across theater, film, and visual art. Rather than surveying the many representations of Lot's wife in twentieth-century literary, theatrical, and visual art, I offer a sequence of close readings of a few examples that are particularly powerful and suggestive.[9] I focus here on the theatrical theory of Antonin Artaud, on a sequence of related films noirs, and on paintings by Anselm Kiefer. The figure of Lot's wife emerges as a way to imagine the desire to destroy the spectator—as in Artaud—or, as in the films, as a way at once to reflect on the fascinations of Sodom and to think about the cinema's work upon the spectator. Kiefer, in his *Lot's Wife*, engages this fascination with the potential destruction of the spectator, acknowledges the risks in spectatorship, and yet places the spectator elsewhere. The painting subsumes the modernist fascination with self-destructive spectatorship: it invites the dangerous fascination of retrospection, and it suggests that the desire to produce, or to experience, an artwork that would destroy the spectator is a fantasy.

In Michael Fried's sense, the works I consider here are all *theatrical*: each "includes the beholder."[10] As in Fried's art historical work, this acknowledgment is the product of a certain historical necessity. Fried argues that while antitheatricality remained a leading impulse in French painting from Greuze to Manet, the conditions of antitheatricality changed: "the overarching, transgenerational aim of making paintings that seemed genuinely indifferent to the spectator could never be realized definitively and so remained continually in force."[11] To borrow Fried's formulation: the aim of making works that would destroy the spectator could never be realized definitively and so remained continually in force. The disastrous histories that surrounded the works I discuss—and, in particular, the destructive events of the middle of the twentieth century—altered the conditions under which this desire had flourished. In general, my focus falls on formal codes that produce certain positions for the spectator. Certainly, any given spectator may in fact resist, or simply be unreceptive to, the ways a work positions her. In Peter Bürger's account, the avant-garde challenged the status of the artwork as commodity to be displayed in museums and sold on the art market by refusing forms that might become commodities.[12] Another approach to the same problem was to imagine works that might evade consumption by disrupting the place where consumption

unpacking metaphor (handwritten)

might happen: this artwork would challenge the comfortable logic of the commodity by consuming the viewer. And so my focus falls on the codes: tracing the work of these codes through these various revisions of the story of Lot's wife reveals how it has become a template for reflection on extremes of vision.[13] This book draws from critical work about the formal logic of spectatorship in various disciplines—from histories of theater, from film theory, from psychoanalysis, from art history—but my argument is also that the twentieth century had a particular investment in a formal logic that placed the spectator in a spot where that spectator had to contemplate her own destruction.[14] Further, the story asks the spectator to link these extremes of vision to transgressive desire and to retrospection as they are embodied in an act of destructive looking. Finally, it obliges the spectator to think about mass death.

Housman's maneuver around same-sex desire and around the glance that destroys Lot's wife are, I will show, typical of the ways twentieth-century art treats the figure of Lot's wife. In sixteenth- and seventeenth-century paintings and drawings from the moment when the theme of Lot and his daughters was all the rage in European painting, Lot's wife very often appears, when she appears at all, as a vague pile in a corner of the image, looking more or less like a milestone in the landscape between Sodom and the cave where Lot and his daughters pursue their road. This mannerist moment is an important precursor to the twentieth-century work I will consider. I began *Forgetting Lot's Wife* in pondering the absence of Lot's wife in Antonin Artaud's response to one of these paintings, the Louvre's sixteenth-century *Lot and His Daughters*. As in this early modern painting, so the twentieth-century work I focus on here tends to place Lot's wife in the margins. Housman writes about Lot's wife without describing the backward look or the city she looks backward to; Artaud, more radically, seems to overlook that she is even present in the painting at all. As I will argue in my first chapter, this apparent forgetting *(chapter 1* handwritten) hides a more complicated kind of acknowledgment. There is something odd, I know, in any sentence that puts Housman together with Artaud; my point here is that they share the oddity that provoked this book, which is about complexities in the modern acknowledgment of Lot's wife.

Before considering twentieth-century examples, I turn to two paintings, one, by Orazio Gentileschi, from the heyday of the representation of the story of Lot, the late Renaissance, the other, by Corot, from the nineteenth century. These two paintings point to a choice that divides representation of the Sodom story and of Lot's wife. Put starkly, are the burning cities represented? Or does the artist obey the biblical prohibition? Gentileschi refrains from showing the cities; Corot does not. Gentileschi's "obedience" of biblical prohibitions is not the only possible—or even the most notable—strain in the

visual representation of the story. Very early images show the taboo sight of the doomed cities in flames and Lot's wife after her punishment. Many turn to an illustration from the Nuremberg Chronicle of 1493; a comparably resonant image appears in the fourteenth-century Sarajevo Haggadah.[15] An oscillation between images that "obey" the biblical prohibitions and images that transgress them might structure a history of the representation of the theme.[16] I offer no such history here, but the complexities of a visual tradition built around a specific prohibition on sight never vanish.

In turning to an early modern painting as my first example of the visual representation of the story of Lot, I also follow the example of many of those I discuss in this book, for whom early modern representations of the story of Lot are a touchstone. This painting, Orazio Gentileschi's *Lot and His Daughters* (plate 1), shows the restraint typical of some versions of the story in this period, and yet it also introduces the representational challenges when visual art takes on a story partly about a taboo on vision. Gentileschi's painting is a kind of perverse pieta: the drunken Lot rests his sleeping head on the lap of one of his daughters. With one arm, she seems to comfort his sleeping body; with the other she points to the right of the canvas. Her sister, disheveled, perhaps, after sex with her father, looks in the direction her sister points. This eloquent gesture reminds the spectator of the absent person here, whom we might remember in this instance as the sisters' mother rather than Lot's wife, a name that is not a name in a story in which only one figure—Lot himself—has a name at all.

The gesture in Gentileschi's painting suggests the way images of Lot and his daughters are frequently also in some way about this figure, Lot's wife, who so powerfully challenges the representational modes of these paintings. That salt figure, who appears sometimes as a sort of heap in the corner of a painting or drawing, and sometimes, as here, not at all, figures a mode of destructive spectatorship to which Gentileschi's painting owes some of its calmly eerie power. The painting distances itself from a destructive mode of looking it nevertheless acknowledges. Gentileschi portrays a kind of willful repetition of Lot's wife's look backward. The daughters look backward from safety, or so it seems: revisions of the story often make a connection between Lot's wife's backward look and the incestuous sex between Lot and his daughters. The daughters' looking is a structural variation on the breaking of one taboo—*the* taboo, the taboo against incest—by alluding to the violation of a prohibition by the mother. And Gentileschi frames the scene with this prohibition in mind: the painting is at once alluring and built around the deliberate frustration of the spectator's sight. The spectator sees the smoky sky to the right of the canvas, but cannot see the source of this smoke in the wreckage of

the cities of Sodom and Gomorrah.[17] The spectator of the painting witnesses a
scene of spectatorship, which is also a scene of transgression. The painting
lures the spectator with its array of primary colors and intertwined limbs, and
the lure is a double one. The illusion of peace—the sleeping man, now dead
to the world—conceals at once the scene of sex that has preceded it and the
mother's transgression, which the daughters recapitulate. We can imagine that
they are looking backward as Lot's wife did; we can also imagine that they are
looking backward *at* Lot's wife, as though she herself has become an object of
dangerous contemplation, a monument to destructive sight that others can-
not avoid.[18]

So far, I have treated the daughters' looking toward the cities on the Plain
and toward Lot's wife as a repetition of her transgression and a sign of their
transgression with their father. As many piously read Lot's wife's destructive
glance backward as a reflex following from her sympathy with the license of
Sodom and Gomorrah, so I have been implying that the daughters' looking
backward focuses our attention on the paired transgressions of the story, their
sex with their father and their mother's sexualized look backward.[19] I think
this implication is indeed at work in the painting, and that the mannerists'
fascination with the imagined perils of feminine desire underlies this painting.
And yet the gesture backward is also a gesture toward a necessary form of
remembrance.

*Lot's wife's
sexuality;
interpre-
tation
↓
feminine
desire
↓
remembrance*

The harmonies of Gentileschi's composition are then not a false lure only,
but an image of the necessary work of memory. Gentileschi's painting, with
its gesture toward a pointed absence the spectator must try and must always
fail to recover, anticipates the mostly twentieth-century works I pursue in this
study by pondering the relationship between an impossible form of spectator-
ship and the demands of memory. The daughter's gesture is a sort of impera-
tive, but the painting's central device makes it impossible for any spectator to
obey this imperative. Insofar as to look backward is to repeat Lot's wife's
transgression, the painting reminds viewers of their position of safety. Insofar
as this gesture reminds the viewer of the commandment to remember Lot's
wife, the painting's closing off of the sight the spectator should recall is a
mark of the spectator's perhaps inevitable failure to recall what he or she
should. The closed-off world of the daughters is an image of something like
what Michael Fried calls "absorption"; here absorption may be the image of
a privileged remembrance that the spectator must, again and again, forget.[20]

Corot's *The Destruction of Sodom*, painted and reworked between 1843 and
1857, offers one late and pointed contrast to Gentileschi's painting (plate 2).
Corot paints an earlier moment in the story: an angel leads Lot and his daugh-
ters away from the burning cities, gesturing—in marked contrast to the

daughter in Gentileschi's work—toward the left of the canvas, away from the conflagration. Lot's wife, an almost flat form to the right of the canvas, has already looked back. Behind the fleeing figures and Lot's wife is a conspicuous cistern. Behind the cistern, the cities, an obscure line of structures near the horizon, burn; a second angel casts brimstone down on the cities from the sky. Corot was hardly the first to transgress the representational prohibitions Gentileschi respects. Corot's painting is, then, typical of a tradition of paintings that violate the commandment against looking at the cities—or ask what it might mean for a painting to show what could not, in the Bible, be seen without punishment. This formulation testifies to a certain latent belief in the power of images that is among the subjects of this book.[21] To say that Gentileschi refrains from showing—or that Corot does show—the forbidden prospect of the burning cities is to engage a tradition according to which the representation of the catastrophe potentially possesses some of the destructive power of the unmediated sight of the catastrophe itself.

Corot's painting, shown in very different states at the salons of 1844 and 1857, was controversial in its time and, as this history of reworking might suggest, the painter was evidently attached to the canvas: "Corot described the painting as one of his favorites, and in later life told Claretie: 'That wife of Lot isn't very famous [célèbre]. Well! if my studio caught fire, that's the first painting I'd want to save.'"[22] Corot imagines a destructive scene in miniature, in which he might save Lot's wife from the fiery destruction of his studio. His shorthand is revealing: his association of the painting with the "wife of Lot" rather than its official subject—the burning of Sodom— underlines his handling of the figure. Corot follows a long tradition in placing Lot's wife behind and to the right of the main group; a substantial history of painting places Lot's wife in a similar position.[23] Corot also challenges the standard association of Lot's wife with Sodom and Gomorrah, the tradition that asserts she is punished for her lascivious sympathy with the desires of those condemned. Corot, by contrast, links Lot and his fleeing daughters to the burning cities. This is most remarkable in the daughter to the right, whose horrified face the viewer sees: her red hair, splayed out horizontally behind her, resembles the glow of the burning cities above her in the canvas. A red clasp around her waist, too, recalls the fire. Similarly, Lot's blue cloak, intermingling with the hair of the daughter who hides her face, echoes the few patches of light in the otherwise apocalyptically dark sky above the cites. These visual echoes, like the darkness into which the angel leads them, might foreshadow the incest to follow, although I do not detect the sort of pious judgment such an association might encourage. These visual affiliations point to Lot's wife's vivid separation from the rest of the canvas. Not only does Corot

disappearance + return of The effaced body

not link her to the cities, but she scarcely belongs to the visual order of the painting. There is hardly a mark to suggest the sort of sculptural fullness that Corot bestows on the clothing of the fleeing group and the angel. Perhaps more remarkable still, her "body" is not illuminated and she casts no shadow. Light from the right casts a striking triangular shadow on the cistern, immediately to the left of Lot's wife, and it illuminates Lot, his daughters, and the angel; in a very dark painting, there is an exceptional bright patch immediately behind Lot's wife. Both of these elements of the painting highlight the oddity of Lot's wife's lack of shadow.[24]

One more element of this haunting painting needs mention: the object under the arm of the daughter to the right. Other than clothing, this thing is the only visible trace of the possessions the family might have taken from Sodom. (One might compare this to the elegant metalware in Gentileschi, or to the great crowd of objects in the canvas associated with van Leyden [plate 3].) The object is also anthropomorphic: it resembles a mask, with exaggerated features, at precisely the angle of the other daughter's head. In a painting so dramatically concerned with effacement, with the erasure or hiding of features, this face in the bundle appears as the almost comic return of what catastrophe has erased. One daughter hides her face; her face returns, as a Cheshire cat–like grimace without a body, in the bundle they carry with them away from Sodom. Similarly, the haunting face of the sister bearing the bundle seems an expression of what the vanished face of Lot's wife can no longer show.

This disappearance and return of the effaced body is a continuous feature ✳ of the representations of Lot's wife that I will trace here. In Corot, Lot's wife's transformed body becomes an abstract negation of space and of the visual field. But that abstraction and negation coincide with a generalization of the predicament of Lot's wife: the daughter, hiding her face, obeys the commandment and does not look backward. The spectator who imagines Lot's wife's backward look—and who contemplates the scene that Lot's wife cannot see— begins to see Lot's wife everywhere. Corot's painting anticipates the ways Lot's wife's evacuated body tends to multiply, to become the body of others—to become, even, the spectator's body. Just as the contemplation of disaster and mass death has become a general predicament, so the spectatorial place occupied by Lot's wife has become a place anyone might occupy. Painting has long anticipated this generalization of hazardous, and potentially destructive, spectatorship.

multiplication of Lot's wife

CITIES AND SUBJECTS

The elements that most readers remember in the biblical story are precisely Lot's wife's backward look and the men of Sodom. Sodom is not just any city,

city/secular nexus

and one sturdy tradition has seen Lot's wife's backward glance as an embodied confession of complicity with the transgressive desires of Sodom and Gomorrah; these desires, in turn, are associated with male same-sex desire. The present study at once recalls that the association of the men of Sodom with queers is historically anachronistic and recognizes that such an association, anachronistic or not, is inseparable from the modern understanding of Sodom.[25] Whether in the contemporary Christian fundamentalist attempt to map Sodom onto the Hudson—which I will discuss in my epilogue—or in the sex-positive effort to "reclaim" Sodom, the problem that in the ancient world same-sex desire did not name an identity disappears.[26] However, this study is not a hermeneutic project designed to discover the horizon of biblical meaning, but instead a book about how the story of Lot's wife resurfaces in modern works, and so this association of Sodom with same-sex desire is essential. Modern uses of the figure rely at once on reminders of historical difference and on partial erasures of this difference.

To extrapolate again from Housman's poem: it is hard to know what Lot's wife, in these strange and mostly fragmentary representations, stands for. Where is this "wilderness of salt"? The problem of reading Lot's wife is partly a matter of not knowing how to read a biblical figure in the art of a secular age. Indeed, I would argue that Lot's wife is always potentially a secular figure, even a figure for secularization. The backward look establishes a tie between Lot's wife and the doomed city that she flees, and in a certain powerful religious discourse, which is, if anything, growing more intense in contemporary culture—and especially the culture of the United States—the city looms always as a potential Sodom, the place where too many busily forget God, have sex with the wrong people, and tempt destruction.[27] A suspicion of the urban marks Genesis from Cain's founding of a city (Gen. 4:17) to the story of Babel (Gen. 11:1–9) to the devastation of the cities on the Plain.[28] The city *is* the secular. The destruction of Sodom and Gomorrah is one of the first versions of the powerful fantasy that imagines the destruction of cities as the lamentable but necessary way to undo secularization. The question, then, might be: why do those who (to paraphrase Artaud) want to have done with the judgment of God nevertheless insist on remembering Lot's wife? Why, in short, has a secularized art not abandoned this figure?

secular return to Lot's wife

This book focuses on two reasons for the continuing turn to Lot's wife. The first of these has to do with a powerful notion of the impact of aesthetic experience on the spectator. Lot's wife provides a way to look at one of the dominant, but rarely directly articulated, fantasies of modern spectatorship, a fantasy that has at once narrowly aesthetic and widely political applications.

1.

[handwritten: destruction of spectators not metaphoric; the fantasy is on concrete terms.[15]]

The basis of this fantasy is the threat of, or desire for, an experience of spectatorship so overwhelming that it destroys the spectator. One might imagine that one should understand this fantasy of destruction as metaphor, as a way to describe a transformative and disruptive spectatorial experience, something like a twentieth-century sublime. Part of the power of the icon of Lot's wife is that it makes it possible, indeed necessary, to see past the overly rapid recourse to the metaphorical. If Artaud, at one end of the spectrum, and the architects of political mass spectacle, at the other, say they want utterly to alter the spectator through participation in spectacle, they may mean what they say. *[handwritten: destruction]*

I find myself returning to a single resonant sentence in a piece by Hal Foster: "All political regimes are involved in the business of subject-formation."[29] Foster's immediate subject here is Jeffrey Schnapp's study of an inadvertently hilarious Italian fascist attempt to stage a mass spectacle starring a truck, but resonances beyond this context are pertinent here. The cultural production of subjects has been a concern of massive scholarly research over the last years. Foster's sentence crystallizes some of the assumptions of this research. The sentence almost assumes that we no longer need to ask about the aims of political regimes: they are "in the business" of making subjects. Nor, to turn more directly to my subject here, do we need to ask about the subject's susceptibility to formation; this perturbing thing—the subject—is made, and can then be remade. To use Althusser's terms, it is as though the massive and accretive institutional work of interpellation might be undone all at once, as though the ideological work performed by the school and every other ideological state apparatus might be evacuated in a single spectacular, catastrophic performance.[30] In the particular context of Schnapp's study, it is as though a political regime could decide all at once to produce a new kind of subject. (Part of the importance of Althusser's essay is that it partly accounts for the difficulties of achieving such a revolutionary project.) It is this fantasy of the subject's catastrophic susceptibility, shared (at times) by political regimes and by critics of these regimes, as well as by artists with doubtful connections to these regimes and to their critics alike, that is one of the two poles that have guided my research here. The figure of Lot's wife suggests that we may learn as much about how we imagine subjects from how we imagine their destruction as from how we imagine the ways in which they are made. *[handwritten: 2.]*

The second argument of this study—one rarely separate from the first—concerns a more narrowly psychic component in the ways Lot's wife is imagined. Lot's wife's punishment becomes the model for the individual's self-destructive, even masochistic, retrospection. Lot's wife looks backward; she turns to salt. Her punishment suggests the potentially self-destructive nature *[handwritten: 2nd argument]*

of retrospection, as if looking backward posed dangers to the self, as if to look backward were in itself a form of masochism. This opaque narrative simply passes over the question of motive, and that very opacity, it seems, has inspired speculations about her motives. Some of this speculation, in its dogmatic certainty, does not even recognize that it is speculation. Two questions may summarize the directions in which this speculation tends. Does Lot's wife lust after the so-called perverse pleasures of Sodom and Gomorrah? Or does she simply care about—and want to look back upon—her own past? One can read the story as a parable about the damage done by our attachments to the past, as a narrative about the sometimes violent work of cathexis.

The psychoanalytic account of the genesis of masochism has influenced my account of Lot's wife's turn in this book. This account argues that masochism is the result of sadism turned inward; whether through guilt or some other cause, the masochist turns aggression that no longer finds an object outside itself inward.[31] The "all-important turning against the self," as Otto Fenichel calls it, becomes a problem of Ovidian complexity.[32] When the turn happens, and how to "see" this turn, are problems that dog the psychoanalytic literature. The sadist's metamorphosis into masochist is very often a problem of visibility. Masochism's challenge to the domination of the pleasure principle makes this question of the genesis of masochism especially urgent. Where does the masochist's pursuit of pleasure through pain—or, more controversially, of pleasure as pain—come from? The psychoanalytic account asks us to see desire where desire seems unimaginable.

Between the two poles of the fantasy of an endlessly and suddenly malleable mass subject and the concern with the experience of the masochist, Lot's wife comes finally to stand for a powerful synthesis of both. Lot's wife is not, I want to stress, an image of some generalized masochism, but, instead, a vivid emblem of the twentieth-century problem of self-destructive historical spectatorship. Lot's wife's desire to look backward toward the destruction of Sodom and Gomorrah returns as a condensed image of the individual's witnessing historical catastrophe; the power of the story lies partly in its melding together the singular trauma of Lot's wife with the more sweeping historical damage of the destruction of the cities. She figures the coincidence of dangerous individual memory with catastrophic historical damage. On the one hand, Lot's wife becomes an emblem of individual psychic damage in retrospection; on the other, she gives a form to worries about the self's encounter with the larger wreckage of the past. One can see her as a variant of Walter Benjamin's Angel of History. If that angel figures the inertial force of what "we call progress"—a force that makes it impossible for the angel to turn back toward the future—Lot's wife figures the petrifaction of the self at

desire for unmediated vision → bodily alteration (margin annotation)

the moment of, and as a result of, the witnessing of a particular catastrophe, the destruction of the cities of Sodom and Gomorrah.[33] It is as though certain powerful sights force the body to become a too-solid memorial to what the spectator has seen.

At the very least, Lot's wife is an extreme instance in the modern period of the post-Romantic desire for what Geoffrey Hartman calls "unmediated vision," and her metamorphosis directly and violently translates sight into extreme bodily alteration.[34] In the traumatized pages of *Minima Moralia*, Adorno writes, "there is no longer beauty or consolation except in the gaze falling on horror, withstanding it, and in unalleviated consciousness of negativity holding fast to the possibility of what is better."[35] Lot's wife sometimes reappears as the subterranean insistence that the gaze, "falling on horror," has *not* withstood that horror; the "unalleviated consciousness of negativity," so to speak, cannot grasp, never mind hold on to, anything better. So, for Artaud, Lot's wife's petrifaction in a salt effigy threatens to become the sign not of a peculiar traumatic punishment but, instead, a mark of the thoroughgoing punishment of those who have let their gaze fall on horror and not survived it. That is to say, in Artaud, writing in the 1930s, Lot's wife becomes a sign of the threat of a culture's imminent petrifaction, of its reification and inability to respond to the crisis that surrounds it. This oscillation between the irreducibility of this particular punishment and the universalization of this punishment is not unique to Artaud. In many works, one encounters a similar movement between the singularity of that punishment and the implication that it is not singular at all, that it has become instead a more general fate.

inability for one to respond to crisis (margin annotation)

Forms of the word "trauma" in the previous paragraph point to the prevalent discourse of trauma in contemporary theory. I can perhaps best define the relationship of this book to such work by discussing a passage in what may be the field's single most influential work, Cathy Caruth's *Unclaimed Experience: Trauma, Narrative, and History*:

> If traumatic experience, as Freud indicates suggestively, is an experience that is not fully assimilated as it occurs, then these texts, each in its turn, ask what it means to transmit and to theorize around a crisis that is marked, not by a simple knowledge, but by ways it simultaneously defies and demands our witness. Such a question . . . whether it occurs within a strictly literary text or in a more deliberately theoretical one, can never be asked in a straightforward way, but must, indeed, also be spoken in a language that is also always somehow literary: a language that defies, even as it claims, our understanding.[36]

Many questions arise from these basic formulations. What experience, especially if we follow Freud, *is* "fully assimilated as it occurs"? Most important here is Caruth's discussion of the forms of response to a crisis that demands "our witness." The texts she discusses ask questions, and these questions are never "straightforward" but "must . . . also be spoken in a language that is also always somehow literary." These texts, that is, *are* questions; they are texts that respond to traumatic crisis neither through statement nor diagnosis, but rather through the interrogative form of the literary. Further, as Caruth's subtitle suggests, these literary questions take the form of narrative.

I cannot follow Caruth's emphasis on the literary, and by extension on narrative, as the form that such questioning *must* take. What might the place of the image or performance be? Partly in a response to an essay by Caruth, Peggy Phelan has pursued the relationship of vision, images, and trauma. Analyzing the logic of the visible in Freud's *Beyond the Pleasure Principle*, Phelan concludes that the "fort-da" game's recognition of finitude is tied to the limitations of vision. Phelan argues that the small boy who plays the game of disappearance and reappearance with the spool "seems to recognize that he too will someday be out of sight. This is the traumatic core of all seeing."[37] For Phelan, sight's necessary encounter with blind spots means that seeing always has a "traumatic core." From this perspective one might then read the story of Lot's wife as an allegory of this universal trauma only partly hidden in the everyday experience of sight; Lot's wife's refusal to recognize a blind spot, a place where she cannot look, marks the trauma of vision's limits. This universalization of trauma, however, leaves the theory of trauma in a precarious position.[38] As Phelan goes on to acknowledge, some experiences—such as those of the shell-shocked soldiers Freud also studied—seem not to belong to the same category as the game of the child in the cot rehearsing the disappearance and reappearance of his mother. If vision is always an encounter with trauma, are unassimilable historical catastrophes simply extraordinary events in case histories that will always be marked by similar wounding? To pursue this question with any thoroughness would require a different book and an author with greater psychological expertise. The particular importance of Phelan's work here lies in her insistence that narrative and the visual must be considered as part of a spectrum. This insistence is essential to understanding contemporary conditions of spectatorship.

Trauma may describe the subject matter but it does not describe the effects of the works I discuss here. One might say that sometimes artists aspire to traumatize the spectator. I will argue that something like this is true for Artaud. It is precisely in the violence of this aspiration, however, that the category of trauma reveals its limits for my project. *Can* an artwork transmit

trauma?[39] The artwork that openly aspires to traumatize the spectator reveals the breakdown of the fantasy of the instantaneous production (or destruction) of the subject. Trauma theorists are too often indebted to this model of catastrophic subject-formation that the figure of Lot's wife throws into relief.[40] The problem of the transmission of trauma from person to person, and from generation to generation, is one of the most contested points surrounding trauma, and this controversy is germane.[41] The works I discuss in the pages to follow point away from the sharing of trauma and toward acts of a necessary masochism that accompany certain kinds of historical retrospection. Part of this masochism lies precisely in the notion that the only true historical knowledge would be traumatic repetition of traumatic experience: we should share the trauma of the victim or original witness, we should be Lot's wives, destroyed by historical knowledge, but we are not, and blame ourselves.

The catastrophic sights of the last century defy counting, and the start of the new millennium has not given us any reason to believe we will rest our eyes any time soon. One can imagine a Borgesian atlas of salt memorials. This book does not disguise such a melancholy encyclopedia in its pages; I focus instead on two events. Each of these events—if "event" is the right word at all—provoked responses that explicitly link the dilemma of looking at catastrophe to the story of Lot's wife. In my third chapter I discuss Anselm Kiefer's painting *Lot's Wife*, a meditation at once on the biblical story and on the genocide of Europe's Jews. This chapter necessarily ponders Kiefer's relationship to German and European history. Its argument concerns, however, not so much the question of Kiefer's attitude toward history as how Kiefer's work obliges the viewer to ponder, and perhaps momentarily to occupy, or to imagine occupying, a certain place in relation to the Holocaust. Kiefer's *Lot's Wife* is a remarkable instance of his work's address to the viewer, an address that demands that the viewer scrutinize what it means to "look" at genocide. If serious historical retrospection—the contemplation of the Holocaust—forces the spectator into a kind of self-destruction, is the choice to make the turn toward this historical retrospection not itself a form of masochism? The imperative to remember collides with the angels' warning: do not look back.

The second of the events I discuss here, the destruction of the World Trade Center, I saw myself from a corner in Greenwich Village. While I do not strive for anonymity in the rest of this book, in this epilogue I turn more directly to some of the peculiarities of my own experience as a way into problems of spectatorship that so trouble many witnesses of that day. On the one hand, I show how the story from Genesis has provided a way to think about the catastrophic watching of that day. On the other hand, this chapter also argues that the biblical narrative lies behind the interpretation of September 11th in

more disturbing ways: September 11th becomes another chapter in a sacred history in which Sodom continues to be destroyed. The chapter is, then, a call to perform the work of my title. To forget Lot's wife is part of a necessary break with a figural reading that continues to see the destruction of the towers—and the destruction of cities—as an attack on Sodom. If this is a book about cities, it is also a book about a particular city, New York. If this is a book about the destruction of cities, it is also a book inevitably marked by the events of September 11th, which interrupted and altered its composition. While acknowledging the particular shock of September 11th, part of the work of this book should be to remind readers of the extent to which New York has always figured in a modern apocalyptic imagination, not least among those to whom such an imagination might seem foreign. Sartre, for instance, could write immediately after World War II: "I see in the distance the Empire State Building or the Chrysler Building pointing vainly toward the sky, and it occurs to me that New York is about to acquire a history, that it already has its ruins."[42] Sodom and Gomorrah still inform urban thinking to a surprising and disturbing extent.[43]

FORGET

One of the many quandaries that arises here is that a solution to the dilemma of a masochism in historical retrospection might be that of Sam Masterson, the rootless protagonist of one of the films I discuss in my second chapter: "Don't look back, baby, don't ever look back." The escape from spectatorial damage may look like willed amnesia. Indeed, there is the allure of a whole counterethic of not looking back, an allure that helps to explain why D. A. Pennebaker called his documentary about Bob Dylan's turn away from his folk past in 1965 *Don't Look Back*.[44] It is as though the angels' warning in Genesis had become a slogan, and Lot's wife the negative example for a counterculture constantly turning away from turning back. The point here must not be simply to use Lot's wife as a way to caricature a culture and to raise a jeremiad against some supposedly typically American fashion of forgetting. One can see Lot's wife, after all, as a reminder of the *necessity* of forgetting. Lot's wife embodies antinomies of spectatorship and retrospection, and these antinomies suggest not that we can somehow do away with retrospection or spectatorship, but that we need to find forms for retrospection and spectatorship alike that do not turn them into traumatic experience.

In this project on Lot's wife, I argue that modernity encounters a particular aspect of itself in Lot's wife. Three intertwined issues are central: watching disaster, retrospection, and masochism. What happens when retrospection

begins to look like, and to feel like, masochism, a choice to damage the self? We tell ourselves we have the responsibility to remember and to look back; we think less often about what it means that such looking back may simply cause pain. One can think of Beckett's Winnie, in *Happy Days*, telling herself she is really enjoying turning into a pile of sand. In Winnie, who seems to me a descendant of Lot's wife, the audience encounters the spectacle of its own retrospection. If Winnie's retrospection seems almost entirely limited to the vagaries of so-called personal life and the "classics" she is afraid of losing, Lot's wife is at once absolutely singular and the crystallization of the mass death in the cities on the Plain for which, many have imagined, she mourns. Her story is a myth of the body's absolute responsiveness to historical catastrophe, at once legible as a sign of the body's submission to the spectacle it confronts, and, in the turn toward the cities, a gesture of the willingness to confront that spectacle, to look back when you know that looking will destroy you.

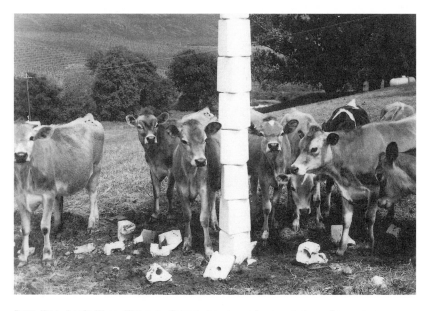

PAUL KOS, *LOT'S WIFE*. MEDIUM: SALT BLOCKS AND JERSEY CATTLE. COLLECTION: DIROSA ART PRESERVE, NAPA, CALIFORNIA.

Artaud, Spectatorship, and Catastrophe

About suffering they were always wrong, the Old Masters.

—Alan Bennett, *A Question of Attribution*

FIGURES OF SPECTATORSHIP

The spectators imprisoned in Plato's cave and Lucretius's witness of ship-wreck are perhaps the most canonical figures for spectatorship in aesthetics and philosophy.[1] While these figures, and especially the spectral watchers in Plato's cave, continue their vigorous afterlives, the changed conditions of modern spectatorship also have demanded new critical models. Film's challenge to familiar regimes of spectatorship and the increasing centrality of spectacular mass political forms make the 1930s a period of particular pressure in the history of spectatorship. That spectacle might radically change people was at once a conviction, and a fear. Antonin Artaud embodies these antino-mies with force and fascination. As a form to express these antinomies, he found Lot's wife.

The partly occulted figure of Lot's wife and the Genesis story's concern with looking as destructive participation haunt Artaud's *The Theater and Its Double*, a collection of essays he wrote during the 1930s. The goal of that collection is to establish a theater that would radically disrupt the spectator, *disruption* compelling the spectator to occupy a place beyond psychology, on the one *of spectator* hand, and beyond politics, on the other. Precisely this sweeping goal locates the historical place of Artaud's project. That is to say, rather than being an "outsider" artist whose production bears an only accidental relationship to the main trends of his time, Artaud's theatrical formulations have distinct filiations to problems many identified as central in the 1930s. Many longed

for a theater that would attain the condition of ritual and wanted to reclaim theater's central role in society as a privileged site of the sacred. Theater artists were at once threatened and flattered by massive state ceremonies that also aspired to a grasp on the sacred. The state claimed ritualized, sacralized theatrical powers. The central exhibits in this theater at once political and theological are the massive spectacles of totalitarian states, which in many cases were explicitly based on ritual models. Theater artists saw the state seizing a theatrical power, and longed for an efficacy to equal that of the state. These political spectacles seemed to possess the power to produce subjects, and some artists desired this power. Central to this political theater is the abolition and transformation of the observer; at least in principle, or in the fantasies of ideology, the spectator becomes participant.[2]

Walter Benjamin's analysis of this ideology of spectatorship as it played itself out in the mass rallies of the Nazis is especially germane here for its emphasis on the ritual elements in these spectacles. Fascism, writes Benjamin,

> sees its salvation in granting expression to the masses—but on no account granting them rights. The masses have a right to changed property relations; fascism seeks to give them *expression* in keeping these relations unchanged. *The logical outcome of fascism is an aestheticizing of political life.* The violation of the masses, whom fascism, with its *Führer* cult, forces to its knees, has its counterpart in the violation of the apparatus which is pressed into serving the production of ritual values.[3]

One response to violation of the theatrical apparatus in the enforced expression of ritual values was Bertolt Brecht's. Theater could refuse that mode of expression and abandon the ritual interpellation of the subject. The phantasm of theatrical participation, seen from a Brechtian standpoint, always remains potentially a kind of ritual, and it is precisely such ersatz and politically deleterious magic that theater must reject. Like Brecht, Artaud rejected the false magic of theater; unlike Brecht, Artaud hoped to counter this false magic with true magic, not the disenchanted stage. Artaud's failures—his failure to raise money for various attempts to realize the Theater of Cruelty, his failure ever to stage a production that approached his ideal—were in many senses inevitable. Artaud's "failures," then, are similar to the "failure" of Eliot's *The Waste Land*, which, Franco Moretti has provocatively claimed, is a consequence of its desire to achieve what only mass culture could achieve—the creation of modern myth.[4] Artaud's failure has similar causes: Artaud desired a thorough, ritual demolition of the subject. Such demolition work was, perhaps, possible, but only in the mass cultural or political arena Artaud scorned.

Lot's wife is one of Artaud's ambivalent figures for this demolition. Lot's wife is not explicitly central to *The Theater and Its Double*. Indeed, Artaud

engages in a kind of obsessive forgetting of Lot's wife as if conscientiously to
undermine Christ's commandment: "Remember Lot's wife" (Luke 17:33). In
the essay that forms the third part of *The Theater and Its Double*, "Metaphys-
ics and the *Mise en Scène*," Artaud elaborates on *Lot and His Daughters* (plate
3), a painting in the Louvre long attributed to Lucas van Leyden.[5] Artaud
argues that the painting renders the centuries of painting after it "inane and
useless," and that the theater should learn from this canvas.[6] Those who have
written about the painting after Artaud have often repeated the quirks of his
reading. Especially remarkable is Artaud's neglect of the men of Sodom and
their desires, and of the figure of Lot's wife. I focus here on Lot's wife because
she is a nexus for Artaud's concerns about spectatorship.[7] *Lot and His Daugh-
ters* is a large canvas that collapses into a single frame a sequence of moments
in the story of Lot. At the upper right, brimstone falls spectacularly on Sodom:
a church tower collapses, ships sink, a crowd gathers in a square.[8] In the
distance, one sees open water and Gomorrah's destruction. Below the bay, a
path crosses a large pier or bridge heading to the left of the painting: Lot and
his daughters, one carrying a pack on her head, walk to the right, followed by
a mule. Lot's wife stands at the end of the pier, facing the collapsing cities,
illuminated by the light of the disaster. In the lower left, before a bright red
tent, Lot sits with one of his daughters in his lap, one hand on her knee, one
around her neck; a tree rises behind them, and forms a powerful visual divi-
sion between the right and left sides of the painting. Lot's other daughter
pours out wine. The skeleton of a large animal, maybe that of the mule that
earlier walked across the bridge, lies in the foreground. In the upper right, a
craggy hill rises. The path from the pier winds through this landscape. At the
top of the hill sits a structure that includes what may be the end of the path:
a bridge that resembles an aqueduct.

One goal of the contradictory project of the Theater of Cruelty is to achieve
a theater that will radically, and perhaps fatally, disrupt the spectator and
the codes—especially the linguistic codes—upon which the viewer depends.
Artaud's reading of *Lot and His Daughters* is of a piece with this project.[9] He
concentrates on the foreground of the painting, in which Lot's daughters get
Lot drunk and seduce him; he remembers the details of the incest quite
clearly. Artaud comically leaves out the earlier part of the biblical story of Lot
from his account: "an unprecedented naval disaster seems to have occurred,"
he writes. "It would be difficult to say," Artaud continues in this deadpan
mode, "why the impression of disaster, which is created by the sight of only
one or two ships in pieces, is so complete" (35). In the opening paragraph of
"Metaphysics and the *Mise en Scène*," he clearly knows that the painting is
based on the Bible story: "Of course the Bible in the Middle Ages was not

understood in the same way we understand it today, and this canvas is a curious example of the mystic deductions that can be derived from it" (33). The whole chapter returns to this system of "mystic deductions" that was, according to Artaud, interpretation of the Bible in the Middle Ages. Yet Artaud proceeds by his own process of mystic deduction—or mystified subtraction—as if the viewer has no way to interpret the cataclysm in the background of the painting. Perhaps Artaud's reading of the painting provides a model for the rejection of the text he champions for his new theater. Artaud asks why, in Occidental theater, "everything that cannot be expressed in speech, in words, or, if you prefer, everything that is not contained in the dialogue . . . is left in the background?" (37). At the margin of the painting Artaud lavishly celebrates is Lot's wife, an image of the destruction of the subject in thrall to spectacle that the Theater of Cruelty should perform. With a certain amnesia—whether symptomatic or strategic, or an amalgam of symptom and strategy—Artaud actively forgets much of the biblical text that provides the viewer one way to decode the shipwreck and destruction of cities on the right. Artaud represses what everyone remembers and remembers what most forget: he chooses to remember the incest—if this remembering is a choice—and represses the fate of Lot's wife.

To imply that Artaud has repressed the figure of Lot's wife may intimate that *The Theater and Its Double* is the symptomatic registration of some complex of Artaud's. This may well have been the case. More important to my argument here, however, is how Artaud's leaving Lot's wife out of his discussion of the painting illuminates his notion of spectatorship. Theater, in his best-known analogy, is like the plague:

> The theater like the plague is a crisis which is resolved by death or cure. And the plague is a superior disease because it is a total crisis after which nothing remains except death or an extreme purification. Similarly the theater is a disease because it is the supreme equilibrium which cannot be achieved without destruction. It invites the mind to share a delirium which exalts its energies; and we can see, to conclude, that from the human point of view, the action of theater, like that of the plague, is beneficial, for, impelling men to see themselves as they are, it causes the mask to fall, reveals the lie, the slackness, baseness, and hypocrisy of our world; it shakes off the asphyxiating inertia of matter which invades even the clearest testimony of the senses; and in revealing to collectivities of men their dark power, their hidden force, it invites them to take, in the face of destiny, a superior and heroic attitude they would never have assumed without it. (31–32)

Artaud Lot

No passage better illustrates what Susan Sontag calls Artaud's "ultimate, manic Hegelianism":[10] for Artaud, theater becomes a force for *Aufhebung,* so powerful that some participants expire in its dialectical violence. Theater achieves "supreme equilibrium," but death is as likely a result as cure on the way to this equilibrium.[11] The destruction of the cities on the Plain, then, prefigures Artaud's desired attack on corruption. This passage about the theater as plague also underlines affinities between Artaud's project and the aims of political mass spectacle. Revealing "to collectivities of men their dark power" in order to foster "a superior and heroic attitude" is analogous to what Benjamin calls, in a debunking mode, "the production of ritual values" and the giving of expression to the masses.

Lot and His Daughters achieves the bodily impact Artaud wished for theater:

> It seems as if the painter possessed certain secrets of linear harmony, certain means of making that harmony affect the brain directly, like a physical agent. In any case this impression of intelligence prevailing in external nature and especially in the manner of its representation is apparent in several other details of the canvas, witness for example the bridge as high as an eight-story house standing out against the sea, across which people are filing, one after another, like Ideas in Plato's cave. (35–36)

Artaud comes no closer to mentioning Lot's wife, one of the figures on the bridge, in his analysis of the painting. He occludes Lot's wife, a figure for the dangers of looking, only immediately to read those figures on the bridge as part of a Platonic model of spectatorship. The figures on the bridge are like those puppets masquerading as "Ideas" that the prisoners in the cave take to be real. One can wonder, however, whether Artaud means to include Lot's wife, separated as she is from the other figures on the bridge, among those who bear a likeness to the spectators in Plato's cave. At least in one way, Plato's spectators are the antithesis of Lot's wife: they cannot look back. Plato writes that they have been "prisoners since they were children, their legs and necks being so fastened that they can only look straight ahead of them and cannot turn their heads."[12] One may compare Lot's wife with the one separated from the crowd, Plato's figure for the philosopher who sees the real: "Suppose one of them were let loose and suddenly compelled to stand up and turn his head and look and walk towards the fire" (318). Plato's scheme is the puppet show of cruelty: the philosopher must be "compelled to stand up" and is "forcibly dragged" from the cave (318). Artaud and Plato alike depict a certain sadism in the loss of illusion. But one might also venture that Lot's wife embodies an "Idea" of the wrong kind of looking. It is not clear whether

Artaud's reification of loss <=> Lot's wife's looking

Lot's wife looking in the wrong way?

Lot's wife figures the spectator of the theater Artaud imagines, or the reverse, the anathematized double of that spectator, the spectator who looks at the wrong thing, who participates in the wrong way.

IS THE IDEAL SPECTATOR DEAD?

The punishment of Lot's wife figures the impossible achievement of one aim of Artaud's theatrical project: the spectacle of destruction destroys the one who looks. But this metamorphosis and its strange violence are not the ful-fillment of Artaud's project; if destruction were all he desired, Artaud would be a much duller figure than he is. Destruction should also be transformation. Lot's wife, then, embodies the ambivalence that marks Artaud's ideal specta-tor. Lot's wife disappears in "Metaphysics and the *Mise en Scène*"—along with other fragments of Sodom—only to surface as the figure of a cultural crisis in the opening of *The Theater and Its Double*, its preface "The Theater and Cul-ture," which was probably written after all the other essays that make up the volume. This appearance of Lot's wife illuminates Artaud's ambivalence about the place of destruction and transformation in his desired theater.

destruction of spectator => precludes transcendence

The crisis Artaud identifies is one of signification—Artaud laments a con-fusion with its roots in "a rupture between things and words, between things and the ideas and signs that are their representation" (7)—and, more specifi-cally, a crisis of looking. Lot's wife becomes the image of this general crisis. It is as if the repression of Lot's wife causes the dispersal of symptoms across the body of *The Theater and Its Double*. Artaud's central argument in this preface is that the crisis of the moment of *The Theater and Its Double*, first published as a collection in 1938, results from the fact that culture, rather than being "coincident with life," has instead been designed "to tyrannize over life" (7): "If our life lacks brimstone [*soufre*], i.e., a constant magic, it is be-cause we choose to observe our acts and lose ourselves in considerations of their imagined form instead of being impelled by their force" (8, OC 4:13). Here the ambivalence that motivates Artaud's representation of the world Lot flees becomes especially apparent. The word Artaud uses here, "*soufre*," is the term the French Bible uses to describe what falls on Sodom and Gomorrah (Gen. 19:24): The brimstone our lives lack is what destroys the biblical cities. Observation itself is part of the false culture Artaud attacks. Lot's wife's look backward, then, embodies the reification that follows from the loss of self in consideration of "imagined form." The look backward is a partial solution to the crisis Artaud has identified: her looking is itself action, drastically undoing the rift between observation and impulsive force. But this look is also, quite vividly, a corporeal loss or petrifaction of self.

Artaud's solution to this loss is explicitly sacred. He imagines a return to a world of "constant magic." Specifically, the preface announces the necessity of a return to totemism. Totemism and magic will heal the rifts that result from the confusion of signification and observation. Totemism, that is, at once acknowledges the damage done by the cultural crisis, and undoes its petrifying work. Lot's wife explicitly surfaces in the preface when Artaud describes the "gods that sleep in museums," a group of Mexican deities. Artaud imagines a different, magical culture, the

> world of obligatory servitude in which a stone comes alive when it has been properly carved, the world of organically civilized men whose vital organs too waken from their slumber, this human world enters into us, participating in the dance of the gods without turning round or looking back, on pain of becoming, like ourselves, crumbled pillars of salt [*sous peine de devenir, comme nous-mêmes, des statues effritées de sel*]. (11, OC 16)

Modulation?

These sleeping gods of stone invert the petrified figure of Lot's wife. When Lot's wife improperly looks, she turns into a pillar—or, as Artaud writes in following the French translation (Gen. 19:26), a statue—of salt. When these statues are "properly carved," the carver frees them from the petrified forest of signs. Should Artaud's audience risk participating in "the dance of the gods," it would risk the penalty of becoming an assembly of Lot's wives, "crumbled pillars of salt," crumbling like ruins. Artaud's idealized anthropology has at least the virtue of a certain recognition of difference, however imprecise: the association of too intimate a participation in the divine with petrifaction belongs for him to a peculiar culture that, however widespread, is identified with "us." And the disappearance of the look backward toward the cities of Sodom and Gomorrah into the "dance of the gods" again suggests the complexities of Artaud's translation of the story of Lot's wife. Totemism is Artaud's answer to a general petrifaction of the human in the West.[13] Theater has a privileged place in undoing this reification because it is itself "*no thing*, but makes use of everything—gestures, sounds, words, screams, light, darkness" (12).

Lot's wife is in part the icon of the spectator who has already looked back, a representative of the benighted world Artaud wants his totemic theater to redeem. But it remains difficult to reconstruct what looking backward might mean for Artaud, what catastrophe we "ourselves," Lot's wives, might have witnessed, or might be in danger of witnessing. Here, again, Artaud takes part in an argument of the 1930s, an argument in which the central question is whether the catastrophe we fear has already occurred.[14] On the one hand, the

grammar of Artaud's description of "ourselves" as "crumbled pillars of salt" leaves open the possibility that we have already witnessed the feared catastrophe, that we are ourselves part of a salt landscape. On the other hand, Artaud often suggests in *The Theater and Its Double* that the catastrophe is yet to come; he writes, for instance, of "this slippery world which is committing suicide without noticing it [*ce monde qui glisse, qui se suicide sans s'en apercevoir*]" (32, OC 4:39). For the writer who was to describe van Gogh as "suicided" by society, the rather different valences of the reflexive form of the French verb seem important: here, the world suicides itself.[15]

Lot's wife figures suicidal historical spectatorship: to witness divine "history in the making," so to speak, is forbidden. Artaud thought the anonymous painter's *Lot and His Daughters*, a representation of such history, a model for theater. The crux of the constellation I have identified with Lot's wife is the question of whether there is some form of looking at disaster that can also undo it, whether spectacle can undo the spectacular destruction toward which the world heads. This crisis, then, raises the question of the spectator of *Lot and His Daughters*. The painting becomes a paradox: the viewer of the painting can look at a representation of the catastrophe, the sight of which destroys Lot's wife. Theater, with what Artaud somewhat surprisingly calls its "virtual reality" (49), should be the representation of historical catastrophe which, if actual, would destroy us.

In his investigation of the relationship of Artaud's work to history, Herbert Blau argues that the crucial figure to consider in *The Theater and Its Double* is the Sardinian Viceroy in Artaud's first chapter, whose dreams inspire him to turn away a ship that will bring the plague virus to Marseille. (The ship's name, the Grand-Saint-Antoine, surely caught the attention of Antonin Artaud.) Blau uses this story to illustrate what he calls Artaud's "homeopathic conception of the cathartic," which teaches, Artaud writes, "precisely the uselessness of the action which, once done, is not to be done, and the superior state unused by the action and which, *restored*, produces a purification" (82). "What is unused by the action" argues Blau,

> is the theater's endowment to history. It is a material endowment in the form of absence. What's not to be done again *can't* be done again, since, consumed by theater, it is useless to history. But the superior thing, restored, saved by/from theater, is *in history*, already there, and there to begin with, in the sense of beginning again. For all the affinity to dream, the theater of Artaud is very much attached to the objective and external world, where the sky can still fall on our heads. To make the audience know that is to restore the audience to history.[16]

[handwritten margin notes: Artaud + history / theater transcends to / show / already there]

Blau's argument captures the contradictory logic of Artaud's text. On the one hand, in another version of Hegelian *Aufhebung*, the theatrical event enacts, purifies, and subsumes the threatening promise of the future: the Viceroy dreams of the dangers of the passing, infected ship, and, acting on his dreams, saves his city from the plague. Theatrical excess wards off actual excess; theater's rehearsal of horrors will mean the world will never need to perform them. On the other hand, the plague is already there, in history: the ship passes on to bring it to Marseille. Our dreaming may save us, but it will not save others.

Blau's central premise here—that to remind the audience that "the sky can still fall on our heads" is to restore it to history—implies that knowledge of one's own vulnerability to catastrophe marks the essence of the historical. This notion of the historical and of theater's relationship to it is incompatible with other, equally important emphases in Artaud's text. In "Metaphysics and the *Mise en Scène*," Artaud turns his attention to precisely the question of what theater should do to culture, and his terms are considerably less abstract than those of the phrase of Artaud's to which Blau alludes; when Artaud pictures cultural intervention here, Chicken Little doesn't come to mind. Artaud rejects the idea that it is the place of theater to "wrestle with all the problems of a topical and psychological nature that monopolize our contemporary stage," such as "whether we can make love skillfully, whether we will go to war or are cowardly enough to make peace, how we can cope with our little pangs of conscience, and whether we will become conscious of our 'complexes' (in the language of experts) or if indeed our 'complexes' will do us in." The debate, Artaud complains, rarely raises "to a social level" (41), and he delivers his own judgment on the social:

> I believe . . . that our present social state is iniquitous and should be destroyed. If this is a fact for the theater to be preoccupied with, it is even more a matter for machine guns. Our theater is not even capable of asking the question in the burning and effective way it must be asked, but even if it should ask this question it would still be far from its purpose, which is for me a higher and more secret one. (42)

Artaud suggests here that "[o]ur theater" does not have the means to ask questions of the social, but it is important to note that he asserts both that machine guns deal better with the iniquities of the social than the theater can, and that, even if theater were capable of asking the proper questions, it would be missing its "higher and more secret" purpose. The real importance of theater is not historical and it has nothing to do with "our present social state."

[handwritten margin note: vs. Blau: Artaud is not claiming theater as having historical import]

The dadaist Hugo Ball, a figure comparable to Artaud in his combination of avant-garde practice and mystical conviction, achieves, at least for a moment, a dialectical understanding of his own ascetic "longing" that Artaud does not: "It is much more difficult not to be concerned with these times than it is to oppose them. Whenever they come into contact with us, we are still bound to them. It is the punishment for our intellect and a sign of the fact that the rottenness has a share in us. The purity we aim at is perhaps only a longing, and this is a sign of our involvement in destruction."[17] Ball sees a direct relationship between a longing for purity, a longing that includes an explicit rejection of historical engagement with "these times," and the historical circumstances that such longing putatively transcends. "These times" create the desire to escape their bind, and one cannot separate purity from destruction. Few figures are more remarkable for resistance to concern with "these times" than Artaud, and the scary strength of his work lies partly in his refusal ever to follow Ball in admitting the specificity of the moment that fostered his own desire. Artaud may gesture to "these times," and he may describe a crisis, but that crisis seems to be as old as Western civilization, and "our present social state," in the end, bores him. The path of Lot's wife through *The Theater and Its Double*, from underground existence to later emergence, traces the inevitable failure of Artaud's resistance to such an admission.

In Lot's wife, Artaud figures being subject to history as feminized objectification. The problem of Lot's wife, according to sometimes laughable exegeses of the biblical story, is that her desires capture her: "The deadliest looking back is that of the imagination which has become entangled in sinful associations which it cannot willingly let go . . . Lot's wife held her hot desires too close to Sodom, and the result was disastrous."[18] This sentence directly follows Jesus' injunction, "Remember Lot's wife": "Whoever seeks to save his life will lose it; and whoever loses it will save it, and live" (Luke 17:32–33). One wonders if Lot's wife is not, then, a figure for salvation: it is Lot, not his wife, who desperately bargains to save his life, and one could read his incest as the first loss Luke describes. (Lot's wife, after all, never becomes part of the incestuous community after the destruction of the cities.) One can then argue that Jesus and Artaud are "meditating on the same problem":[19] salvation through destructive participation in historical spectacle. Drastic purity is purity all the same, and to die from the plague would be, for Artaud, better than to survive, choked by the "asphyxiating inertia of matter." The Theater of Cruelty's demolition of the subject becomes the last available form of resistance to history.

The final paragraph of Artaud's Preface calls for a new, sacrificial art:

Furthermore, when we speak the word "life," it must be understood we are not referring to life as we know it from its surface of fact, but to that fragile, fluctuating center which forms never reach [*cette sorte de fragile et remuant foyer auquel ne touche pas des formes*]. And if there is still one hellish, truly accursed thing in our time, it is our artistic dallying with forms, instead of being like victims burnt at the stake, signaling through the flames [*comme des suppliciés que l'on brûle et qui font des signes sur leurs bûchers*]. (13, OC 4:18)

Few have connected this passage to Carl Dreyer's *The Passion of Joan of Arc*, the silent film of 1928 in which Artaud memorably performs (fig. 1).[20] The end of Dreyer's film concentrates on the face of Maria Falconetti's Joan of Arc as she burns at the stake (fig. 2). The figure of Joan had a peculiar hold on the imagination of the 1920s and 1930s; she became a privileged female figure of an occult relationship to the forces of history.[21] If Lot's wife is the figure who witnesses the moment of divine judgment, rather than its aftermath, Falconetti's Joan of Arc figures the attempt at signaling. Falconetti, that is, forces one to imagine destruction as a choice. She refuses to save her life, and the picture of her death embodies the intersection of purity and destruction

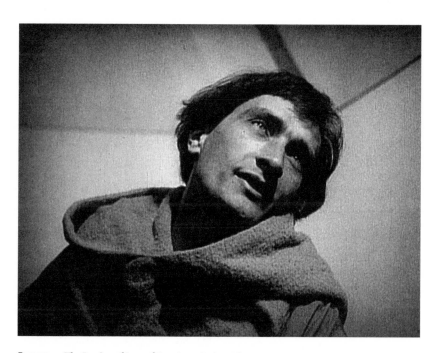

FIGURE 1 *The Passion of Joan of Arc*: Antonin Artaud

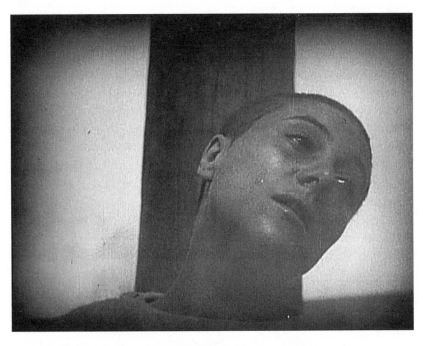

FIGURE 2 *The Passion of Joan of Arc*: Maria Falconetti

that Ball describes. As in his equation of theater and plague, Artaud here imagines the work of art that gets close to the "fluctuating center which forms never reach" as one that borrows its strength from death. This connection is clearer in the French. The translation here inevitably missed the many connotations of the French word *foyer*, which is at once a "center" (*foyer de la rébellion* is the example of this usage from the 1937 *Petit Larousse*), "a hearth," "the cause of a disease," and, in a usage familiar in English, "the gathering place of the audience between acts in a theater." This "fragile, fluctuating center," then, combines in a word many of Artaud's concerns: medical and theatrical connotations point to the first chapter following the preface, "The Theater and the Plague." More immediately, the hearth foreshadows the final image of the preface, which, to retranslate somewhat literally, pictures "the condemned who are burned and who make signs atop their pyres." The condemned occupy the burning center and make "signs"; these "signs" are implicitly opposed to the "forms" that cannot reach that moving center.[22] It is not that communication from this "foyer" is impossible, but that forms cannot contain it; such communication instead requires signs.

This raises the question of what a "sign," as opposed to a "form," might be, and *The Passion of Joan of Arc*, again, provides a context for this large

[handwritten margin notes: "entrapped in phantasmic construction of the past" / "statue" / "Lot's wife"]

issue. Artaud valued silent film precisely for its silence, Denis Hollier has argued, as a step away from articulation, and toward noise.[23] The closing of Dreyer's film certainly challenges articulation, in two senses: its affective power eludes translation, and yet it demands response. The face of Falconetti may "make signs," but what these signs signal is obscure. We should, Artaud says, not dally with forms but instead, like the condemned, make signs. As Mathieu, the monk in Dreyer's film, Artaud's role is just the reverse; he quite literally dallies with forms, hoping that Joan will sign her name to a written recantation rather than become a martyr.

We are Lot's wives; we should be at the stake. It is around the ambiguities of Artaud's gendering of the experience of catastrophe that the pair of Lot's wife and Falconetti's Joan most resonates. What Artaud represses in his forgetting of Lot's wife has been analyzed by his antagonist, Lacan, in a discussion of the perils of the analysand's becoming entrapped in a phantasmatic construction of the past no less illusory than the analysand's current predicament: "The danger involved here is not that of the subject's negative reaction, but rather of his capture in an objectification—no less imaginary than before—of his static state or of his 'statue,' in a renewed status of alienation."[24] I have bracketed the question of Artaud's diagnoses here, but will note that it is possible to read his schizophrenia, his experience of subjection to occult forces, as an historical malady. Artaud, institutionalized in 1937, emerged from asylums only after the war; as Guy Scarpetta has noted, in a strange way Artaud interiorized the madness of an entire culture—his madness becomes legible as a symptom of a vast cultural malady. (One might read Artaud alongside the Schreber of Eric Santner's *My Own Private Germany*.) The French Bible insists that Lot's wife, looking back, becomes a statue of salt: "Et la femme de Lot, regardant derrière elle, fut changée en une statue de sel" (Gen. 19:26). Lot's wife is precisely the image of an objectification such as Lacan describes; she becomes the "statue" of Lacan's description in her investment in the rapidly vanishing historical past. One can argue, with Blau, that Artaud's project is to "restore the audience to history." But more important to Artaud, I would argue, is the creation of a defense against history. Artaud was already imagining, to anticipate the title of his radio transmission, ways to have done with the judgment of God. Historical determination, for Artaud, is an objectification as repulsive as any other.[25] The ambivalence that shapes Lot's wife in *The Theater and Its Double* has two cruxes. On the one hand, Lot's wife and Falconetti's Joan represent sheer subjection to the power of history; on the other, they embody Ball's flight out of time—the sheer, material resistance of those who have chosen to signal from the *foyer*.

BODIES AFTER THE DISASTER

I have argued that Artaud's failure to say anything about the figure of Lot's wife in the painting from the Louvre points toward a symptomatic conjunction of the figure of the reified woman and the urges of Artaud's impossible theatrical project. Before closing, I want to speculate about a drawing Artaud executed in 1946, at the end of the long period he spent in various asylums. At the center of the drawing, called, plainly, *Le Théâtre de la cruauté* (plate 4), the figures of four women, each confined to what looks like a strange, five-sided coffin, intersect. In the lower left is a biomorphic form. It is an image of oppressive constraint; one must ponder the relationship between the "title"—the legend written across the top and the bottom of the drawing—and the image itself. Is this constraint the result of the Theater of Cruelty, or is it the condition Artaud's theater aims to undo?[26] This drawing, I think, is a revision of the painting Artaud so admired in the Louvre, the painting that he thought should be a model for the theater. *Le Théâtre de la cruauté* performs a drastic revision of the *Lot and His Daughters* attributed to Lucas van Leyden, doubling the number of Lot's daughters, and leaving out Lot entirely. Artaud also recalls Lot's wife, at the bottom left, as an androgynous shape, at once aggressively phallic and feminine, a crumbling pillar of salt. If Artaud claims in "Metaphysics and the *Mise en Scène*" that theater should base itself on the force of the Louvre's *Lot and His Daughters*, *Le Théâtre de la cruauté* appears to be a late meditation on Artaud's aims for a theater that seemed always to abandon him.

In 1932, the problems of "our present social state"—those problems best solved by machine guns—"stink unbelievably of man, provisional, material man, I shall even say *carrion man [l'homme charogne]*" (42, OC 4:51). Artaud links the antimetaphysical concerns of the everyday to the body, seen as so much rotting meat. That this *charogne* may also be translated as "slut" also suggests the consistency with which Artaud anathematized sexuality: the promiscuity and materiality of sex are one of Artaud's consistent targets.[27] Small wonder, then, that in 1946, when Artaud drew *Le Théâtre de la cruauté*, Sodom and Gomorrah were at least occasionally on his mind. In Jacques Prevel's diary of his time with Artaud between Artaud's release from the asylum at Rodez in 1946 until his death in 1948, Prevel writes that Artaud diagnosed him by touch as "very sick": "A few minutes later, he tells me that it's necessary to avoid the act of sex. 'There's nothing pure anymore in sexuality, it's become a dirty thing as during certain periods the function of eating. It's in this way that Sodom and Gomorrah perished.' [*C'est ainsi qu'ont fini Sodome et Gomorrhe*]."[28] This reading of Genesis is also an idiosyncratic history of sexuality. Following neither a scholarly understanding of the biblical destruction as punishment for a breach in hospitality nor the popular interpretation which

links it to homosexuality, Artaud argues that sexuality as such had become ⟶
"dirty." The solution to this historical predicament of sexuality is not another *abstinence*
kind of sexuality—not, for instance, a putatively purer heterosexuality to op-
pose to the sexuality of the cities on the Plain—but instead simply abstinence
from *l'acte sexuel*, which, Artaud had insisted in conversation with Prevel
about a month before, "is [a] thing absolutely to avoid at this moment be-
cause the spirit is threatened."[29]

 This corporeal, sexualized, and anathematized body provides a context for
the mummified bodies in Artaud's drawing. Where the women's bodies are
exposed, they are violently constrained and marked by violence: the body at
upper right, with its fanged breasts, is an image of *vagina dentata* displaced
upward. But mostly these bodies are sheathed and protected. The formless
pile at bottom right, which I have identified with Lot's wife, seems the waste *Lot's wife*
product of these bodies partly purified of the desires they have sloughed off.
Like Lot's wife after her look backward, this formation is purely material,
amorphously sexual, at once humanoid and alien: this body is *all* organs.[30] It
is possible that an illustration from the *Dictionnaire de la Bible* of Vigouroux
influenced Artaud's drawing: the shape in the lower right closely recalls the
illustration of a column of salt on the Dead Sea, and long associated with
the figure of Lot's wife, included in that volume (fig. 3).[31] This particular
iconographic connection is more suggestive than conclusive. But it empha-
sizes a kind of catachrestic movement in Artaud's career. If the Louvre's *Lot
and His Daughters* provides a visual model for the Theater of Cruelty that
should follow, Artaud's drawing comes near the end of a career of thinking
about how this theater should work. It seems possible to read this extreme
division of bodies in the drawing as an image of the aftermath of the work of
cruelty. In his preface to *The Theater and Its Double*, Artaud writes that the
properly totemic Mexican culture allows the experience of "participating in
the dance of the gods without turning round or looking back, on pain of
becoming, like ourselves, crumbled pillars of salt" (11). *The Theater of Cruelty*,
in 1946, likewise divides the world of human bodies between totemic survivors
and abject remains. Artaud drives the logic of destructive spectatorship to its
limits. No longer awaiting disaster, the world is divided between those who
could not sustain the force of the sight of catastrophic theaters of cruelty—
those who have become "crumbled pillars of salt"—and those who have sur-
vived. In his reading of the Louvre's *Lot and His Daughters*, Artaud
emphasizes that scene of sodomitical sex after the destruction of Sodom: Lot
is "seemingly placed there among his daughters to profit unfairly by them,
like a drone" (36). This, writes Artaud, is the only "social idea" the painting
contains (36). In this aftermath, there are only constrained bodies, prophylac-
tically sheltered from the world, and an abject pile.

111. — Colonne de sel à *Usdum*. D'après une photographie.

FIGURE 3 Illustration of Pillar of Salt on Dead Sea, from F. Vigouroux, ed., *Dictionnaire de la Bible*, 4:366. Permission of Butler Library, Columbia University in the City of New York.

I have, as I noted, mostly bracketed the question of Artaud's psychic state, and preferred to concentrate not on the writings he produced while institutionalized, but, instead, on what remains for me his most compelling work, *The Theater and Its Double*. Artaud was an extreme cultural critic, and it is Artaud, participant in and critic of the age of mass spectacle, on whom I have focused here. His enthusiastic anatomy of mass spectacle at once challenges and has filiations with the work performed by the mass spectacles of totalitarian states. Rainer Friedrich, indeed, has argued that the "deconstruction of the self" in Brecht and Artaud complements totalitarianism: "in both authors the negation of the subject is inextricably bound up with a totalitarian bent."[32] The aims of some of the most adventurous theater of the 1930s and of mass spectacle were, then, according to Friedrich, not only analogous, but the same. It seems to me important to question both sides of this equation, both to look closely at the specific kinds of "deconstruction" Brecht and Artaud might have desired and to ask whether such demolition was what totalitarian states

wanted or required in the 1930s. There is a trace of a Rousseauistic naivete in the assumption that, in order to form totalitarian subjects, totalitarian states had first to deconstruct selves through spectacles, rallies, and all manner of political discipline. It may, that is, be mistaken to assume that the "self" will capitulate to totalitarianism only once "deconstructed." Fascist selves may have been all too solid. The negative achievement of Artaud's theater, in contrast, might have been the creation of subjects unfit for any politics: on the one hand, *The Theater of Cruelty* depicts bodies cut off from communication; on the other, a speechless pile. One might object that the apolitical self is chimerical, but this objection only repeats what is clear in any case: Artaud's project could not "succeed" in the 1930s, or in any time since.

Artaud's forgetting of Lot's wife has its most familiar analogue in Auden's "Musée des Beaux Arts." Like Artaud in "Metaphysics and the *Mise en Scène*," Auden responds to early modern painting, Pieter Bruegel's *Landscape with the Fall of Icarus*. Like the publication of *The Theater and Its Double*, Auden's poem belongs to 1938, and this date is symptomatic:

> About suffering they were never wrong,
> The Old Masters; how well, they understood
> Its human position; how it takes place
> While someone else is eating or opening a window or just walking
> > dully along;
> How, when the aged are reverently, passionately waiting
> For the miraculous birth, there always must be
> Children who did not specially want it to happen, skating
> On a pond at the edge of the wood:
> They never forgot
> That even the dreadful martyrdom must run its course
> Anyhow in a corner, some untidy spot
> Where the dogs go on with their doggy life and the torturer's
> > horse
> Scratches its innocent behind on a tree.
>
> In Breughel's Icarus, for instance: how everything turns away
> Quite leisurely from the disaster; the ploughman may
> Have heard the splash, the forsaken cry,
> But for him it was not an important failure; the sun shone
> As it had to on the white legs disappearing into the green
> Water; and the expensive delicate ship that must have seen
> Something amazing, a boy falling out of the sky,
> Had somewhere to get to and sailed calmly on.[33]

Artaud, missing Lot's wife in the corner of the painting to which he devotes such close yet idiosyncratic attention, is like the ploughman in Auden's poem.[34] Auden's poem offers a way to understand the move from the suppression of the figure of Lot's wife to her partial emergence in Artaud's preface. Lot's wife shifts from total absence to universal condition: we are all already Lot's wife. In Artaud's preface, that "leisurely" turn from disaster Auden describes is no longer possible. If Auden's turning away illuminates Artaud's understanding of the turning of Lot's wife, Artaud also illuminates Auden's poem. Artaud allows one to recognize the poem's description of the experience of suffering as anachronism. What Auden captures in "Musée des Beaux Arts" is a moment in the history of nostalgia: the poem captures nostalgia for a past or passing time when suffering "takes place / While someone else is eating or opening a window or just walking dully along." Auden's poem, that is, captures nostalgia for a past in which one could choose not to look back.

Hollywood Sodom

[handwritten margin note: Artaud = audience destroyed by disaster. Hollywood: pleasure at looking at it]

ENJOYING THE PAIN OF OTHERS

If Artaud imagines his audience as twentieth-century Lot's wives, petrified by the spectacles it must witness, Hollywood films often imagine a different audience and a different experience: we take pleasure in looking at disaster. The burgeoning literature on the ethics of spectatorship for the most part assumes a liberal or cosmopolitan subject granted access to scenes of distant destruction he or she can do little about.[1] The pathos of a distanced sympathy, with varying degrees of identification and claims of political solidarity, marks much thinking about the problem of seeing carnage and destruction happening far away. But this massively mediated spectatorial predicament has a history. To return once more to the *Lot and His Daughters* attributed to van Leyden (plate 3): in a brilliant short essay that focuses on the upper-right-hand corner of the painting, where cities fall and towers collapse, John Berger speculates that the early modern viewer might differ from his or her modern counterpart in that the former might have seen the destruction as a matter of the justice of a divine father:

> The power of this father lies not only in his ability to rain fire down upon the city, but in the very form of the fire in the sky. It is symmetrical, ordered, lucid—like a perfectly developed part of a chrysanthemum. It is part of the order of justice which man fails to understand but cannot escape. Perhaps the reason why such an image can still work on one powerfully—if one allows it time—is to be found in the fact that in one's dreams and unconscious the notion of a higher order may remain. The word "father" can be very potent in this respect, while scenes of destruction by fire often possess, if we are not in immediate danger, something of the quality of a dream.[2]

Berger partly dissolves the historical difference he earlier insists on, and it may be that traces of the medieval experience of "scenes of destruction by fire" still survive in twentieth-century disaster movies. Again and again, after September 11, 2001, one heard that the sight of that day's destruction was dream-like; equally often, as many observers have by now noted, witnesses averred that, perhaps because of this dream-like quality, those events resembled a Hollywood spectacle.[3] And yet the most remarkable feature of the Hollywood extravaganzas that seemed a model for the destruction of the World Trade Center may be that they produce spectatorial pleasure. Perhaps lurking in all these testimonies of mass-mediated déjà-vu is, then, an unconscious confession of pleasure—or, if not pleasure, the reassuring intimation that only a "higher order" could be responsible for such a "symmetrical, ordered, lucid" scene of destruction.

Along with the Bible, I would argue, Hollywood has shaped what Susan Sontag called the "imagination of disaster" in the post-Christian world. Hollywood has also, however, been the object of this imagination; depicted as falling or figured as doomed to fall, its critics picture Hollywood as one of the key targets of onrushing calamity. Further, this fantasy has fueled Hollywood: it revels in the spectacle of the Hollywood sign blasted to smithereens.[4] This chapter examines a set of films, ranging from an experimental depiction of the story of Lot to a pair of noir films to a biblical epic, in which Lot's wife emerges as a figure for a set of concerns about spectatorship. Latent in all these depictions is not only a fear about the potential dangers of spectatorship, but also something like the reassurance that Berger sees in immersion in *Lot and His Daughters*. Sontag describes how science fiction movies allow one "to participate in the fantasy of living through one's own death and more, the death of cities, the destruction of humanity itself."[5] These films elicit the anxieties that surround Lot's wife; beneath these anxieties, they invoke a desire to escape being Lot's wife, indeed to look back at Lot's wife, to recall the place of a spectator that is no longer one's own. They invoke, that is, the pleasure of a total disaster one can somehow escape.

Hollywood is rarely among the palimpsestic cities of the modern imagination. For the dazzling layers of Freud's Rome, the historian of Hollywood must trade stories of the mammoth ruins of the set of Griffith's *Intolerance*. These structures stood for a year or so after the shooting of the film on the margins of the city. In an accelerated and simulacral version of the incorporation of slabs of antiquity into modern structures, set-builders slowly cannibalized the massive remains. When the subject is the everyday business of Los Angeles, many commentators imagine the city as flat, amnesiac, a place without history where strangers routinely discard their pasts and "natives" never

come to possess one. But the exceptional Los Angeles of sex and drugs and ingenues inspires comparison with the ancient world; rumors of license create their own empires and their own ruins. Indeed, Griffith's film provides the template for a range of fantasies about Hollywood's depravities. It is a short distance from the Babylonian orgies of *Intolerance* to Kenneth Anger's catalogues of wild parties and other fantastic outrages in *Hollywood Babylon*. Indeed, Anger's book begins with a discussion of Griffith's movie and its ruins.[6]

In this chapter I focus not on fantasies of a Babylonian Hollywood, but on Hollywood imagined as that other decadent ancient city always on the verge of calamity, Sodom.[7] To imagine Hollywood as Sodom invokes a whole range of anxieties and fascinations involving sexuality, punishment, and the apparatus known by the city's iconic name. "Hollywood" becomes a synecdoche for mass culture, and mass culture a synecdoche for modernity. Modernity imagines itself as the negation of sacred legend and ancient ruins, so the undoing of modernity appears as its catastrophic decline into ruins. And to imagine Sodom is also to picture a place inextricably tied to the persecution of same-sex desire. The engagement with the myth of Sodom I will trace here, however, does not limit the meaning of Sodom in this way. Same-sex desire is part of a whole range of practices—many not explicitly sexual at all—that make these imagined cities Sodoms. Hollywood Sodom maintains a much older notion of Sodom, similar to that Puritan conception described by Michael Warner: "The fable of Sodom represented, in a way no other image could, an entire society open to discipline and in need of saving."[8] One problem with this fable, as in the fictions of Hollywood Sodom I pursue here, is that discipline and salvation often look like apocalypse.

My argument in this chapter is that fantasies of Hollywood Sodom are not external to the films that make a Sodom of Hollywood. Hollywood as Sodom also captures the dystopian fears about the Hollywood apparatus: Hollywood's alleged project of mass subject-formation through identification and imitation remains a basis of a common critique of Hollywood. The incarnation of Lot's wife in film enacts this problem while also troubling it. The mass audience watches the enigmatic suffering of an individual who herself suffers because she sympathizes with mass suffering, the deaths of her friends in Sodom. Or, that is, this is what might have happened had film used the figure in a way that, to my knowledge, it does not. I know of no film that screens the story of Lot's wife in the way an orthodox reading might suggest, where Lot's wife's intense (if, perhaps, sinful and certainly self-destructive) sympathy for the dead of Sodom would make her the traumatic embodiment of the individual's participation in a mass identification with suffering. Of the films I discuss here, the one that comes closest to this model, Watson and Webber's

[Margin notes: argument / mass subject formation]

experimental silent film *Lot in Sodom*, complicates such identification through
its resistance to narrative.

The greatest fear of the critics of Hollywood is that the spectator, like Lot's
wife, might be destroyed by the sight of Sodom. And yet the Lot story also
becomes a way to name and to interrogate this fantasy of destructive specta-
torship. In Lot's wife, that is, cinema finds a figure for the supposed incorpo-
ration of the viewer into Sodom. Or, alternately, Lot's wife provides a way to
imagine, even if only by implication, a different relationship to "Sodom."
And this scrutiny proceeds by asking spectators to see where and when they
might look like Lot's wives. The zero degree of Hollywood's portrayal of its
own destruction celebrates the ragtag band who carry on after the wreckage
of the world's great cities. Like Lot and his daughters, survivors look back in
absurd continuations of civilization. "We are merely spectators; we watch."[9]
But films may also realize that this spectatorial position is a precarious, even
impossible, one, and that the destruction of a world also means the destruc-
tion of a place from which one can watch it. That is to say, within Hollywood
and outside it, films scrutinize the fantasies of survival that Hollywood con-
tinues to nurture.

This chapter examines films that explicitly portray or refer to the Genesis
story. In each case, the figure of Lot's wife introduces the constellation of
Sodom and spectatorship. This constellation raises questions about the viewer
in the film as well as the viewer of the film. I begin with a short film produced
far from Hollywood, Watson and Webber's *Lot in Sodom* (1933). While the
most adventurous in form among my examples, *Lot in Sodom* also strays least
far from a straightforward retelling of the Genesis account—which is not to
say that it is entirely orthodox. The product of an all-too-familiar modernist
puritanism, *Lot in Sodom* is at once startling in its representation of a some-
what dreamy homoerotic scene and disturbing in its staging of a divine retri-
bution grounded in the celebration of maternity and heteronormativity. *Lot
in Sodom* also includes, however, the most remarkable of the three cinematic
renditions of the punishment of Lot's wife of which I am aware.[10] Part of an
active modernist film counterculture in the interwar years, *Lot in Sodom* offers
an exception to the viewing positions associated with Hollywood. And per-
haps precisely for this reason, its enactment of the transformation of Lot's
wife is particularly powerful. Following my discussion of *Lot in Sodom*, I turn
to *The Strange Love of Martha Ivers* (1946), a sumptuous and melodramatic
noir from a major studio, Paramount, and a major Hollywood producer, Hal
Wallis. In *Strange Love*, too, Lot's wife becomes a crucial interpretive clue
within the film. In the conclusion to this chapter, I discuss two films directed
by Robert Aldrich, *Kiss Me Deadly* (1955) and *Sodom and Gomorrah* (1963).

Lot in Sodom (handwritten note, top right)

This pairing joins one of the most compellingly strange *films noirs* to an elephantine biblical epic. Dissimilar in virtually every other respect, these films nevertheless both include climaxes involving Lot's wife. In these films the figure remains a form for the complexities of imagining Hollywood, but Aldrich's uses of Lot's wife also bring to the fore the ways the figure signifies not only the danger *of* Hollywood but also the danger *to* Hollywood—the fantasy of the destruction of the whole apparatus that goes by the name of "Hollywood." The notorious ending of *Kiss Me Deadly* stages the paradoxical scene of survival with tragicomic force. But these films also invoke fears of a larger apocalypse that shadowed the post–World War II world after the bombing of Hiroshima and Nagasaki, the wreckage of Asian and European cities, and the growing fears of still larger nuclear destruction. This is not a controversial claim. What I argue here is that film provided a figure for thinking about this imagination of disaster and, more particularly, about the fate and impossible place of the spectator in the face of such catastrophe.

AVANT-GARDE LOT

James Sibley Watson Jr. and Melville Webber's short film of 1933, *Lot in Sodom*, directly confronts some of the dilemmas of spectatorship raised by the story of Lot's wife. Made by well-connected amateurs in Rochester, New York, the film is part of an early American experimental film movement that self-consciously directed its energies against the domination of the Hollywood film.[11] Watson and Webber draw especially on the techniques of surrealist montage. The film's vivid rendering of the punishment of Lot's wife (Hildegarde Watson) encapsulates the figure's combination of damaging retrospection and dangerous spectatorship. Isolating Lot's wife as a glamorous Hollywood icon in an experimental film that distances itself from the techniques of mainstream Hollywood filmmaking, *Lot in Sodom* places her at the nexus of a series of sexualized punishments, variations on the psychologically restrained but resonant biblical story. The film imagines the queer city of Sodom; it imagines Lot's wife's evident curiosity about, and perhaps even sympathy for, this city; it portrays her backward look as punishment for this sympathy. Moving uneasily between a celebration of sensual pleasure and a corrective heterosexuality that puts exposed figures of women alongside the half-naked bodies of the partying men of Sodom, the film makes her punishment at once the expression of masochistic retrospection and an elegy for those lost in the destruction of the city. Montage sequences become a way to fill those lacunae in biblical stories that Auerbach describes so memorably. These montage sequences challenge established codes of making narrative sense in film, and yet it is also

(handwritten margin notes: "traditional reading of Lot's wife ↓", "homosexual – hetero", "masochistic retrospection")

through montage that Watson and Webber return to an orthodox understanding of the story that their film's visual pleasures might seem to undermine.

Watson and Webber portray the punishment of Lot's wife in a vivid way, but they also understand that the biblical story locates her punishment in a particular context of crimes and punishments involving seeing. As I have discussed, the incident in which the angels blind the men of Sodom (Gen. 19:11) forms an enigmatic pair with the punishment of Lot's wife. The punishment for this crime of desire is, it may be, displaced upward, in a movement that recalls Freud's association of blinding with castration. Such an explanation, however, leaves the enigma of the pillar of salt. *Lot in Sodom*'s representation of these paired punishments brings together the volatile combination of transgressive sexuality, dangerous looking, and divine retribution in a number of curious ways. Especially intriguing is the film's treatment of the punishment of the men of Sodom. In between the men's threats against the stranger in Lot's house and their punishment, the space of seven verses in the Bible (Gen. 19:4–11), *Lot in Sodom* plays out a surrealist montage notable for being as concerned with the sexuality of Lot's wife and daughter (Dorothea Haus) as with that of the men of Sodom. The film emphasizes the Lot story's association of mother and daughter through costume and other visual means; their resemblance suggests the substitution to come, which the film does not include. (In the film, Lot and his wife have only a single daughter.) The visual logic of the sequence at once suggests equivalences between the same-sex desire of the men of Sodom and that of the women and also distances that transgressive desire from the women's explicitly reproductive sexuality. On the one hand, the sequence anticipates the punishment of Lot's wife by associating her with the men of Sodom; on the other, it insists, in a series of images and superimposed texts, that the woman's body is equivalent to a temple and to the home the men threaten. It is as though Lot's offer of his daughter to the men—an offer that provokes only laughter among them—inspires an imagistic frenzy bent on the simultaneous sexualization and sanctification of the bodies of the women. The film celebrates exposure; the revels of the men of Sodom are so notable for their screening of male flesh that some see the film as a precursor of a queer cinema.[12] This reading, however, partly ignores the film's turning away from exposure into the punitive restoration of a heterosexual regime.

One of the film's more painful aspects is its stereotyped representation of Lot. Costumed in a long robe, wearing a transparently fake beard and payess, Lot, wrote Marianne Moore in the remarkable modernist film journal *Close Up*, "is the bowed, intense, darkly caparisoned, overclothed, powerful, helpless Jew—talking, gesticulating, resisting. (Played by Frank Hyaak, and not

without lapses).''[13] ''[O]verclothed'' is a nice word. Moore rightly stresses his dress, which contrasts so strongly with the exposed bodies of the men of Sodom. His heavy dress also contrasts, however, with the body of the visiting angel; this angel, too, is at moments naked to the waist. I stress these levels of concealment and exposure because in the sequence following Lot's offer of his daughter to the men of Sodom, the bodies of his daughter and his wife— and of a third actress playing their nude body double—become the film's obsessive interest.[14] On the one hand, Watson and Webber want to distance their film from Hollywood's erotic protocols; on the other, the fascination of bodies remains crucial to their work.

fascination of the naked body

As the men of Sodom insist that Lot hand over the disguised angel, Lot prays, and the film elaborates on the story in Genesis. Lot's prayer inspires a divine message, delivered in an intertitle: "WITHHOLD NOT EVEN THY DAUGH-TER." As if worried that the old excuse of hospitality will no longer convince an audience, Watson and Webber portray Lot's decision to offer his daughter to the men as the result of divine suggestion. In one of the more disturbing of the film's array of stereotyped images, Lot offers his daughter with a partic-ularly egregious set of those gesticulations described by Moore; here, a layer of salacious suggestion accompanying those gestures almost makes Lot an orthodox pimp. As the viewer sees Lot presumably describing his daughter, a miniature, full-length image of her body, clothed in white, appears in the upper-right corner of the frame, as though the commodity were conjured by the salesman's description. This image translates the description of the women Lot gives in the Bible: "Behold now, I have two daughters which have not known man; Let me, I pray you, bring them out unto you, and do ye to them as is good in your eyes" (Gen. 19:8). As in the biblical version, in the film the attractions of the girl's virginity are lost on Lot's audience; the men only laugh. They want the angel they came for. The camera, however, as if ignoring their laughter, zooms in on the body of Lot's daughter, who opens her robes as the camera nears her. The zoom fades to black before the viewer sees what the camera's eye promises to reveal. Lot's salesmanship should put his daughter on display and tempt the men of Sodom, but it utterly fails. The question, then, is where this exposure comes from, whose desire the camera's movement into the folds of the woman's clothes translates or provokes or parodies. The film conjures the full image of the body of Lot's daughter in order to give shape to the desire he tries to provoke, but it seems strange that (the failure of that provocation within the film should inspire an image that suggests instead the successful incitement of desire.)

commodity

I do not want to mystify the problems provoked by this rapid sequence, but I do want to suggest some of the difficulties that follow from trying slowly

to unravel what passes by so quickly in the viewing of the film. The point to isolate, I think, is that this sequence imagines the provocation not as Lot's, or not only as Lot's, but as that of the woman herself: we see the woman's hands pull back her own clothing, as though she were quite willing to offer herself. What the Bible pictures as a transaction between men, the film represents as a gesture flowing, perhaps, from the woman's desire, a desire answered by the probing invasion of the camera. This movement may translate Lot's desire—his hands frame her body as she approaches the screen—and it may translate the desire of a part of the audience. But for the moment the film understands this story as one about female desire. The passive object of a failed bargain becomes an active subject of self-exposure. This self-exposure may, no less than sheer passivity, be the product of certain kinds of male fantasy, but the phantasm of action is nevertheless something different from what the Genesis account offers.

A story that has become foundational to the Western demonization of same-sex desire—foundational because it portrays at once the explicit expression of that desire and, according to one dominant reading, divine punishment of it—becomes a vehicle for the exposure of feminine desire. Or, it may be, the film refocuses attention on the way the story has *always* been about this desire as well, about the desire that provokes Lot's wife to look back, and about the more often forgotten desire that drives Lot's daughters to get him drunk so that he will sleep with them. My question is how *Lot in Sodom* pictures the intersection of these different desires. Its montage feels like a fitting analogue to the movement of the biblical narrative, which shifts from moment to moment, leaving provocative gaps where the modern reader might hope for psychological explanation, motivation, and so on. *Lot in Sodom* at once fleshes out some of these lacunae, and finds in the gaps between images a way to mimic the challenges, and what the modern reader perceives as the silences, of biblical narrative.

If the film allows for the expression of female desire, for the provocative revelation of the body offered to the men, it also suggests that this sexuality should be quarantined in a series of architectural spaces. Following the exposure of the daughter's body, the film becomes a meditation on feminine sexuality, a meditation anchored in the equation of the woman with a temple mentioned before. One frame juxtaposes the image of Lot's wife on top with the image of a simple temple on the bottom; the temple is one the viewer sees at the film's beginning, as the camera shows the city of Sodom, a rather simple model with this spare structure at its center. This sudden sanctification of the woman's body in the wake of the equally sudden sexualization of it is curious for a number of reasons. It suggests that the commandment to "withhold not

even thy daughter" implicitly includes the suggestion that Lot should also offer his wife; she, too, might be substituted for the angel. This sanctification also, however, provides the film with new means for picturing violation. On the one hand, intertitles with quotations from the Song of Solomon and Ecclesiastes stress the inviolate nature of the woman's body. "Set her as a seal upon thine heart," reads one of these intertitles, suggesting that the closed body of the woman should, in turn, close off the desire of the man. (The phrase comes from a passage in the Song of Solomon that obsessively imagines the woman's body in architectural terms. A verse close to the one the film paraphrases, speaking of a "little sister," runs: "If she is a wall, / we will build on it a silver parapet, / but if she is a door, / we will close it up with planks of cedar" [Song of Sol. 8:9]). These intertitles and their accompanying images of the sanctified body have their negation in a set of images that proclaim the violation—if this is the right word—of what the intertitles declare sacrosanct. One sequence gives us this set of images: Lot; a snake; a woman looking down; the snake entering the small temple; the woman's fear; flying birds interspersed with opening flowers; finally, the laughing face of the woman. If the snake's violation of the temple that here stands for the woman's body seems a bit heavy-handed, the woman's laughter punctures this melodramatic enactment of the woman's peril. Her laughter connects her to the laughing men of Sodom. Where their laughter indicates the ludicrousness of the idea that they might desire her, however, it seems in her case to be a sign of the pleasure of some sexual consummation. The following frames include flashes of the woman's naked body; direct views of this body supersede the camera's coy disappearance in the folds of the daughter's dress. These flesh shots soon have their normative negation, however, when we see a series of images from the perspective of Lot, showing his daughter giving birth to a child. The display of the naked body ends in the celebration of happy family life. Glimpses of naked bodies more adventurous than anything Hollywood of this time would offer find their tame reversal in the corrective movement toward domesticity. Herman G. Weinberg indeed celebrated precisely this aspect of the film in a 1933 review, also in *Close Up*: "I cannot impart how the sudden burst of buds to full bloom, disclosing the poignantly lyrical beauty of the stamens, as Lot's daughter lets drop her robe disclosing her naked loveliness, gets across so well the idea of reproduction."[15] And as if to stress this movement, the film returns to its "plot" soon thereafter: we see the spectacular blinding of the men of Sodom, as rays of light emanate from the body of the angel.

There is more to unravel even in this short sequence, but the questions it raises lead back to the film's end. As I have suggested, *Lot in Sodom* links the

blinding of the men of Sodom to the fate of Lot's wife. The film's central
challenges to the viewer stem from the contrast between its aggressively mod-
ernist technique and the nasty logic of the biblical story of these punishments.
One can see this clearly in the intriguing response of Marianne Moore. On
the one hand she celebrates the film as—at last!—the filmic counterpart to
modernist literary experiment:

> The painting-and-poetry—an atmosphere of the preface to *The Wings
> of a Dove*, of the later bloodcurdling poems of James Joyce, of e. e.
> cummings' elephant-arabesques at their unlabeled truculent best—is
> very nearly too exciting for a patron of the old newsreel. One salvages
> from the commercial ragbag a good bisection or strange-angle shot, but
> there, even a *cum laude* creates no spinal chill, being intellectually un-
> self-realized. Here the camera work, with a correlating of poetic influ-
> ences—the Blake designs in the fire, the Pascin, Giotto, Doré, and
> Joseph Stella treatment—shows us wherein slow motion, distortion, the
> sliding track, can be more legitimate than the face to face stage-set.
> Personality coalescing with a piece of stone, the obliterating cloud of
> doves, "the silver cord" and other historic color, are incontrovertibly
> conclusive for the art of film.

This is not, writes Moore, "just another motion-picture-house Derby dash
for the post."[16] Moore celebrates the sheer pleasure of the camera work, its
distance from the products of the "commercial ragbag"; *Lot in Sodom* gains
excitement thanks to its mastery of technique, to its intellectual self-realization.
And yet Moore's review ends with a passage that seems to encapsulate a dark
reading of the tale, a reading that floats in a rather uncertain temporal place:

> As you know better than anyone else, how to open your combination
> safe, a civilization that has reached an extreme of culture, is going to
> have pleasure, will have it and is meting out justice to any man that
> interferes. But the pleasure is not joy, it is strangling horror—the ser-
> pent that thrusts forward rigid—and does not know it ever was any-
> thing else. We see luxury extinguished and hauteur collapse—with
> gaiety waning into anguish, fire, ashes, dust.[17]

One of the uses of Lot's wife is that she provides a way to contemplate con-
temporary catastrophes, and one wonders what culture Moore is thinking
about. What is this culture, that is going to have pleasure and mete "out
justice to any man who interferes"? The vagueness of the referent here is not
incidental. Moore's strategy in her review is to treat *Lot in Sodom* as though
it were a non-narrative film, as though its isolated and visually compelling

images illustrated some known story without having anything like that story's narrative thrust. She treats the film as a series of compelling images and episodes, and then ends her review with that passage about the vanquishing of happiness—"gaiety" is her word—into "anguish, fire, ashes, dust."

Lot in Sodom's climactic representation of Lot's wife's turn backward is not simply a powerful effect, a moment in a sequence of unrelated powerful effects (figs. 4–9). As I have argued, it has links to the sequence culminating in

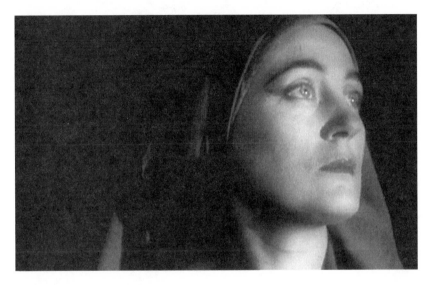

FIGURE 4 *Lot in Sodom*: Lot's Wife

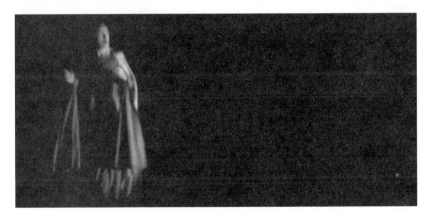

FIGURE 5 *Lot in Sodom*: Lot's Wife Looks Back

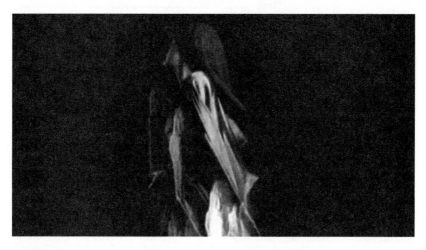

FIGURE 6 *Lot in Sodom*: The Bodies of the Dead Occupy Lot's Wife

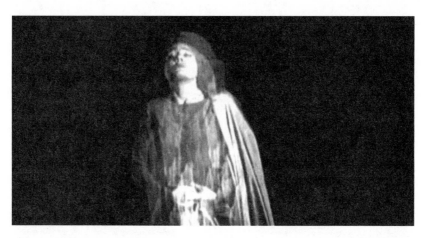

FIGURE 7 *Lot in Sodom*: Transformation of Lot's Wife

the blinding of the men. Most striking, perhaps, is a visual connection. If the earlier sequence imagines Lot's daughter's body as a temple, the scene of Lot's wife's punishment and transformation pictures this process as a metamorphosis of her body into a structure that resembles a cross between a tomb and a skyscraper. The film shows us the model of the city with which it began, with the small temple at its center, the temple that the film has used as an analogue to Lot's wife, and brimstone falling from the sky. When Lot's wife looks back, then, she is looking back upon a city that the logic of the montage

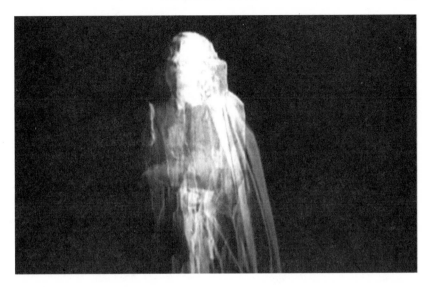

FIGURE 8 *Lot in Sodom*: Lot's Wife Becomes a Pillar

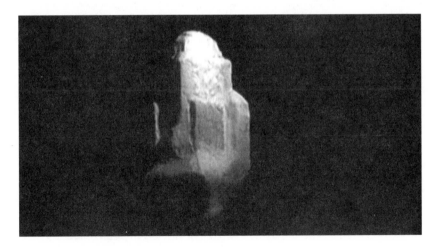

FIGURE 9 *Lot in Sodom*: The Pillar of Salt as Tower

has insisted she resembles. The divine destruction of the city with the temple at its center is already, so to speak, the destruction of Lot's wife, which one knows is on the way. Her dangerous glamour—the Hollywood touch—condemns her from the start.[18]

If retrospection is self-destruction, it is also self-multiplication. The first moment of her transformation shows a series of spectral bodies occupying

the frozen shape of Lot's wife, as though she were incorporating the un-
mourned dead of Sodom. Lot's wife, looking back upon the city she has fled,
has become a modern embodiment of that city; this salt skyscraper looks at
once like the punishment for her sympathy and remembrance, and also inti-
mates a rather troubling judgment on the twentieth-century city. "We see
luxury extinguished and hauteur collapse," writes Moore, and a darker read-
ing of the film suggests that it is anticipating this extinction and collapse in
the film's present, in 1933, looking back on a destruction yet to come. It may
be that the key to the spectatorial logic of this film is, in the end, not a specta-
torial masochism, but instead a sadism that suggests that Lot's wife deserves
everything she gets.

STRANGE LOVE IN SODOM

> *Strange lusts* bring *strange punishment; strange fire* kindled upon earth,
> brings *strange fire* from heaven. Fire naturally *ascends*, but the fire that
> destroyed the Sodomites *descended*, Gen. 19:24., the *sin* was strange, and
> the *destruction* strange: God proportions the *punishment* to the *sin*, payes
> men in their *own coin*; they have *fire* for *fire*, and not only so, but *strange
> fire*, for *strange fiery lusts*.
>
> —Samuel Whiting, *Abraham's Humble Intercession for Sodom* [1666], as
> quoted in Michael Warner, "New English Sodom."

In the final moments of the melodramatic noir, *The Strange Love of Martha
Ivers* (1946), Sam Masterson, the experienced wanderer and World War II
veteran, says to his young beloved, Toni, "Don't look back, baby, don't ever
look back. You know what happened to Lot's wife, don't you?" "Whose wife?"
Toni asks. "Sam's wife," he replies; "Sam's wife," she repeats contentedly
(136).[19] She smiles, the film ends. It is an odd scene, and an odd ending. The
pair is driving away in Sam's convertible from the factory city in the plains
where they met, and where Sam (Van Heflin) has briefly resurrected his ado-
lescent romance with the Martha Ivers of the film's title, a femme fatale played
by Barbara Stanwyck. Robert Rossen's dialogue in this closing moment recalls
an earlier exchange in the film, where Sam associates not Toni (Lizabeth
Scott) but Martha Ivers with Lot's wife. Together, Sam and Martha look down
from a hillside upon the town that bears her name, Iverstown, which she has
come to control. The look down upon the town inspires a biblical comparison
in Sam: "You know what happened to Lot's wife when she looked back, don't
you?" "What?" asks Martha. "She was turned into a pillar of salt," Sam ex-
plains. "What happened to Lot?" asks Martha, sensibly. "He got away—he

didn't look back" (110). In this pair of dialogues, Sam associates himself with Lot, but an earlier moment in the film suggests, comically, that we should see Sam, too, as a version of Lot's wife. He arrives in Iverstown by mistake. A sign by the side of the road naming the town so captures him that he looks back at it obsessively (fig. 10). Unfortunately, he is behind he wheel of his car at this point, and he crashes into a tree (fig. 11). He explains his mishap to a hitchhiking sailor who has been traveling with him: "The road curved—but I didn't" (24).

Stanwyck's Martha Ivers and Lizabeth Scott's Toni respond as though Lot's wife were utterly unknown to them, as though they had never heard of the biblical story. Sam extracts a moral from the story—"Don't look back, baby, don't ever look back"—but in some ways it seems that the women are better able to embody this moral than he. Their apparent ignorance about the story of Lot's wife suggests that they are already successfully not looking back. They claim no knowledge of this cautionary tale of the dangers of backward glances. But their not knowing also provides an image of a noir America immersed in amnesia. Sam knows his Bible thanks to the Gideons' deposits in the sad hotels in which he has lived his drifter's life. His allusions to Lot's wife are moments where the film insists on memory and return, but the film's final exchange, with its translation of "Lot's wife" into "Sam's wife," throws away the dangerous lure of the past and moves toward a standard marriage plot

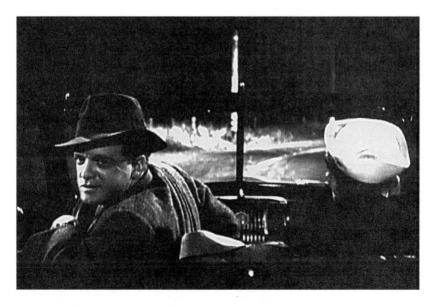

FIGURE 10 *The Strange Love of Martha Ivers*: Sam Looks Back

FIGURE 11 *The Strange Love of Martha Ivers*: Sam Prepares to Crash

that has nothing to do with the sexual topsy-turvydom of the story of Lot's wife or with the strange world of Martha Ivers. The exchange at once asserts an identity between Toni and Lot's wife, as though to say "Sam's wife" is to say "Lot's wife," and also stresses a solid break, a movement into a world where, like Toni, one can be happily innocent of the Bible.

Indeed, Toni's innocence about the Bible is made explicit in the film. At one point, Sam and Toni have adjoining rooms in a hotel in Iverstown with a connecting door. In a seductive moment, Toni makes Sam an offer: "I'll loan you a book for a couple of cigarettes, if you don't mind what kind of book it is" (48). Sam, however, is already in possession of the same book; she is offering him her room's Gideons' Bible. Her ignorance of the Bible, then, is not only a matter of stories or doctrine, but also of some of the conventions surrounding the Bible. Without knowing it, Toni replicates the structure of the Gideons' gifts. She offers the Bible as a loan, for use in the hotel room. She has beautifully secularized this transaction, ready to trade the Bible for cigarettes, which, no doubt, she has no intention of returning. In this strange and momentary economy, a pair of cigarettes is equal to the loan of the Bible; the most consumable of all commodities stands in for a kind of reading that is supposed to transcend commodity status entirely.[20] Sam, as if following the Gideons' hints in the early pages of their Bibles for travelers, turns to a particular passage, which he gives Toni to read. The scene moves from the redundant offer of a questionable loan—Sam already has a Bible—to something

gratuitously withheld: the audience never learns what passage Sam and Toni read during this tantalizing moment of private Bible study.

Although they keep mum about what they have read together, in a specific way this moment is related to the story of Lot's wife and its deeper structural significance for the film. Unsurprisingly for a melodrama, *Strange Love* is built around an intensely kept, foundational secret; unsurprisingly for a noir, discovery of this secret satisfies no one and damages those most involved.[21] Martha Ivers has married the dull, and now most often drunken, Walter P. O'Neil (Kirk Douglas, in his film debut), because the young Walter and Walter's father were privy to her killing of her guardian, a domineering aunt, on a staircase. Martha and Walter mistakenly believe, however, that Sam, too, witnessed the murder immediately before fleeing Iverstown with a circus. When he returns to the city to find that Martha has become rich and that Walter is running for mayor, they guess that he has come back to blackmail them; given that blackmail is the source of their own intimacy, this suspicion comes naturally. The plot, then, is built around a mistake, and it is a mistake of a particular kind. Martha and Walter believe that Sam has seen something that could destroy them. And this is not their error alone. That is, the audience cannot know whether or not their notion is correct. The film encourages the audience to believe that Sam has seen the murder, although in fact the audience sees it from a scramble of angles, none of which could plausibly be Sam's point of view. The first sustained shot after the murder does, however, draw our attention to the open front doorway from a place near the top of the staircase; the door itself moves slightly, as though blown by the wind or brushed by someone just vanished (fig. 12). So the film does not, so to speak, "lie" by giving us shots from a point of view that no one occupied; indeed, the audience sees the murder from no stable point of view at all. After the killing, the audience knows that Sam has gone, but it cannot know when he left.

Strange Love may nevertheless produce the illusion that one has seen the event from Sam's point of view—from the point of view, that is, that Martha and Walter believe Sam occupied but never did. The force of the plot, of Martha and Walter's belief, is such that the spectator may invent a scene of witnessing that the movie never represents. (I should say: I found at one point that I had invented such a point of view in my own memory of the film.) This illusion, that one has seen from the point of view of someone who, one later learns, cannot have been present, is part of what makes Lot's wife the paradoxical icon of *Strange Love*. That one does not, in fact, see the killing from Sam's point of view makes this all the stranger. As I argue at many moments in this book, one of the aesthetic dilemmas posed by the representation of

FIGURE 12 *The Strange Love of Martha Ivers*: The Open Door

Lot's wife is the problem that the formal position the work allows for the spectator—the spectator's position, the witness's position—is one that the plot or diegesis tells us no one has occupied or *can* occupy. *Strange Love* lays a trap for the spectator, inviting spectators to believe that they identify with the point of view of Sam Masterson, informing spectators only belatedly that no one saw what they have seen—at least not from that place. As the mannerist painter who so provoked Artaud paints a disaster no one can look at, so *Strange Love* makes us witnesses who identify with a witnessing that never happened. Sam Masterson arrives in Iverstown because he looks back at a sign announcing the town and crashes into a tree, as though the emblazoned name were in itself the sign and cause of disaster. Upon his arrival, Martha and Walter, panicked over what they believe Sam has seen, plot to seduce or to destroy him, to his temporary befuddlement. (In the event, their retrospection or involvement in the past destroys them.) So this explains the bizarrely deliberate scene where Sam, craning his neck while pleasurably rubbernecking, crashes into the tree: it is only ever by accident that he becomes Lot's wife. Or, as Sam puts it: "smacko!—Your own home town hits you right in the face" (23).

"Where are we?" asks Sam's passenger, jolted awake in the crash. "A small accident," answers Sam (24). The slightly strange syntax of this exchange bestows the status of a place on an accident. Sam does not answer the hitchhiker's question so much as *why* they are where they are. Sam's equation of place and accident also makes one think again about whether anyone, even the cynical and weary Sam, can return to his home town simply by chance. The opening section of the film, set in 1928, which begins with a failed attempt by the young Martha and Sam to escape Iverstown and ends with her in the clutches of Walter's father after she has killed her aunt, is suggestive here. After policemen have brought Martha back to the Ivers mansion, she angrily promises to run away again: "You don't own the whole world!" she shouts at her aunt. "Enough of it," her aunt retorts, "to make sure you'll always be brought back home" (9). So the threat of the quasi-juridical compulsion to return home establishes a context for the strange compulsion that traps Sam in Iverstown through the siren-like power of the sign bearing the town's name. And Sam must stay in Iverstown longer than he hopes because of another chance incident that is not an accident. Martha arranges for the garage to delay the repairs to his damaged car. (It is not for nothing that when Sam leaves his car there, men gamble in the foreground. Nor is it for nothing that Sam places a quick ten-dollar bet and wins.)

The film's emphasis on "home," and on how no return there can happen quite by chance, invites speculation about what this place, Iverstown, is. We know very little about it. Iverstown is somewhere between East Coast and West, and the mesmerizing sign tells us that it is "AMERICA'S FASTEST GROWING INDUSTRIAL CITY." At various points, we have brief, panoramic views of the works, and Martha's office includes a photographic mural of tumultuous but indistinct industrial activity, but the audience never learns what the Ivers factory produces. (What it produces, in effect, is productivity.) The streets, which, according to the noir convention, we almost invariably see at night, are not particularly exceptional; nor are the town's restaurants or nightclubs. Its hotel, we learn in a comic moment, features one bath for every two rooms. It is worth, then, asking why this place inspires the biblical reflections with which this section begins. "You know what happened to Lot's wife when she looked back, don't you?" The invocation of Sodom gives a particular form to film noir's fascination with urban corruption, but what is this form?

Strange Love is in some ways absolutely typical of film noir. Alain Silver and Elizabeth Ward, the editors of a standard reference work, describe some of the social forces behind the film noir:

Both the social upheaval of World War II and the sociopathy on a smaller scale of American gangsterism in the decade preceding it created a class of individuals that would frequently be depicted in film noir. From the latter came the film stereotype of the ambitious criminal and his corrupt organizations; from the war, in considerably greater number, came the veteran and his burden of readjustment to civilian life.[22]

Utterly deracinated, Sam Masterson is not particularly ambitious and belongs to no organization, but he is certainly one of film noir's many unhappy veterans.[23] And Sam is not alone. With the exception of Toni's mention of a possibly abusive father, no character in the film mentions a living blood relative, nor is there mention of any historical event smaller than the "war." (A detective names some of the places where Sam fought, ranging from Africa to the battles of Anzio and Normandy; Sam prefers to keep quiet about these.) Toni looks slightly puzzled when Sam, in search of what she calls his "people," says he might "go to the courthouse and look up the deaths in the last eighteen years" (30). The immediate referent is Sam's lost family, but behind this one can hear another, impossible kind of historical counting. It is significant, in this evacuation of family and history alike, that Sam leaves in 1928 and returns in 1946; these seventeen or eighteen years cover both the Depression years and those of World War II, precisely the period that produced the historical conditions that Silver and Ward argue underlie the film noir. One date is, by contrast, exceptionally precise; we know that Sam's departure and the murder of Martha's aunt both occur on September 27, 1928. (The filmmakers resist the stock market crash's October 29, 1929.) This calendrical precision calls attention to the otherwise thorough evacuation of historical detail.

Strange Love, then, has two prominent frames for its action. One is the pair of dates notable for their historical resonance; another is the interpretive framework offered by the story of Lot's wife and Sodom. These two frames meet each other in an oddly symmetrical structure of emptied-out content. On the one hand, the dates bracket a period of vast historical tumult; it is as though Sam is the film's representative refugee from this history. On the other hand, the sacred connotations of the Sodom story seem utterly out of place in secularized Iverstown. After Sam compares Martha to Lot's wife, she remarks: "You know your Bible." (So she knows something about the story after all.) "You would too," he replies, "if you spent as much time as I did in hotel rooms" (110). Sam has the double burden of being at once agent of political history and cynical repository of biblical warnings, but, as his reply to Martha suggests, he wears this burden lightly. Paul Schrader writes:

> The *noir* hero dreads to look ahead, but instead tries to survive by the day, and if unsuccessful at that, he retreats to the past. Thus *film noir's*

D.A.Miller

(shame)

noir = style

techniques emphasize loss, nostalgia, lack of clear priorities, insecurity; then submerge these self-doubts in mannerism and style. In such a world style becomes paramount; it is all that separates one from meaninglessness.[24]

This passage offers one way of understanding Sam's biblical knowledge; the allusions to the Bible are a form of style. They ostentatiously point toward a grand source of knowledge, but also imply that this is a source of such knowledge only for others. Style, the new guarantor of meaning, cannibalizes the old; the equivalence of cigarettes and the Bible in the hotel scene now may make more sense. But Schrader means to describe not only the individual style of the noir hero, but also the style of the films themselves.

Bible through style

Strange Love, then, brings together these two common features of the film noir. Its action forms a pair of parentheses around the huge historical events of depression and war, and, through the figure of Lot's wife, it explicitly thematizes film noir's emphasis on loss and nostalgia. To understand this conjunction more fully requires looking more closely at the scene in which Sam compares Martha to Lot's wife. This scene shows not only that *Strange Love* participates in the tragic attitude toward history others have identified in the film noir, and that this attitude is part of the film's style, but also that this style—at least in the case of *Strange Love*—is not so much a quasi-existentialist protection against meaninglessness as an elaboration of a difficult relationship to the sources of historical knowledge. The thorough verdict of the story of Sodom, so to speak, puts the absence of much meaningful historical specificity in relief.

tragic attitude to history

elaboration of relationship to sources of historical knowledge

Martha picks Sam up at the hotel where he and Toni share adjoining rooms. In a very striking scene, Toni displays new clothes for Sam. While Sam admires Toni's new, very short shorts, Martha arrives unannounced. If Toni embodies, for the moment, every theory of the female performer as object for the male gaze, what are we to make of Martha, who enters wearing a costume that I can describe only as a cross between a fringed covering for a coach and a cast-off from a Cecil B. DeMille biblical extravaganza? Complete with fringed headdress, Martha's costume contrasts so violently with that of the scantily clad Toni that she seems to embody some other principle of the gaze: the woman furtively in hiding from the camera. There are diegetic reasons for her unwillingness to be seen; she owns the hotel where Sam and Toni are staying, and she might not want to advertise her visits to private rooms there. But the scene invites a corollary to Mulvey's thesis about the role of the male gaze: not only does the pleasure of the male spectator require the exposure of the woman's body, but, recalling the revelation of the daughter in *Lot in*

exposure of body =>
innocence

Sodom, that exposure also marks the woman who exposes herself as ethically superior. Martha's furtiveness is in itself questionable. Sexualized display not only serves male pleasure, but also marks the woman who displays herself as outside the lures of film noir's fabulous spiderwomen.

This alignment of the object of the desiring gaze with the ethical provides an immediate antecedent to the following scene, when, in a massively overdetermined moment, Sam compares Martha to Lot's wife. She looks down on Iverstown; for a moment the audience sees only the back of her headdress. "You know what happened to Lot's wife when she looked back, don't you?" The film moves quickly, then, from a scene in which the spectator, watching Toni's fashion show, plays the voyeur with ethical sanction, to one that summons one of the most powerful myths of the ethics of spectatorship. But this moment also summons the spectacle of Hollywood itself; the view is recognizably that of Hollywood. What appears to be the Chateau Marmont is visible just to the right of Sam, as he is talking, among other things, about rather shabbier hotels (fig. 13).[25] So this scene is a palimpsest, overlaying the strange love of Martha Ivers with the story of Lot's wife, and the fastest-growing industrial city in America with Hollywood.[26] Or, that is, the scene invites the audience to conceive of Iverstown as Hollywood, and then to think of both

FIGURE 13 *The Strange Love of Martha Ivers*: The View of Iverstown, a.k.a. Hollywood

of these places as Sodom. What does it mean, here, to look down on this place? This is not the scene of the painting beloved of Artaud; Iverstown is not in flames, and no brimstone falls from the sky. Sam, at this point in the narrative, has no idea what he is talking about, has no idea how telling his conjunction of spectatorship and destruction might be.

Or, that is, within the world of the film, Sam has no knowledge of the spectacular event that makes him so feared by Martha and Walter. I have argued that Sam is the film's representative of the history that *Strange Love* utterly brackets, and this scene on the hill strikes me as a moment when the film emphasizes this representative status. Sam leaves Iverstown with a circus in the giddy 1920s and returns a veteran of some of the harsher battles of World War II. Partly the film contrasts the ahistorical Iverstown with the real history of war and mass death; the valorization of historical experience that it cannot or will not show is part of the bitter work of the film noir. On the other hand, the gesture toward Sodom suggests that this place, too, might become a city on the Plain. The rubble of Vienna in *The Third Man* is in this sense the "natural" setting for the film noir; these are the ruins that many of its protagonists have seen firsthand and toward which the condemned American cities to which they return are always tending. To the banal observation that the United States is not a land of ruins, *Strange Love* offers a correction: not yet.[27]

[margin handwriting: spectre of ruins / like a film on Hollywood]

So, in an offhand but resonant way, Sam brings home the possibility of cataclysm. Martha responds to the panorama rather differently. For her the view brings a sensation of power:

[SAM]: From up here it doesn't even look real, does it?

[MARTHA]: It's real. Very real. Owning it gives you a sense of power—you'd know what I meant if you had it. (111)

This panoptic view of the urban grid reassures her, with the irony that she does not see the extent to which she does not know the person beside her. The scene's rapid turn to the assertion of power from the narrative of Lot's wife suggests that that story may undermine the confidence with which Martha can assert power. Indeed, the film consistently and increasingly associates political and financial power as such with corruption, and the juxtaposition of Lot's wife and Martha's proud look downward underlines this association.[28] The look back at Iverstown does not destroy her, but the scene that follows brings together retrospection, nostalgia, and traumatic spectatorship in a way that emphasizes the continuing resonance of the story of Sodom.

As Martha and Sam take in the view, smoke rises not in the valley below them, but in the woods behind them, as though that Sodom they do not quite

see were in the trees there. Sam rushes to put it out. "Let it burn, Sam," Martha implores him (111). The fire reminds her of fires they set in the same place as children. Thinking of these fires leads her to imagine what might have happened had Sam never left. Finally she asks him why he did not stop her from killing her aunt; he tells her that he was not there, which takes her a moment to hear, as though she were breaking out of a trance. Martha responds to her shock by raising up a burning branch from the fire; her attempted assault on Sam, however, quickly turns into a violent kiss initiated by Sam. The passage from looking down on the city to nostalgia to violence to kiss is remarkably quick, but this speed is precisely the point. It is not only through the invocations of Lot's wife but in its title that *The Strange Love of Martha Ivers* asserts its sodomitical context. This scene encapsulates what the title might mean. There is a certain scapegoat logic to the identification of this strange love with Martha alone, though the title's genitive might describe the desire of others for Martha as well as the qualities of her love. The strangeness of the quality of the love in this scene, in any case, comes from its continuity with an act of violence. And we have been prepared for this in a previous scene by Martha's taking a sadistic pleasure in seeing Sam punch a thug who had beaten him up. "You wanted to kill him—didn't you?" she purrs (110). This scene helps to establish a link between spectatorial sadism and pleasure that gives a special charge to the movement from Sam's recalling the story of Lot's wife and Martha's talk of power. This juxtaposition suggests that Martha's thrill is linked to the spectacle of others' suffering, and that this thrill is a doomed pleasure; the spectator who takes pleasure in suffering will in turn suffer spectacularly. This, in turn, points to the importance of the empty spectatorial position associated with Sam: "I wasn't there, Martha" (113). The scene on the hilltop is at once repetition—Martha raises the branch against Sam in a gesture that recalls her raising a fireplace poker to murder her aunt—and a reminder of Sam's absence at the event that structures many of the film's crucial events. In a sense, what follows is about Sam's attempts to reclaim that position, to return to a position from which he sees nothing. If Lot's wife becomes a figure for a fantasy of the total transformation of the subject through spectatorship, this figure points to a corollary: the power of resistance to such transformation. This power takes the paradoxical form of refusing to see, refusing to look. The corruption of the city has no solution, as Schrader suggests, in nostalgia; nostalgia and looking back are themselves corrupt.

"What happened to Lot?" "He got away. He didn't look back." On the hilltop, Sam learns not only that Martha murdered her aunt but also that she and Walter conspired to send an innocent man to the electric chair for her

act. His response to all this news, and to her attack on him, is a passionate kiss; a time-lapse showing the burnt-out fire implies that Sam and Martha engage in more than that kiss there on the hilltop. Up to this point, Sam is isolated from the pervasive corruption of Iverstown; his is not so much another, affirmative position as the classic noir refusal of involvement. He shows some cynical gambler's interest in the enigmatic business proposals offered by Martha, but this interest never really looks like any real commitment. It is tempting to suggest here that *Strange Love* performs something like the collapse of temporalities in the Louvre's *Lot and His Daughters*. The figure who represents the patriarch's escape from the doomed city becomes sexually implicated in that sodomitical scene exactly at the moment when he has full knowledge of that city's dangerous corruption. (Sam does not have even the tepid excuse of drunkenness.) The fall of the city and the patriarch's fall happen at once.

There are several problems in this interpretive temptation. Sam is no patriarch, and Iverstown is intact. The Genesis narrative does not provide an allegorical map for *Strange Love*, onto which one may superimpose its characters. (Martha is not Lot's wife, Sam is not Lot.) Instead, as I have suggested, the story of Lot provides something like a framework for a problem. *Strange Love* is not so much about the universal potential to become a victim of catastrophe as an investigation of the conditions of watching catastrophe. The positions of Lot and Lot's wife, the one who survives by not looking and the one destroyed by looking, are not positions occupied unambiguously by any one character, but rather ways of imagining the work of spectatorship that the film at once depicts and enacts.

This focus on spectatorship becomes especially clear in the closing sequence of the film. Sam and Martha meet again at the Ivers mansion, to agree, it seems, on the terms of their newly consummated relationship. Troublesome Walter, however, gets in the way. Among other things, he drunkenly narrates a long, erotic catalogue describing the various men with whom Martha has had flings and whom she has tried to persuade to murder him. Soon enough, Walter has fallen down the stairs and lies sprawled, unconscious, on the staircase, and Martha indeed urges Sam to murder her husband, arguing that they can call it an accident. Instead, Sam carries the pathetic Walter to safety—as he thinks—and leaves the house. As he departs the Ivers mansion, he witnesses the double suicide of Martha and Walter. He walks away.

double suicide?

Sam's *not* killing Walter looks for a moment like the reversal and undoing of the traumatic event, an end to this regime of willed accidents. Yet the double suicide that follows at the very least complicates this sense of the ending. The plot thus far has been built around a misunderstanding about shared

experience and perhaps shared trauma: Martha and Walter believe that Sam saw the initial murder. Martha has not been able to implicate Sam in the murder, but in another way he has been forced to take the place he has resisted. He now occupies the place of witness to destruction; their way out of trauma is his way in. And what he sees is not just the deaths of two people, but in a meaningful sense the collapse of America's fastest-growing industrial city. Its mogul and its chief representative of the law die together. Sam's comic occupation of the place of Lot's wife when he looks backward while driving becomes, at the film's end, a variant of tragic spectatorship; it is as though Sam's fate is to become the witness to the disaster to which he consistently alludes. The odd alteration of modes in *Strange Love*, however, is such that the film ends by pointing to this structure while undoing it. Toni has waited for Sam despite her knowledge of his affair with Martha; they drive off into the sunny countryside and she looks back at the twin of the mesmerizing sign that trapped Sam in the first place (fig. 14). "Whose wife?" "Sam's wife." The film ends as if to rescue both Sam and the audience from the problematic structures of spectatorship it has established, as though, with Toni, we can quite easily forget Lot's wife and, like the couple, translate the story into the marriage plot.

FIGURE 14 *The Strange Love of Martha Ivers*: Toni Looks Back

ON THE BEACH

The predicament of destructive spectatorship that structures *The Strange Love of Martha Ivers* comes to a climax in two later films directed by Robert Aldrich, *Kiss Me Deadly* (1955) and *Sodom and Gomorrah* (1962). It is as though in both cases, Aldrich, who worked as assistant director on *Strange Love*, had remembered the conceptual charge surrounding Lot's wife in that film, and exploded it, releasing its absurd and terrible potentialities.[29] If *Kiss Me Deadly* is the bizarre and nightmarish quintessence of certain film noir strands, *Sodom and Gomorrah* is at once at the tail end of a long series of biblical epics and a film that suggests the sodomitical roots of the disaster film, which, over and over, satisfy our desire for seeing what Sontag called "urban disaster on a colossally magnified scale."[30] Lot's wife is destroyed by watching a city burn and fall; film spectators are not. The strain involved in stressing this figurative, or even figural, relationship between Lot's wife and film spectators within film marks the limits of the parallel. Aldrich's films investigate these limits by exposing them.

In *Sodom and Gomorrah*, Lot's wife ends as a commodity. This may also be where she began; in the ancient world, salt was precious and—surely significant in this tale of contracts and negotiations—often associated with covenants. (See, for instance, Numbers 18:19: "This is a perpetual covenant of salt before the LORD with you and your descendants also.")[31] The heart of the plot of *Sodom and Gomorrah* concerns the integration of Lot's tribe of "Hebrews" into Sodom, and their evacuation of the city on the eve of its destruction. Lot's wife, Ildrith—at last she has a name!—begins as a slave in Sodom, a city built on slave labor and a monopoly on salt. As part of a negotiation, the Queen of Sodom, played by Anouk Aimée with a lascivious, campy languor that almost rescues the picture, gives Ildrith (Pier Angelli) to Lot (the execrable Stewart Granger). Lot grants the slave her freedom, a blessed condition here consisting mostly in doing chores for Lot in the Hebrews' rustic encampment across the river from Sodom. Soon enough, Lot and Ildrith are married, and just in time for invasion by the Helamites, who are conveniently drowned in a deluge following the Hebrews' strategic destruction of their single great asset, a dam that makes agriculture possible. This battle leaves the Hebrews homeless; the inundation, however, miraculously leaves behind a huge vein of salt. This inspires Lot: the Hebrews will break the Sodomite monopoly on salt by opening the market to free and fair trade. Through free trade, Lot will justify the Hebrews' settling in Sodom. Life in Sodom, however, involves compromises for the chosen people, and soon enough Lot, in eye-catching

spectator => destruction

red robes, is watching the lewd dance routines that pass for fatal decadence in the city. After Lot has landed in prison for killing the Queen's brother, who has seduced both of his daughters, angels arrive in a vision to Lot. What remains is more familiar: after angelic warnings, the Hebrews flee, the city falls, Lot's wife turns to salt.

Sodom's economy has its base in salt; the superstructure built on the wages of salt is a series of increasingly sadistic entertainments that culminate in the roasting alive of rebel slaves. (The entertainment ends, says the languid Queen, when the victims are dead.) The transformation of Lot's wife, then, encapsulates one of the sins of Sodom—looking at suffering—in the form of Sodom's principal commodity, salt. Her salt remains are not so much the sign of mourning, the trace of dried tears, as in *Lot in Sodom*, as a monument to economic man, the tomb of the secular culture the Hebrews are fleeing. Ildrith's reason to look back is itself a purely secular one. In her skepticism about supernatural causation, she is like the Queen, who scoffs along with her people at the divine threats Lot delivers and, to the end, reads the signs of Sodom's destruction as a natural disaster. We hear Ildrith's thoughts before she makes her fatal turn: "It's Lot's name that should be on their lips. *He's* responsible for everything good that has happened. There is no such thing as Jehovah." Not only does the look not confirm her skepticism, but it also almost seems as though the skeptical look itself causes the final devastation to Sodom. After she looks, and as if in immediate response to that look, the city collapses in a mushroom cloud.

destructive spectatorship

Ildrith's destructive spectatorship figures the amusements of Hollywood. As in *The Strange Love of Martha Ivers*, what makes the city sodomitical is not same-sex desire but other sexualized passions. Here, as in moments in *Strange Love*, that pleasure is sadistic viewing, scenes of which surface again and again. This is not to say that the film posits no relationship between this sadism and same-sex desire, however; the Queen of Sodom, who has a succession of female favorites, is the privileged viewer in the audiences of Sodom. *Sodom and Gomorrah* also flattens out some of the complexities of the place of the spectator that mark *Strange Love*. With a directness that recalls that of some of the early modern landscapes that include the destruction of Sodom, Ildrith's point of view at the film's climax, for instance, is the spectator's point of view. The spectator sees with her, looking back; the spectator sees the beginning of the explosion; there is a close-up of Ildrith's face, then the mushroom cloud (figs. 15–18). The spectator sees the taboo scene. The point of the scene in the narrative is the divine punishment of fatal skepticism; one can imagine that Ildrith comes to believe at exactly the moment when the force in which she now has faith destroys her. But the staging of this fatal conversion must also

FIGURE 15 *Sodom and Gomorrah*: Ildrith Looks Back

FIGURE 16 *Sodom and Gomorrah*: Sodom Begins to Explode

FIGURE 17 *Sodom and Gomorrah*: Close-up of Ildrith

FIGURE 18 *Sodom and Gomorrah*: The End of Sodom

always acknowledge the artifice that partially vitiates the power of the scene. It is only in a distanced and secularized representation—one no longer under the spell of the commandment not to look back—that the spectator can see the destruction of Sodom. And this secularized spectatorship is to some extent the subject of the film: its climax makes the spectator too much like the residents of Sodom, taking pleasure in a scene of destruction. *Sodom and Gomorrah* ends with a perverse critique of film's spectacular power.

In one way, then, Hollywood Sodom produces an audience of sodomitical viewers: the audience's pleasure in the destruction of Sodom looks disturbingly like the pleasures Sodom takes in spectacles of death. But to assume this pleasure is not to take seriously the deliberate use of the mushroom cloud in the apocalypse at Sodom. This climax also summons the negative form of the audience's witnessing the destruction of Sodom. For the sacred apocalypse the secularized audience can now witness, it exchanges the fear of a destruction that leaves no witness at all.

As Bill Krohn has noted, Aldrich anticipates the concerns of the end of *Sodom and Gomorrah* in his earlier, more powerful noir, *Kiss Me Deadly*.[32] *Kiss Me Deadly*, a crucial terminus in the movement of noir, gives a quintessential form to the problems of spectatorship I have described here, and in doing so deliberately invokes Lot's wife. "The aim of film noir," write Raymond Borde and Étienne Chaumeton in their pioneering study of the form, "was to create a specific alienation."[33] In my reading of *Strange Love*, I have shown how one specific form of this alienation and disorientation disrupts the viewer's sense of place in relation to disaster. In its sudden ending, *Strange Love* rescues the viewer from this disorientation even as it reminds the viewer of its icon, Lot's wife. If noir insists on the implication of American culture in the general wreckage around it, this chipper ending suggests the post–World War II American confidence that it was the nation's manifest destiny to beat the odds and dodge apocalypse. *Kiss Me Deadly* is less sanguine in its evocation of Lot's wife. Critics have noticed the ways apocalyptic possibilities hover over film noir; these possibilities find one culmination in the startling ending of *Kiss Me Deadly*.[34] This ending screens a local apocalypse, but it is part of the symptomatic history of the film that it is not correct to speak of it as having a single ending. In one of those quirks of film history, for many years the most widely distributed and copied prints had a mutilated form: the Malibu beach house where Gabrielle opens "the great whatsit" explodes, murdering all those inside. Recently, Aldrich's preferred ending has been restored: Mike Hammer and Velda flee the house and look back at the atomic calamity engulfing the beach house from the ocean's edge (figs. 19–20).[35]

FIGURE 19 *Kiss Me Deadly*: Mike Hammer and Velda stumble on the beach

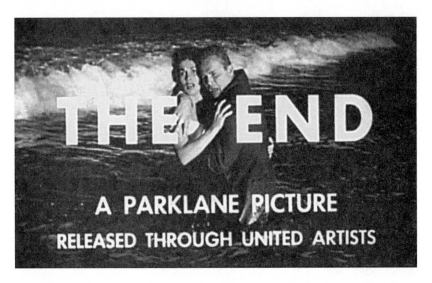

FIGURE 20 *Kiss Me Deadly*: Mike Hammer and Velda look back at disaster

Whether because someone thought it made more sense to have all the characters die in the house or because a wayward projectionist "corrected" a ripped print with a pair of scissors, it seems to me symptomatic that this pair of endings draws attention to the problematic status of the witnesses. One ending offers a blunt solution: everybody dies. The other offers a seemingly absurd one. As if in perverse homage to the title and most famous scene of *From Here to Eternity*, the couple watches a nuclear explosion from the surf, a proper Hollywood apocalypse. "What joy it is, when out at sea the storm-winds are lashing the waters, to gaze from the shore at the heavy stress some

other man is enduring!": this absurd version of Lucretius's shipwreck with spectator, however, also illuminates the oddity of the mutilated ending where no one survives.[36] If there is something shocking or silly in the survivors gaping back at the house melting down, there is something blankly disturbing in looking back when the film provides no surrogates for viewing. Where is the spectator? In both versions, the film ends abruptly, in part to acknowledge the impossibility of imagining what follows, in part to underline that disorientation of the spectator. (This is the end?)[37]

Kiss Me Deadly comes to its climax because the film's femme fatale, Gabrielle, opens what Velda has tellingly dubbed "the great whatsit," the leather suitcase containing the nuclear device. The film supplies a range of classical and ancient warnings in the voice of Dr. Soberin, the erudite villain. (The film marks erudition and connoisseurship as in themselves suspect: a patient who lives in his own museum of modern art provides the clue that leads Hammer to Soberin.) A passage of dialogue begins as if copied from *Strange Love*:

[SOBERIN]: Did you ever hear of Lot's wife?

[GABRIELLE]: No.

[SOBERIN]: No . . . Well, she was told not to look back, but she disobeyed and she was changed into a pillar of salt.

[GABRIELLE]: Well, I just want to know what it is.

[SOBERIN]: How? Would you believe me if I told you? Would you be satisfied?

[GABRIELLE]: Maybe.

[SOBERIN]: The head of the Medusa, that's what's in the box. And whoever looks on her will be changed not into stone but into brimstone and ashes. But of course you wouldn't believe me. You'd have to see for yourself, wouldn't you?

Once again, a man narrates the biblical story; once again, the woman has somehow never heard of it. (Soberin pauses for a moment after hearing she does not know the story, as though to wonder what this ignorance means.) As several critics have noted, there is something exaggerated, even pretentious, in Soberin's obsessive search for figures. "You have been misnamed, Gabrielle," he intones. "You should have been called Pandora." Why can't he simply describe the danger? The closest the film comes to naming it is in a series of talismanic names: "Manhattan Project, Los Alamos, Trinity." The contrast between the man's effusive figurations and the woman's deadpan responses draws attention to an almost ludicrous excess in mythical explanation, on the

myth/symbol → failure

one hand—"the great whatsit" becomes a compendium of all fantasies of the destructive power of women—and a hollow, protoscientific curiosity, on the other ("Well, I just want to know what it is"). The force of Soberin's mythical invocations is the reverse of what he desires; the free-floating prestige of his examples seems only to add to the glamour of the box. Gabrielle shoots him, and opens it.

The inadequacy of Soberin's warning is matched by its iconographic complications. This Medusa's head turns its onlookers not into stone but into the supernatural stuff that rains down on Sodom and Gomorrah. Neil Hertz's reading of the Medusa is suggestive here. Drawing on Jean Laplanche, Hertz unravels the contradictory aspects of Freud's reading of the myth. On the one hand, the Medusa's head is a reminder of the threat of castration; on the other hand, "Medusa's grim powers of petrifaction are translated, reassuringly, into the stiffening of an erection." Laplanche, writes Hertz, "insists on the primary apotropaic power of symbolic concentration itself. The symbol of the Medusa's head is reassuring not only because its elements can be read in these ways but because it is a symbol."[38] Two critics of *Kiss Me Deadly* write: "Soberin's references to Lot's wife and 'Cerberus barking with all his heads' are too archaic and unfrightening to keep Gabrielle/Lily Carver from opening her own Pandora's box." And yet these same critics, on the same page, call the film "modern myth" or "anti-myth."[39] The symbol, in Hertz, is a kind of countermagic; the condensation of the "scarifying" and the "reassuring"—the symbol's tautological power comes from the fact of its rhetorical work. One might say this scene from *Kiss Me Deadly* illustrates this power: the symbol's symbolization effectively veils the real threat. The more Soberin mixes and matches tales from his mythological dictionary, the more blasé Gabrielle becomes. But is Soberin's erudition, then, "archaic"?

The insight in Silver and Ursini's reading also makes it deeply problematic. This scene establishes the obsolescence of the mythical: would any myth be just archaic enough to still be frightening? This obsolescence contrasts with the very mythical, or antimythical, project that they see as the work of *Kiss Me Deadly* itself: forget Pandora and Cerberus, forget the Medusa's head, forget Lot's wife—here is the real myth, the unnameable, "the great whatsit." Gabrielle, so plainspoken as to be a parody of the hardboiled detective she imitates in her inexorable and inexpressive search after knowledge, herself embodies a certain myth of mute incomprehension in the face of mass disaster. The film counters both her aggressive refusal of symbolization and Soberin's overindulgence in figural examples by screening a conclusion that points to the bankruptcy of both responses. "In the final analysis," write Silver and Ursini (with unwarranted confidence in the likelihood of such an analysis),

point

purity

"the 'great whatsit' contains pure phlogiston. The quest for it becomes the quest for the cleansing, combustible element, for the spark of purifying fire that reduces the nether world of *Kiss Me Deadly* to radioactive ash."[40]

This passage ventriloquizes the *desire* for disaster that is a noir response to the corruption and conspiracies the films claim to unmask. The identities and motives of the true culprits remain obscure because the target is elsewhere; to identify the "real" culprit within the film would be to absolve the culture outside the cinema. Silver and Ursini certainly identify an urge represented in film noir, an urge that continues to resonate, for instance, in the neo-noir *Taxi Driver*'s Travis Bickle: "Some day a real rain will come and wash all the scum off the streets."[41] To represent the desire for disaster, however, is not necessarily to share that desire.

If one route travels from apocalyptic noir to the mean streets of Scorcese's psychopathic protagonist, another moves from *The Strange Love of Martha Ivers* to *Dr. Strangelove* (1964), from the intimation of disaster to a comic inoculation against the desire for it. If film noir endorses Artaud's belief "that our present social state is iniquitous and should be destroyed," there is a range of responses to this predicament.[42] One response is the abrupt shift in genre at the end of *Strange Love*, where the drive into the green world simply brackets, even if it does not wholly contain, the dilemma of disaster and spectatorship the rest of the film pursues. *Kiss Me Deadly*, exceptionally, represents disaster and watching disaster head-on. As in paintings that show the burning cities one should not look back at, however, the representation of disaster makes all the difference; the spectator can look at burning Sodom without turning into a pillar of salt. My point here is not that representation inevitably shields the spectator, or that the mushroom cloud could become entertainment. Representations may sometimes shield the spectator from that they represent, and the mushroom cloud did become entertainment: spectators from Las Vegas headed to the News Nob to see atomic tests.[43] (In Fritz Lang's *The Blue Gardenia* [1953], the ace columnist receives a ticket for a front-row seat at an H-bomb test, an invitation that puts the explosion more or less on a level with the scandalous murder of the playboy painter he is investigating.) *Kiss Me Deadly* belongs in this context of atomic tourism, but in its refusal to conspire to produce a safe distance between catastrophe and the spectator, it participates neither in the pleasurable anticipation of necessary apocalypse described by Silver and Ursini nor in the reassuring domestication of the atomic threat in the Nevada desert. If, in the classic account of the cinematic apparatus, cinema works upon the real place of the spectator to produce an imaginary relationship to society—if, that is, cinema has an ideological function—*Kiss Me Deadly* evacuates the real place on which this imaginary relationship depends. There is no place to watch.

Anselm Kiefer's *Lot's Wife*:
Perspective and the Place of the Spectator

SEBALD AND SODOM

In his narrative poem *After Nature*, W. G. Sebald describes a photograph of his parents, taken in a public garden in Germany on August 26, 1943. This photograph is the first entry in a chronicle that leads forward to a story of his own origins and backward to the hallucinatory interruption of an early modern painting:

> On the 27th Father's departure for Dresden,
> of whose beauty his memory, as he
> remarks when I question him,
> retains no trace.
> During the night of the 28th
> 582 aircraft flew in
> to attack Nürnberg. Mother,
> who on the next day planned
> to return to her parents'
> home in the Alps,
> got no further than
> Fürth. From there she
> saw Nürnberg in flames,
> but cannot recall now
> what the burning town looked like
> or what her feelings were
> at this sight.
> On the same day, she told me recently,

from Fürth she had travelled on
to Windsheim and an acquaintance
at whose house she waited until
the worst was over, and realized
that she was with child.
As for the burning city,
in the Vienna Art-Historical Museum
there hangs a painting
by Altdorfer depicting Lot
with his daughters. On the horizon
a terrible conflagration blazes
devouring a large city.
Smoke ascends from the site,
the flames rise to the sky and
in the blood-red reflection
one sees the blackened
façades of houses.
In the middle ground there is a strip
of idyllic green landscape,
and closest to the beholder's eye
the new generation of Moabites is conceived.
When for the first time I saw
this picture the year before last,
I had the strange feeling
of having seen all of it
before, and a little later,
crossing to Floridsdorf
on the Bridge of Peace,
I nearly went out of my mind.[1]

Lot's wife is absent from this passage, as from the painting by Altdorfer it describes, or so it seems (plate 5). This absence, according to a logic now familiar, is not absolute, and the principle of destructive spectatorship embodied by Lot's wife is essential to the poem. Altdorfer, like Artaud's cherished mannerist painter long thought to be Lucas van Leyden, and like Corot, represents what Lot's wife cannot see: the destruction of the cities. If the painting reveals the sight of the burning cities, a spectacle available only to imaginative retrospection, Sebald's poem represents a retrospection that has erased the memory of the sight. Sebald establishes a pattern of seeing and forgetting. His father has no memory of the beauties of Dresden, his mother has no memory

of Nürnberg in flames. In a pattern familiar to post–World War II German culture, the parents' failure of—or resistance to—memory leaves the child with what one can mildly call, following Freud, a "disturbance of memory."[2] Sebald recalls his parents' experiences by recalling Genesis 19; he recalls the biblical passage through the experience of the women in the story. In the poem's figural logic, his mother is an amalgam of Lot's wife, who looks back at the burning city, and Lot's daughters, who, in the aftermath of catastrophe, conceive races who will bear their burdens.[3] By the same figural logic, Sebald himself appears as a Moabite, cursed by the circumstances of his birth.

Altdorfer's painting takes the place of memory. Just as the logic of memory is disturbed here, so the logic of Sebald's poem moves, not ungrammatically but also not exactly logically, from "Nürnberg in flames" to the painting by Altdorfer. "As for the burning city . . .": this clause might lead to discussion of the wreckage of Nürnberg but, instead, Sebald moves to a description of the destruction of the city in Altdorfer's painting. What is this burning city? Nürnberg, Dresden, Sodom? The shifting referent recalls the logic of my last chapter: every city is, potentially, Sodom. The selective retelling of Genesis 19 also recalls Artaud, who, like Sebald, describes the burning city in a painting of Lot and his daughters as though he does not know the city's name and, also like Sebald, forgets Lot's wife.[4]

This passage from *After Nature* suggests a psychic structure that accords with Cathy Caruth's understanding of trauma as an experience that forces us to

> recognize the possibility of a history that is no longer straightforwardly referential (that is, no longer based on simple models of experience and reference). Through the notion of trauma . . . we can understand that a rethinking of reference is aimed not at eliminating history but at resituating it in our understanding, that is, at precisely permitting *history* to arise where *immediate understanding* may not.[5]

No figure in the passage from Sebald possesses anything resembling "immediate understanding," and indeed many parts of this passage rely on a knowledge that could not possibly have been immediate. The impossibility of such immediate knowledge is a matter of detail, such as the number of aircraft, a fact to which even those flying the bombers very likely had no access. A specificity that has nothing to do with lived experience grounds a certain historical confidence: the flat tone of the historical chronicle complements the refusal to acknowledge the horrors witnessed. Most important, however, is the sequence of failed or lost memory: the forgotten beauties of Dresden, the forgotten sights of the burning city of Nürnberg. An idiom in Michael Hamburger's translation captures both a simple failure of memory and the

search for an analogue that might help understanding: she "cannot recall now / what the burning town looked like / or what her feelings were / at this sight."[6] The lost memory of a catastrophic sight becomes, as Caruth insists, not a matter of the "straightforwardly referential," but, here, of likeness, metaphor, or analogy, of what "the burning town looked like." But *is* trauma the right word for the experience narrated in the poem?

In certain ways Sebald's sequence perfectly fits Caruth's conception of trauma. And yet the painting with which it culminates complicates some of the arguments about the force of the image that inform work on trauma. Ruth Leys's fierce critique of current theorizations of trauma is built partly around the question of the status of the image; one of her central claims illuminates the importance of Sebald to my own project.[7] To summarize Leys's characterization of this theory of the traumatic image: traumatic experiences, impossible otherwise to integrate, are stored by the mind as icons. "Permanently 'etched' or 'engraved' in a way that is theorized as standing outside all ordinary cognition, traumatic memory on this hypothesis returns in the form not of recollected representation—the usual understanding of the term 'memories'—but of literal icons and sensations."[8] The sacred connotation of the word "icon" is not an accident: as the final phrase here implies, the icons are exempt from the distortions and changes to which other memories are susceptible. They are true, if enigmatic, visual embodiments of trauma; after a long latency period, trauma returns in reenactments of these iconic images.

Given this theory of the role of imagery in traumatic experience, there is something immensely strange in Sebald's story. If Sebald's is a story of trauma, then this poem points to a very different role for the image: a manifestly "fictional" painting transmits trauma. The forgotten image of trauma surfaces not as a repetition or rehearsal of the initial shock—the sight of wrecked beauties and wrecked cities—but as a well-known painting that depicts Lot and one of his daughters, in the words of Christopher Wood, as "a horizontal sward of flesh that is almost unbearable to look at."[9] ". . . I *nearly* went out of my mind." As important as the threat of destruction in Sebald's poem is the qualification: What is its force? Is "nearly" to go out of one's mind to be traumatized? Trauma as paradigm for historical understanding threatens to erase such qualifications. Another Freudian category may better describe the complicated place of memory in Sebald's poem. In one of his last and most moving contemplations of memory, the 1936 essay "A Disturbance of Memory on the Acropolis," Freud discusses the paired terms of "derealization" and "depersonalization," phenomena which take "two forms: the subject feels either that a piece of reality or that a piece of his own self is strange to him." Freud also discusses the "positive counterparts" of these defenses, "what are known as '*fausse reconaissance*,' '*déjà vu*,' '*déjà raconté*,' etc.,

illusions in which we seek to accept something as belonging to our ego, just as in the derealizations we are anxious to keep something out of us."[10] Sebald, one might say, responds to a family history of derealization with an attempt to claim something he cannot possibly own as "belonging to" his own ego. But that very claim to belonging results in an encounter with the anxiety behind the attempts to alienate those memories in the first place: the painting by Altdorfer is the image that produces a certain illusion, "the strange feeling / of having seen all of it / before." "Derealization" is a weak term for his parents' forgetting; "trauma" exaggerates the poet's predicament.

The solution to the problem of likeness lies in the story of Sodom and Gomorrah. *After Nature* puts an image of Sodom in the place of an impossible memory of wartime experience. The image "closest to the beholder's eye" is precisely the one that cannot be seen, as it is an image of the beholder's conception. The painting becomes a primal scene that links the trauma of witnessing the parents' sex to the destruction of the cities. Where there was no memory, there is suddenly a sense of *déjà vu* so overwhelming that it threatens to destroy the sanity of the spectator of the painting. Throughout this book, I have insisted on the ways visual representations of the burning Sodom and Gomorrah ask the spectator to ponder the possibility of looking at what might destroy the spectator. As I suggest in my introduction, such a formulation rests on a problematic model of representation, a model that elides the difference between image and the event. This problem is especially acute where the "event" in question—the destruction of Sodom and Gomorrah—is a mythical one. And yet *After Nature*, a phantasmagorical, ekphrastic poetic sequence that begins with a section on Matthias Grünewald and closes with a capacious description of Altdorfer's *Alexander Battle*, suggests throughout that we underestimate the power of images.[11]

Joseph Koerner argues that the landscapes of Caspar David Friedrich "locate *us* in our subjectivity as landscape painting's true point of reference."[12] Altdorfer's *Lot and His Daughters* contains a partial landscape, that "strip / of idyllic green landscape" Sebald describes. Even this phrase in Sebald demands scrutiny: what's left out of ekphrastic description signifies, and here, once more, the woman in the "idyllic green landscape" disappears. Forgetting Lot's daughter? Perhaps. It may also be that Sebald's overlooking the figure in the landscape points to the place that figure holds. Although accounts I have seen always associate her with Lot's second daughter, that figure occupies the spot so often occupied by Lot's wife, that place in the painting behind and to the right of the larger figures that I discuss in my introduction. I am not arguing that this figure *is* Lot's wife, but that this placement points to the erotic economy by which the daughters take the place of the mother. Another economy,

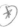

as the quotation from Koerner suggests, assures the spectator that she knows where she is, that the painting places her. But the force of the story of Lot's wife is that we no longer know who's who or who belongs where, or who takes what place. The landscape gestures toward our subjectivity, then suggests that the place it had assigned to us is a place we do not want to occupy or cannot occupy. Lot's wife: the signal for the kind of trap that a certain image is—a landscape that places us, and then makes it clear that to occupy that place will nearly drive us mad.[13]

In Sebald, an image of Sodom takes the place of memory. This complex intersection of the story of Sodom and the problem of spectatorship offers a narrative analogue of that intersection in the painting of one of Sebald's contemporaries, Anselm Kiefer. With Kiefer, I return to painting, with which this project in many ways began: Artaud's reading of the mannerist painting long attributed to Lucas van Leyden contained the kernel of this project. Sebald's concerns with the two incommensurate and yet paired traumas of twentieth-century German history—the genocide of Europe's Jews and the destruction of German cities from the air—are also of central importance to Kiefer's work. Even to put these two catastrophes side by side is to risk the appearance of rendering them equivalent. The impossibility of any dialectical relationship between the destruction of cities and of a people, like the impossible memory in Sebald, calls for an image which functions neither as resolution nor as conclusion. Kiefer carries on a long tradition of the visual representation of Sodom by carrying that tradition's challenge to the place of the spectator to a catastrophic vanishing point. ←

FROM THE COCKPIT

> This horrific vision of urban sprawl was inspired by Kiefer's visit to São Paulo in Brazil. Tangled copper wiring signals the breakdown of communication. The city is engulfed in an apocalyptic haze, which Kiefer created by spreading dust and earth across the painting, then burning parts of its surface. According to Hebrew mythology, Lilith was Adam's first wife, a seductive and demonic airborne spirit. In Kiefer's painting, Lilith seems to bring destruction from the air upon Oscar Niemeyer's modernist buildings.[14]
>
> —Display caption for Anselm Kiefer's *Lilith*, Tate Modern, London, September 2003

September, 2003. Teenagers on a school trip to the Tate Modern have settled down into a haphazard half-circle around Anselm Kiefer's *Lilith* (plate 6).

Their male guide elicits responses. "It's like rocks and soil"; "like a city you're looking down on"; "skyscrapers"; "barbed wire that looks like clouds . . ." The guide replies to the last observation with a question of his own: "Is the wire actually barbed in any way?" The child looks again, and sees that it is not actually barbed. There is nevertheless something right in this wrong response, and *Lilith* may be barbed—barbed, that is, like certain questions, if not like wire. After the students' initial responses, the guide tells them a few things about *Lilith*. Kiefer mixed ash with paint. A flight over São Paolo inspired him. The guide is immediately careful to prevent a misapprehension: "It could be almost any major city." A few minutes later, he reiterates, "It could be any city." You look down on a city of rocks and soil, a landscape of skyscrapers from which a tangle of wire emerges. Yes: any city, and yet he pulls photographs of New York from a plastic envelope. And surely for many viewers Kiefer's vertiginous skyscrapers do evoke New York before other cities. This vista of buildings could not represent, for instance, London. And the guide relied on not having to remind those students that two years before New York had joined London on the lengthening list of cities attacked from the air.

What if these teenagers in London knew enough—enough, that is, to read the painting? The display caption puts *Lilith* at once inside and outside the Bible; the name evokes an apocryphal woman, and the name puts this figure against—or outside—a long history of Western art, with its thousands upon thousands of Eves. This evocation is, however, a mysterious one. *Lilith* neither matches name and subject matter (in the manner of a caption: "Lucas Cranach, *Adam and Eve*") nor elusively links name and abstraction in the manner of the modernist ("Robert Motherwell, *Elegy to the Spanish Republic*"). As the panel suggests, the spectator might locate Lilith not in the representation—unless the painted name counts as a representation—but elsewhere, "airborne," above the painting. The name itself is at once part of the painting, inscribed within it, and outside the dominant perspectival system that defines the cityscape. The name, that is, is analogous to the place of the spectator, who, like Lilith, stands above the city, looking down, and yet is nowhere to be found and cannot occupy the represented space. Written words across a canvas are most often the signature of the absent painter; here, however, "Lilith" gives a name to the spectator, who may be present and yet is obliged to cope with her absence from the depicted scene(an absence shared with Lilith.[15]

Lilith exemplifies Kiefer's engagement with the poles of myth and history that Andreas Huyssen has most influentially analyzed. Indeed, Huyssen has discussed a related painting by Kiefer, also called *Lilith*:

> The old story of Lilith meeting the demon in the ruins merges with
> cities in ruins, urban decay, the haze of pollution. . . . The age-old topos

(handwritten margin note, top right: spectator as agent of destruction was Lilith)

of equating the metropolitan body with the female body (the great whore of Babylon) is deliberately restated as myth and retracted by the double disembodiment of Lilith, who appears in the form of hair and language only.[16]

The Tate Modern *Lilith* enacts something analogous to this "double disembodiment"; in the Tate Modern *Lilith*, language also appears, and one might see the tangle of wires as a technological revision of the hair in the painting Huyssen discusses. I am not sure, however, that one can be so categorical about what does or does not appear in Kiefer's paintings, or what sorts of appearances might count in this context. Neither *Lilith* is, in the strict sense, figurative, but both paintings, by putting the perspectival system to work and by inscribing the name across the canvas, evoke a location for the figure of the spectator and give that location—and therefore also that spectator—a name: the spectator is in a real sense the "subject" of these paintings. *Lilith*, that is, reverses this book's emphasis on the destruction of the spectator, and imagines the spectator as agent of destruction.

Huyssen's central contribution to the understanding of Kiefer lies in his insistence that Kiefer's invocation of myth constitutes, rather than an evasion of history, a means of understanding history. Further, Huyssen insists that Kiefer's art responds to the particular dilemmas of post–World War II German *(margin note: historical)* history through its complicated and contradictory engagement with some of the most charged strains in "German" mythical thought, from the triumph of Arminius over the Romans in 9 CE to Wagner's narratives.[17] Huyssen has also, not incidentally, provided the most telling description of how Kiefer's paintings work upon the spectator. He summarizes his discussion of a few of Kiefer's paintings of "fascist architectural structures": "Here, then, is the dilemma: *(margin note: fixation ↓ critique)* whether to read these paintings as a melancholy fixation on the dreamlike ruins of fascism that locks the viewer into complicity, or, instead, as a critique of the spectator, who is caught up in a complex web of melancholy, fascination, and repression."[18] The second possibility here rests on the first. If the paintings work as critique, it is because the spectator is first complicit in the paintings' fascination, already "caught up" in that "melancholy fixation on the dreamlike ruins of fascism." That is to say, the dilemma is whether or not the spectator goes beyond the first stage, "fixation," to the second, critique. "These works exude an overwhelming statism," writes Huyssen, "a monumental melancholy, *(margin note: stasis = petrification)* and an intense appeal of color, texture, and layering of painterly materials that can induce a deeply meditative, if not paralyzing, state in the viewer."[19] It is as though the threat of paralysis in the earlier paintings were tending toward a work in which the dangers of the spectator's petrifaction would be explicit.

Lilith, to return to the Tate Modern's wall panel, "seems to bring destruction from the air upon Oscar Niemeyer's modernist buildings." If, as I have argued, the painting—through the force of perspective and through its name—places the spectator in the position of Lilith, then this painting also invites a disturbing form of complicity: demonic participation in the desire to destroy the modern (or modernist) city from the air. *Lilith* responds to the dilemma of the notoriously empty or nameless place of the spectator by giving that spectator a name. But no sooner does the spectator encounter her interpellation by the painting than she must also face the impossibility of owning that name: are you, then, "there," with Lilith, bringing destruction "from the air"? Should the spectator, here, in London, identify with the place she is asked to occupy, she must occupy the place of the demonic destroyer of cities. The cityscape is not London's, but memories of the Blitz are now part of the painting's world. And surely Londoners have memories of the Blitz, even if those memories are not exactly their own. Such memories are crucial to *Lilith*: one of the neglected and crucial historical contexts for the painting, and more generally for Kiefer's work, is the bombing of civilians. Further, the point of view Kiefer has chosen, however abhorrent it might seem for a London audience, has ties both to the mythical narrative of Lilith and to a dominant post–World War II model for the representation of warfare: "The perspective of the bombardier, who sees his urban target only as a map through the clouds," write Ryan Bishop and Gregory Clancey, "became (and arguably still is) the agreed-upon shared perspective of the postwar war-consuming public."[20] Kiefer works in a postwar context in which it has become necessary to alienate audiences from a perspective that brought destruction to their own cities.

One exhibit in this mythical history is particularly relevant here. As Sebald notes, without comment, the devastating Allied bombing campaign against Hamburg in the summer of 1943 had a peculiar codename: "The aim of Operation Gomorrah, as it was called, was to destroy the city and reduce it as completely as possible to ashes."[21] There were probably local reasons for this name. Hamburg, then as now, was well known for prostitution, and the city's historic center of sexual liberty, the Reeperbahn, was part of the decimated area.[22] The biblical name, then, was a form of symbolic action, authorizing the bombing as a vice raid conducted from the sky. But why did the Allies choose "Gomorrah," and not "Sodom"? Given the debate surrounding the ethics of the Allied bombing of German cities, the question may seem jejune. The name itself, however, like many such names, took a position in this debate. It announced in advance a plan for absolute destruction on the model of the biblical storm of fire and brimstone and made a claim to divine sanction for this destruction. (There is debate about whether the British command

anticipated the extent of the firestorm, so memorably described by Sebald, which ravaged Hamburg.[23] There were certainly, however, intimations of this firestorm in the operation's name.) The codename also sexualized the urban target, associating Hamburg neither with heterosexual nor male same-sex desire, but with the lesbianism of mythical Gomorrah. The name participates in the feminization of the city Huyssen describes, and, as so often, this feminization is indistinguishable from a fierce demonization. This code name described not a horizon of apocalyptic desire but a plan for warfare. Or, to put this otherwise: a plan for warfare came coded as apocalyptic desire.[24]

I do not want to exaggerate the force of one code name in 1943, when the Allies hardly lacked motives for attacking Germany and there was no need for a name to create the aura of potential apocalypse. I introduce this name because it points to the simultaneous feminization and anathematization of a German city; because its context—the destruction of Hamburg and other German cities—is so clearly relevant to Kiefer's painting, visually, but not only visually (fig. 21); and because the perhaps makeshift mode of twentieth-century mythological thinking behind the code name strikes me as at least as relevant to Kiefer's project as the more elaborate mythical schemes most often traced by scholars. That is to say, the valuable work on Kiefer's sources in

FIGURE 21 Hamburg in Ruins

ancient <=> modern

Kabbalah and elsewhere has too often obscured what, following Adorno, one might call Kiefer's "phantasmagorical" mode.[25] The mythological stratum is not the resurgence of some archaic mythological or *Völkisch* force, but a way of thinking—through the phantasmagorical entwinement of ancient and modern—about the exigencies of the present through the archaic.

OUT OF PERSPECTIVE

Kiefer's phantasmagorical mode requires that one articulate the ancient and modern, the paintings' saturation by mythological references with a visual vocabulary that engages the antinomies of modernist representation. As Huyssen's and numerous other accounts suggest, it is hard to resist Kiefer's paintings' intense interpellation of the spectator. That interpellation requires attention to the perspectival tradition in which he works and to the specificities of painting's placement of the spectator. But Kiefer's compositions are equally intriguing for what falls out of perspective: intensely layered paint, found objects, words. To begin with words: while Kiefer's loopy letters appear frequently across his body of work, it is remarkable that they are especially common in works that feature perspectival compositions. Such iconic and troubling early paintings as *Germany's Spiritual Heroes* (1973) and *March Heath* (1974), for instance, are early instances of Kiefer's use of deeply perspectival designs, and both feature the writing that has remained a feature of Kiefer's paintings. In *Germany's Spiritual Heroes*, the painted names of Wagner, Beuys, Storm, and others diminish in accordance with perspective.[26] In *March Heath*, the German title, *Märkische Heide*, appears prominently across the middle of the road that leads up the middle of the canvas. The question arises, then, of what relationship these titles bear to the canvas as a whole. In *Germany's Spiritual Heroes*, Kiefer's treatment of names as though they were themselves receding in space looks like an abandoned experiment; *March Heath*, in which the words more drastically interrupt the visual order of the painting and are unassimilable to its perspectival design, is more typical of the works that follow, including *Lilith*.

Lilith is the painting's name, but what does this name do? Its first function is to ask the observer to contemplate writing in the field of the painting. The relationship of *this* writing to *this* painting is, however, unclear. Kiefer has given the same title to a number of paintings, and critics, most notably Lisa Saltzman, have discussed the Kabbalistic themes in Kiefer's group of paintings and other works on the theme of Lilith. According to a long line of Kabbalistic thought, Lilith, Adam's demonic first wife, is Eve's destructive and rebellious predecessor. Saltzman argues that for Kiefer, Sulamith, from the Song of

Songs, and Lilith together represent an "embodiment of mystic and mythic figures of German womanhood": "Further, if her source is not, or is not only early Kabbalah, but later Lurianic Kabbalah, she may embody aspects of cosmic creation and catastrophe, but she is first and foremost the product of, the transposition of, historical catastrophe and trauma, a history of catastrophe that now ends not with the expulsion of the Jews from Spain but with genocide."[27] Following Gershom Scholem, Saltzman understands Lurianic Kabbalah as the transposition of "historical trauma, the expulsion of the Jews, into mythic trauma, the shattering of the mystical vessels" (36); Kiefer's paintings, Saltzman suggests, are a similar transposition of a later catastrophe into art and into myth. In her argument, that is, Kiefer's paintings verge on becoming another Kabbalistic work, transposing the catastrophes and traumas of twentieth-century European history into myth. The paintings, in this view, participate in what Leo Bersani has called the "culture of redemption," offering a sublime aesthetic or encyclopedic solution to recalcitrant human conflict.[28] Although I am in many ways in sympathy with Saltzman's readings, it seems to me that formal qualities of the paintings at times evaporate in her invocation of Kabbalah and myth. Too often, names alone generate interpretation.[29] Kiefer's works are powerful responses to the catastrophes of twentieth-century history, and, in particular, to the Nazi genocide. Here, I ask how Kiefer's works are designed to force the spectators to ponder how they can "look" at the histories Saltzman rightly evokes.[30] Concentration on some of the mythical elements his titles invite has led to neglect of some of the nearer—and potentially more contentious—historical and aesthetic contexts for his work. In such readings, the striking power of these works becomes the ground of a new mythmaking. But this reading of Kiefer's work on myth *as* myth misses its disruption of the spectator's place. This disruption challenges the very force by which it might become myth. And to trace this disruption requires following the paintings' formal codes. Most important, this requires working through the paintings' contrasts between perspectival grandeur and heavily worked surfaces that do not belong to this perspectival order.

Many have recognized that the contrast between perspective and heavily worked surfaces is central to understanding these works. Mieke Bal and Norman Bryson, for instance, turn to this contrast as an example of how to read the various viewing positions in narrative paintings. Drawing on the first of Huyssen's essays on Kiefer, they argue that Kiefer's paintings carry on "a debate with Nazism":

Kiefer's dialogic approach refuses to silence, ignore, repress, and thereby conserve fascism today. By integrating another partner in this debate,

the tradition of linear perspective, that emblem of realism and objectivity, Kiefer's works also signify the complicity of art with politics. The suggestion is that perspective, and the scientific pursuit it stands for, collaborate with fascist tendencies, which an obliteration of the Nazi past facilitates. The resulting narrative presents a highly complex account of both fascism and painting, within which the various possible focalizers take their share in the production of meaning. The narrative of the painting is constituted by the tensions between these focalizers.[31]

Bal and Bryson introduce central problems in the reading of Kiefer: the question of the Nazi past; the signification of perspective; the contrast between perspective, with its placement of the spectator, and other formal "focalizers"; and, most challenging, the relationship between these formal elements and the historical questions raised by Kiefer's work.[32] My aim here, however, is to accept Huyssen's invitation to take a "sustained gaze at specific works."[33] Too often, a single element, especially a work's title, has become the key to reading Kiefer's work; critics have been all too willing to read his titles reverently, especially those taken from the Old Testament and Kabbalah. *Lilith* demonstrates that those elements that do not belong in the perspectival grid—impasto, damaged canvas, painted names, found objects—are not only legible in particular ways, but that together these elements challenge perspective's placement of the spectator. The works I discuss here, however, suggest instead that the spectator should find her place in those elements that resist the perspectival order and its interpellative force. Kiefer's work, that is, at once relies upon and challenges perspective, *the* dominant technology for placing the spectator in painting. It is then seemingly inevitable that, as I shall discuss at greater length in a moment, Kiefer turned to that story about the power of and resistance to the visual order, Lot's wife.

If Kiefer's work relied on his grandiose projections of perspectival space alone, they might justify Benjamin H. D. Buchloh's dismissal of his work as "polit-kitsch" or the rather savage criticism of Arthur Danto, for whom Kiefer's "sludged and operatic fabrications" are an exercise in "the usual Wagnerian war music, tooted and thumped by the oompah brass of the marching bands of German nationalism, a heavy-handed compost of shallow ideas and foggy beliefs."[34] Kiefer's perspective is, indeed, in the service of a certain Wagnerian—or Dionysian—overpowering of the spectator; even so friendly a critic as Daniel Arasse calls it "dictatorial."[35] But there is a counterweight in what Danto calls the "sludge," the "compost." Many of the marks and signs in Kiefer's works contest the perspectival vortex that threatens the spectator's sense of her stable place. Kiefer's paintings engage the desire to overwhelm—or even to destroy—the spectator; Kiefer does harness something

perspective as dictatorial (for the eye)

paintings desire to destroy spectator

counterweight to perspective.

like the Wagner of Nietzsche's early enthusiasm: the Wagner whose music, like the tragedy of ancient Greece, would do the sublime Dionysian work of evacuating individuation. Further, Kiefer engages a modernism that carried on Nietzschean fantasizing about the destruction of the spectator. In the two works I discuss at greatest length here, there is, however, a formal counterweight to these seductions of perspectival space. That counterweight comes in the elements that fall out of the perspectival grid. These elements, I will argue, at once identify the spectator as the endangered subject of perspectival representation and provide a precarious formal space outside of perspective and its designs on the spectator.

history of perspective

Before turning to *Lot's Wife*, it is important to review some relevant arguments about the function and force of perspective. Kiefer's use of perspective recognizes that the technique does not exist in some limbo of technical skill and geometry, but instead has its own complex history.[36] In particular, Kiefer works inside, and in contrast to, that contradictory modern moment where the almost omnipresent mode for the representation of the world, perspective, was absent from what a generation had been schooled to consider the most compelling visual art. More specifically still, Kiefer works within the particular history according to which perspective has been associated with the work of coercive subject-formation; the manipulations that put the spectator of *Lilith* in the place of a destroyer are part of this larger history. Because fascism has become the prime example of such coercive subject-formation, Bal and Bryson can associate perspective with fascism and Arasse can call it "dictatorial."

To use Hubert Damisch's formulation, perspective constitutes one of the subjects of Kiefer's paintings.[37] Damisch asks whether paintings in perspective might be considered abstract, and his question, then, is whether there might be a tradition of "abstraction" within the perspectival tradition, and long before the advent of modernist abstraction. I draw on Damisch, but I will propose something like the reverse to his formulation. In Kiefer, perspective, once again, becomes the subject of painting *after* modernist abstraction. Paintings such as *Lilith* "think" about perspective. From a strictly high modernist standpoint, such a movement back to the perspectival grid might seem a regressive movement away from the refusal of illusion in the properly modernist picture. But Kiefer has his sights on the place of the spectator. By returning to the perspectival system that has helped to produce the conditions of modern spectatorship, Kiefer engages those conditions and the antinomies of abstraction, absorption, and destruction that have determined them. Kiefer's work is paradoxical: through its use of perspective, this technique of subjection, it forces the viewer to ponder the disembodiment, if not the destruction, of the viewer.

The regime of perspective, as Damisch stresses, is hardly over:

> But there is a great danger of treating perspective as just one object
> among others, if not as a simple product or effect, whereas it interests
> us here primarily as something that is *productive* of effects, insofar as its
> capacity, its power to inform, extends well beyond the limits of the era
> in which it was born. Without any doubt, our period is much more
> massively "informed" by the perspective paradigm, thanks to photogra-
> phy, film, and now video, than was the fifteenth century, which could
> boast of very few "correct" perspective constructions.[38]

Kiefer's engagement with precisely the system that dominates images in the
popular sphere does not immediately place his work in the realm of the popu-
lar, nor does it erase his equally evident commitment to working with myth.
The works I consider here require a dialectical coordination of perspective
with the mythical or literary strata.[39] Neither in the case of perspective nor in
the case of myth does Kiefer simply put an existing system to use. He uses
perspective to question the model of the subject for which perspective as a
system is supposedly exemplary; he evokes myth to point to some of the
dilemmas most typical of modernity.

Kiefer does not question the status of perspective through hypostatization
only, as though the force of perspective might simply expire when pushed to
grandiose extremes. As Huyssen observes, "This monumentalism of central
perspective itself seems to be undermined by the claims the multiply layered
surfaces make on the viewer, by the fragility and transitoriness of the materials
Kiefer uses in his compositions."[40] In the simplest way, these surfaces make
"claims" by pulling the spectator's attention away from the perspectival de-
sign; in their recalcitrant and obtrusive resistance to perspective, they are the
counterpoint to the nearly overwhelming force of perspective. So, as Huyssen
suggests, they partly undermine the force of that design. Here, I argue that
these surfaces do not simply contrast with perspective, but that they gesture
to another order of spectatorship: an order located not at the point to which
the painting assigns the spectator, but instead in the signs dispersed across
the canvas.

resistance to perspec

TRACKS

Kiefer's *Lot's Wife*, like *Lilith*, establishes, and then undermines, the place
of the spectator through perspective, evokes the destruction of cities, and
negotiates—but does not resolve—a troubling line between biblical myth and
modern memory (plate 7). The painting also evokes the Holocaust. It is a

[handwritten margin note: paralyzed state on looking at genocide squarely]

visual meditation on what Inga Clendinnen has called the "Gorgon effect," "the sickening of the imagination and curiosity and the draining of the will which afflicts so many of us when we try to look squarely at the persons and processes implicated in the Holocaust."[41] Kiefer's painting, like the ones described by Huyssen, aspires to produce a certain "paralyzing state" in the viewer. This "paralyzing state" threatens to reproduce, in the form of the fascination of one image, the "Gorgon effect" that Clendinnen fears will strike one who contemplates the Nazi genocide "squarely."

And yet the story of Lot's wife is always a challenge to the notion that knowledge belongs directly to the visual order at all. As I have stressed, the history of the representation of Lot's wife is one marked by an anxiety that tends to place the figure of Lot's wife—if "figure" is indeed the word—at the margins. In painting after painting, drawing after drawing, she appears as a ghost without the corporeal fullness of other figures, or not at all. One of the earliest images of Lot's wife that I have seen solves the problem of how to represent her as a pillar of salt in a most simple, and rather comic, way: in a German manuscript of about 1330, Lot's wife is a head and partial torso sitting on top of a column.[42] A more common solution has been to represent her as a pale and ghostly figure, as a woman of salt who, in other ways, more or less resembles other figures in the images in which she appears; in such images, she appears as a salt statue. As I have discussed, in the painting attributed to Lucas van Leyden (plate 3), as in Corot (plate 2), Lot's wife is only problematically part of the field of the painting. I review this tradition briefly because it puts in relief one element of Kiefer's painting: its refusal to follow even this odd history of representing the human figure. As in *Lilith*, the spectator contemplates the uneasy link—or lack of any link—between name and image. And yet the name is part of the image: *Lots Frau*. In this *Lot's Wife*, as in *Lilith*, a combination of name and perspectival design points to the spectator.

[handwritten margin note: problem of representation of Lot's wife.]

Lot's Wife now hangs in the Cleveland Museum of Art, where it dominates a room. A huge work in two panels, both backed in lead, it measures 11½ by 14 feet. Train tracks vanish toward an obscure vanishing point in the lower panel; the upper panel is encrusted with the salty residue produced by the reaction of the panel's lead to sodium chloride.[43] From a distance, that residue reads as a threatening sky, just as, from a distance, the impasto of the lower section reads as damaged ground. *Lot's Wife*, too, even more intensely than *Lilith*, works to complicate the spectator's understanding of the painting's perspectival space as one the spectator might occupy. Pieces of the distressed fabric in the bottom panel are ripped, revealing the underlying lead. The far left and right margins of the painted panel are especially ravaged, but there are holes of various sizes in every area of the painted half. There are four pairs

of tracks on the left; the two central pairs merge at a switch, and then seem
to merge again with a less distinct pair of tracks on the far left. The central
pair heads without divergence toward the blurred vanishing point, which is
to the right of the center of the panel. Another pair of tracks to the right, as
if submerged under earth, is, like the pair on the far left, indistinct and yet
unmistakably outlined; these tracks grow less and less distinct as they near the
space of the spectator, and it is in this general area—where the vanishing
tracks nearly enter the space of the spectator—that the name in white chalk,
"Lots Frau," appears. Another remarkable divergence from the perspectival
design is, in Tom E. Hinson's words, "a long, delicate vertical mark—centrally
positioned—to which [Kiefer] attached the three-dimensional twisted form
of a heating coil, covered with a white substance."[44] The coil interrupts the
strongly delineated pair of tracks that moves unswervingly to the horizon.
That is to say, it is just where the painting comes nearest to the representation
of "real" space—in that central pair of tracks—that Kiefer has placed the
object that most disrupts the perspectival order of the panel.

That "long, delicate vertical mark," the coil, and the chalked name all
disrupt the perspectival field of the painting. As in *Lilith*, these elements that
disrupt the work's perspectival order are precisely the elements that "locate"
the spectator—the elements, that is, that contribute to the work's destruction
of the place of the spectator. The painted mark, as Hinson observes, is "cen-
trally positioned"; indeed, the line leads from a point almost exactly at the
center of the work, at the hinge between the upper and lower panels. This
mark, then, draws attention to the off-center vanishing point; the ideal place-
ment of the observer, given the work's ordering of perspective, is to the right
of center. That placement is hardly unprecedented, but the mark remains as
a sign, outside the perspective scheme, that pulls the spectator's attention
toward the more customary placement of the vanishing point at the painting's
center. The work does not, like some paintings, have two vanishing points,
but it does have what might seem an arbitrary reminder of a second vanishing
point, a ghost of another ordering of perspective. The mark draws attention
to the work's center—the center of the object's dimensions—but that center
is not the center of the visual order of the work.

That mark, in turn, leads to the excrescence of the coil. In a work marked
by its many violations of perspective, the coil stands out, quite literally, as the
most remarkable of these violations. Unlike the painted surfaces, it is not
assimilable from a distance to the visual order of the painting, nor, on close
inspection, is it part of the massed impasto in which the spectator can see
signs of the artist's tools, if not hands. Like the skull in Hans Holbein the

Younger's *Ambassadors*, it is the element out of perspective that, in the colloquial sense, puts things in perspective. Holbein's anamorphic skull comes into focus when viewed from a position to the left of the painting; the coil comes fully into view only when observed from the side. Holbein's skull is a resonant object, and it has been the subject of much critical speculation, some of which is especially relevant here. It is worth stressing the initial force of that skull, however, which is to challenge the monocular address of perspective; there are two—at least two—perspectives on *The Ambassadors*.[45] The anamorphic skull requires a point of view that distorts the resplendent scene of the fat diplomats and their humanist trophies; to see the men and the objects that surround them correctly, in turn, requires overlooking the skull. Some have judged that the skull is the key to the painting, and that it makes *The Ambassadors* legible as a work in the *memento mori* tradition: the apparently wrong perspective allows the spectator to see the painting correctly, and to understand death as the truth behind all the triumphant equipment displayed in it.

Kiefer's coil, like Holbein's skull, belongs to an order of perspective outside of that which dominates the work. Further, the coil also suggests mortality: that "white substance" covering the coil evokes Lot's wife. One might even say that the work's title applies to the coil, and that the coil stands as a synecdochic representative of Lot's wife. Looking the "wrong" way, looking awry, the spectator contemplates a fragment that stands for looking the wrong way, looking back. That mortal coil, like the skull the skeletal remains of a vital force, stands out awkwardly from the visual field of the work, as Lot's wife has always stood out awkwardly—or been simply erased—from visual representations of the story of Sodom and Gomorrah. But it would be a mistake to equate Lot's wife with the coil, as though the name to the right simply belonged to the coil to the left. This is a not a covert figurative painting, with the coil as the woman, as, for instance, in Hanne Tierney's mechanical marionette version of Wilde's *Salomé*, in which a silken cloth plays the role of Salomé and a metal spiral takes the role of Yokanaan. Or, if *Lots Frau is* a covertly figurative work, it is not figurative in this way, where a search for the figure in the carpet uncovers the coil. If such performances tend to anthropomorphize objects, Kiefer petrifies the human.

The saline encrustation on the coil also connects the coil to the upper panel, with its salt sprays. This upper panel, like the coil and the name, does not belong to the perspectival design. Even—or perhaps especially—if the spectator reads the panel as a cloudy sky over the damaged railroad landscape, that panel and its clouds do not conform to the system of perspective. As Damisch has stressed, clouds and the sky escape the order of perspective.[46] The salt portion across the upper half of the work suggests a dispersal of the

body of Lot's wife. The present study traces ways in which this body has been imagined as divided, fragmented, and distributed in new and ever-stranger ways. The salt sky in Kiefer's painting almost literalizes this distribution. It is an image of a potential dissolution in another way as well. As the canvas of the lower part of the painting threatens to pull away from its backing, so the salt, one can imagine, threatens to corrode what supports it. It is as though the work of art that represents Lot's wife were itself subject to eventual self-destruction. This is a painting where the figure is dissolved, but not wholly absent; the viewer has to do the work of reconstituting the partially absent body, to figure out where *Lots Frau* is.

It may be that Kiefer's Catholic upbringing reveals itself in his choice of title, if "choice," here, is even the word. The King James rendition reads: "But his wife looked back from behind him, and she became a pillar of salt" (Gen. 19:26). The current official Catholic Bible in German translates the relevant passage: "Als Lots Frau zurückblickte, wurde sie zu einer Salzsäule." Luther, on the other hand, writes: "Und Lots Weib sah hinter sich und ward sur Salzsäule." Given the dominance of Luther's translation in German culture, "Lots Weib" is commonplace; to many ears, "Lots Frau" would have a jarring sound.[47] For the non-German speaker, Kiefer's painted titles often pose problems of translation; here, however, the title poses not only that general problem of translation from language to language, but points to a significant division within German. Indeed, quick translation into English produces a title more straightforward than the work's German, as there is no variation in the phrase in question—"Lot's wife"—across common English translations. (Although it would exaggerate the contrast in German, the Cleveland Museum of Art could contemplate "Lot's Woman" as an alternate English title.)

Lots Frau, then, resists the hegemony of Luther's translation at the same time that it resists the pejorative connotations of "Weib" in contemporary German, along with that word's archaic sound. Kiefer's translation also, one can say, resists Luther, whose exegesis of Genesis 19:26 begins by attacking the "absurdities" of Jewish interpretations.[48] The Nazis embraced Luther as their own. But this is not to say that Kiefer's translation—which is also, and not incidentally, that of the current Catholic Bible—can simply choose another word and so escape the histories of the subservience of the church to the Nazi regime. In a way analogous to the shreds of a second order of perspective beneath the one that dominates the painting, Luther's "Lots Weib" shadows "Lots Frau." The title, then, is part of a group of signs, including the coil and the faint line, which help to locate—or to dislocate—the spectator. The difficulty of translating the phrase "Lots Frau" partly figures the dilemma of becoming Lot's wife, of occupying the place of the destroyed spectator.

handwriting

Another peculiarity of the name will escape the spectator who does not know German, although it does not take much German to catch it: Kiefer has drawn a line over the "u" in "Frau." The standard spelling has no accent, and the most plausible explanation for Kiefer's line is that it mimics a feature of German handwriting, where some put a line over "u" in order to differentiate the letter's shape from that of the similar "n."[49] This line, then, insists on the status of the words "Lots Frau" *as* handwriting. Although expanded beyond the scale of everyday handwriting, Kiefer's writerly marks, while tied to the games with words and image in the works of artists such as Ed Ruscha and Lawrence Weiner, have more in common with the blackboard than with the stylish but anonymous fonts preferred by Kiefer's American contemporaries. An air of a certain deliberate and literal-minded educational project—of what Patricia Crain has called "alphabetization," but an alphabetization through painting—lingers around them.[50] In works where much seems haphazard, the careful letters belong to a different order, as if Kiefer were assuring the spectator, half-pedantically, half-jokingly, that a certain level of legibility must remain intact.

Kiefer's handwriting is the exemplary instance of a whole set of marks that pulls *Lots Wife* away from the order of the sublime, away from the seduction and destruction of the spectator I have examined. This handwriting stands, then, as a literalization of discussions of the painter's hand that circulate around the examination of distinctive marks, a tradition that T. J. Clark has discussed, a propos Jackson Pollock, under what will now seem to be the redundant sign of "handwriting." Clark holds on to the language of oneness and totality that has marked the reception of Pollock; he also insists, however, that the spectator pay attention to those "figures of dissonance" that disrupt this all-over appeal:

> I mean by this simply those aspects of the drip paintings that do not partake of the One-ness Pollock clearly was trying for, and that usher back the temporality he . . . thought had disappeared: the quality of "handwriting" to the pictures, and of handwriting often become wild crossing-out: the figures of obstruction, undergrowth, uncertainty, randomness, of a kind of peremptory violence done (still) with sticks and dried brushes.[51]

Kiefer's use of handwriting declares itself as such, and so points to a division central to *Lot's Wife* and to Kiefer's work as a whole. With "handwriting," Clark produces a metaphor for the production of metaphor: "In order to represent at all, as I see it, marks in pictures have to be understood as standing for something besides themselves: they have to be construed metaphorically"

just b/c they destabilize = does it mean they (signs) destroy?

(336). I have been arguing throughout this chapter not only that the marks in Kiefer's paintings are legible, but also that these marks—those things out of perspective—pull against the influence of perspective.

The marks in *Lot's Wife* pull against the work's perspectival design, but this formal clash of decentered marks and perspective becomes legible here in a particular way. Perspectival allure is automatic; it captures the spectator, places the spectator, whatever the spectator's intentions. "Handwriting," here, ushers back not only temporality, but also a particular and vexed historicity: from the start, it asks the spectator to read. *Lots Frau* is at once a culmination of the fantasy of the destruction of the subject that surrounds the figure of Lot's wife, and a visual critique of that fantasy. Its perspectival drive signifies the power of historical memory and the danger of the spectator's destruction in the necessary masochism of historical retrospection.

?

COMMANDMENTS

I have so far neglected one formal element of *Lots Frau*: the horizontal band through the center of the painting, below the divide between the two panels.[52] Very distinct to the far left, this band becomes less and less defined as it passes to the right, and does not reach the far right, where it is broken off by the appearance of the lead backing. Like other elements I have focused on, this band disturbs the perspectival order. It makes indistinct the division between "land" and "sky," seeming at once to expand and to annihilate the horizon line. This exaggerated "horizon" draws attention to the work's frustration of the seemingly teleological movement of the receding train tracks: the spectator cannot see where the tracks are taking us. This frustration embodies a constant problem of historical representation: history's recalcitrance in the face of our wish to *see* it.[53] Like Benjamin's angel contemplating rubble, we see less than we hope.

frustration of teleological movement of perspective

This impossibility is at once a condition of perspective—the horizon line always marks a limit of visibility—and a complex response to the so-called *Bilderverbot* that forbids images of the Holocaust: *this* obscure horizon marks the divide between the iconic tracks, signs of a movement toward death camps, and the camps themselves.[54] This ban on images is not only a result of our lack of access to images of the death camps, but also poses an ethical problem. This ethical position rests on something like the second commandment's ban on graven images: were we granted such access, we should refuse it.[55] This position resonates with the dynamic behind the representation of the destruction of Sodom and Gomorrah that I have been charting throughout this study: to represent the burning cities is to show the destruction that

(taboo)

horizon line: marks ff visibility
⟹ iconic tracks || camps

Lot and his family should not see. And, to recall Sebald, this limit on vision
is not only a matter of respect for the dead, but also of the sanity of the living.

Miriam Bratu Hansen describes this "quasi-theological invocation of the
second commandment" in discussions of the Holocaust, and argues that it is
linked at once to the assertion of the Holocaust's singularity and modernist
arguments about "the type of aesthetic practice that alone is thought to be
capable of engaging the problematic of representation without disfiguring the
memory of the dead."[56] The story of Sodom and Gomorrah and Lot's wife
points to some of the strangeness of this "quasi-theological" linkage. There
are two bans here: the angels' order not to look back in Genesis and the divine
ban, in Exodus, on graven images and likenesses in the second command-
ment. Kiefer superimposes one of these biblical moments of the *Bilderverbot*
upon the other: Lot's wife becomes the original transgressor of the latter
commandment.

There is something scandalous in this palimpsest of commandments, and
also something wishful—that is, something that responds to a wish. The scan-
dal follows from Kiefer's superimposition of a commandment against repre-
sentation, against likeness, against mimesis, over a commandment not to look
at the destruction of the cities: The spectator must not look back at what she
must contemplate. The context of the Holocaust at once brings the com-
mandments closer, and wrenches them apart. Lot's wife is the original witness
of a great massacre, but only a wholly secular and resistant reading of the
Bible can rescue her as a figure analogous to the "witness" to the Holocaust.[57]
In both Genesis and Exodus, the theological register defines the power of the
commandment: the *Bilderverbot* is divine and absolute. The same theological
register, however, offers a figural parallel—the dead of Sodom, victims of
whatever divine project of destruction; the dead of Europe's death camps,
victims of Germany's genocidal program—that only the most extreme theod-
icy could justify.

Lots Frau engages a modernist fantasy that the artwork might give the
Bilderverbot new life—or, to put it otherwise, that modernity might continue
the underground life of images so powerful that they have transitive, and in
this case, destructive, powers. On the one hand, as Hansen suggests, this in-
volves a modernist revival of certain rules governing the ethical limits of rep-
resentation; in Adorno's sense, art's negative force comes in part through its
recognition of these limits.[58] But, on the other hand, another modernist strain
is also crucial here. If a certain austere modernism requires the establishment
or maintenance of such limits, at once aesthetic and ethical, Kiefer also in-
vokes the fantasy—as I have argued, a recurring one—of an artwork that

might destroy its audience: spectators are Lot's wives. Recognition of the *Bild-erverbot* produces an abstraction in response to the impossibility of representing the extent of modern suffering, but even such a modernization or secularization of the *Bilderverbot* feeds a strain in modernism that imagines that its power might destroy the spectator—that the artwork, that is, might take on the status of the event that cannot be seen, or that can be seen only at risk of destruction. The argument that links abstraction to an ethical or quasi-sacral practice of constructing taboos around what can be seen might rest as much on fear of the power of the image as on concerns about their necessary shortcomings as representations. Rebecca Comay has observed the extent to which the second commandment exemplifies the law's paradoxical production of the transgression it would seem to outlaw: "the law's very inability to authorize itself may testify equally to an even deeper, if perhaps ultimately inscrutable, prohibition—but perhaps equally to the claim of an unspeakable desire."[59] To ban the graven image testifies to the desire for such images, but to what does that desire testify? To forbid the look backward upon the burning cities testifies to the desire to witness destruction, and perhaps also to the desire for self-destruction that might accompany that look. Comay's suggestive reading of the *Bilderverbot* inspires a reverse—and, it may also be, a *perverse*—genealogy: it is precisely the desire for the destruction of the self in retrospection, in looking back on catastrophe, that generates a prohibition. Virtually every reading of revisions of Lot's wife assumes some desire at work, usually some desire too close to that of the imagined desires of the dead of Sodom. To make Lot's wife a figure for modern dilemmas of spectatorship is to ask what desires cause the spectator to look back at what she should not. But this "should," too, still rests on some not-quite-secularized retelling: do not look back. If this is masochism, what sadist enforces the commandment, threatens punishment? By embodying a myth of the power of images, the figure of Lot's wife might defamiliarize that myth, allowing us to see the continuing modernist fascination with this power.

The obverse of the modern *Bilderverbot* is the archive of images cataloguing the destruction that cannot be witnessed: what is lacking?[60] Two contrary arguments collide: on the one hand, the *Bilderverbot* forbids looking at images of the genocide—do not look at the women about to be gassed in the shower. On the other hand, we are told no real image of genocide does exist, could exist, or should exist—there is no film of women about to be gassed, and were there such a film, we should destroy it. But how to destroy the film before looking at it, before the damage has been done? As the story of the golden calf suggests, the second commandment and its variants always arrive too late: the crowd surrounds the idol, someone has already looked back. Comay

stresses that the moment of the commandment and of its undoing are coter-
minous. The simultaneities of the visual field—in painting after painting,
Sodom burns, Lot's wife looks back while Lot's daughters seduce their
father—reproduce the logic of commandment and transgression. The logic
and temporality of the modern *Bilderverbot* is to this extent similar: the ethical
pronouncement—do not look back—assumes that the one who commands
knows what there is to be seen, has looked already, and presumes to protect
others, those less capable of bearing the damage, from a sight that the one
who commands can bear. The double movement of Kiefer's *Lots Frau*, then,
at once rehearses and undoes this *Bilderverbot*. The placement of the spectator
as Lot's wife puts the spectator in the position of the figure who must trans-
gress and look back at disaster: a certain willingness to do oneself damage, if
not masochism, becomes the task of the spectator. And yet the painting also
recapitulates the prohibition: there is a line past which one cannot see.

This combination of turning back, historical memory, and the *Bilderverbot*
will recall, for many readers, Walter Benjamin's perhaps overfamiliar figure
of the angel of history, whose face is "turned toward the past" and who sees
history as "one single catastrophe which keeps piling wreckage upon wreckage
and hurls it in front of his feet."[61] Condemned to contemplate historical
wreckage, Benjamin's angel has no choice but to obey the quasi-materialist
prohibition against contemplation of the future. As if to disrupt the familiar-
ity of this angel, Kiefer sculpted this figure for historical knowledge as a fossil
B-52 of lead, glass, and dried poppies (fig. 22). Its wings overloaded with
Kiefer's scrambled, illegible books, its fuselages sprouting dead poppies, its
tail ripping at its seam, this angel, as they say, is going nowhere fast.

Nowhere is Kiefer's engagement with air war and bombing more visible
than in his series of lead airplanes.[62] His *Angel of History* is radically different
from the image that provoked Benjamin's thesis, Paul Klee's painting *Angelus
Novus*.[63] This refunctioning of the angel as jet conforms to Kiefer's strategy
by which the perspective on catastrophe is aligned with the agent of damage:
the spectator occupies the place of Lillith. The sculpture affiliates a figure
for the tragic accumulation of historical knowledge to the sight of mounting
catastrophe with the shape of a jet that, since the 1950s, has stood ready to
deliver the end of the world. (Is this the Strangelove of Martha Ivers?) And yet
in the movement from painting to sculpture Kiefer gives up the perspectival
placement of the spectator.

There are many ways to read this movement from Klee's image of the
gesturing angel to Kiefer's lead jet. Especially significant here is Kiefer's em-
phasis on two problems in reading the figure of the angel: whether the histo-
rian is to identify with the angel, and how to understand the association of

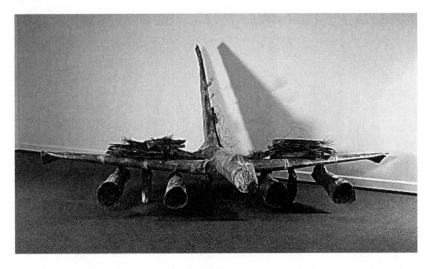

FIGURE 22 Anselm Kiefer (b. 1945), *The Angel of History*, 1989. Lead, glass, and poppies, 157¹/₂ × 197 × 78³/₄ cm. Eugene L. and Marie-Louise Garbaty Fund, Image © 2006 Board of Trustees, National Gallery of Art, Washington.

the angel with destruction. Is the angel a figure for how Benjamin imagined historical work, or should the historian take distance from the angel? And is the angel the chronicler of wreckage, or its agent?[64] In his short text, "The Luckless Angel," Heiner Müller retells Benjamin's myth for and about historians in ways that pick up these questions and recall Kiefer's painting:

> The past surges behind him, pouring rubble on wings and shoulders thundering like buried drums, while in front of him the future collects, crushes his eyes [*Augen*], explodes his eyeballs like a star wrenching the word into a resounding gag, strangling him with its breath [*Atem*]. For a time one still sees the beating of his wings, hears the crash of stones, falling before, above, behind him, growing louder with each furious futile struggle, weakening, lessening, as the struggle subsides. Then the moment [*Augenblick*] closes over him. The luckless angel is silent, resting in the rapidly flooded space, waiting for history in the petrifaction of flight, glance, breath [*wartend auf Geschichte in der Versteinerung von Flug Blick Atem*]. Until the renewed rush of powerful wings swelling in waves through the stone signals his flight.[65]

"That one should make no image, which means no image *of* anything whatsoever, expresses at the same time that it is impossible to make such an image," writes Adorno.[66] Müller's elaboration of the angel of history does not depict such an impossibility as a conceptual matter; it is not a problem of finding

the mimetic equivalent for a taboo subject, as though the future (or the divine) protects itself against misleading misrepresentation (golden calf instead of the real thing). The interdiction, instead, announces danger: the future violently blinds the angel, and the action of this blinding, a local apocalypse of the eyes, becomes the image of the power of the *Bilderverbot*.

Kiefer's *Angel of History* follows some of the cues of Müller's angel more closely than it does that of Benjamin: the books awkwardly balanced on the jet's wings, for instance, recall Müller's rubble dumped on the angel's wings and shoulders. Surely Kiefer's grounded behemoth recalls Müller's "petrifaction of flight glance breath." My inclusion of phrases from the German original emphasizes how this short text associates qualities, summarized in the paratactic phrase without punctuation, at once with the force of past and future and with the angel: the future has a breath, and the angel's breath comes to a standstill; the future destroys the eyes of the angel, and yet there is another eye. It is the force of a moment, the blink of an eye—literally, the glance of an eye (an *Augenblick*)—that brings the angel to its standstill.

Without direct allusion, this story nevertheless recalls the destruction of Lot's wife, with the difference that the future destroys vision and petrifies sight. There is another major difference as well: an anonymous witness, a pronoun really, watches the transformation of the luckless angel: "For a time one still sees the beating of his wings [*Eine Zeit lang sieht man noch seine Flügelschlagen*]." The spectator is separate from the angel. The last and most striking difference is that Müller's text leaves open the possibility that the angel may be reanimated. It is as though the logic of looking and destruction behind the *Bilderverbot*—that logic for which Lot's wife is so striking an image—might be undone. This angel waits for history.

This waiting implies that the tragic history of Benjamin's thesis might have an antidote in another history that returns the powers of flight, sight, and breath to the angel. Only negatively does such a possibility exist in Benjamin's text. As with utopian moments elsewhere in the work of the Frankfurt School, Müller's text rests on a hope for an end to prehistory, the history of class violence, domination, and oppression that is what history has simply been. Müller's revision of Benjamin also illuminates Kiefer's *Lots Frau*: the possibility of the reanimation of the damaged or petrified spectator also informs his painting. To recall Danto's complaints, the grandiose theatricality of Kiefer does carry on the modernist dream—an all-too-German dream?—of inviting the spectator into a place of contemplation that will then be destroyed. But finally the dialectic of spectatorship at work in such a painting concedes that the destructive power it might desire—the power to show the spectator what

will destroy her—does not belong to the painting. The force of the perspecti-val design places the spectator in the position of Lot's wife; the horizon line conceals the petrifying sight.

 Lots Frau rests on a masochistic contract: to turn toward the painting is to undertake to view what may damage the spectator. From this point of view, the painting promises to transgress the *Bilderverbot*, to show what cannot or should not be shown and so to make the spectator the Lot's wife of the title. And perhaps there is some truth to this: after some contemplation, one emerges a little destroyed. Lot's wife, in this way, becomes a figure for the necessity of risking damage to the self that retrospection and historical think-ing may require. And yet the surfaces of Kiefer's painting, as I have been arguing throughout this chapter, consistently work against the logic of the overpowering perspectival composition. *Lots Frau* is as much a painting *about* the fantasy of the petrifaction of the spectator as it is an instance of the desire to achieve this petrifaction. It offers the spectator distance on the fantasy of the destruction of the spectator that informs a powerful undercurrent of modernist art.

Lot's Wife on September 11, 2001; or, Against Figuration

and the side streets of Manhattan are sown with salt. . .

—Derek Walcott, "North and South"

Figural interpretation implies the interpretation of one worldly event through another; the first signifies the second, the second fulfills the first. Both remain historical events; yet both, looked at in this way, have something provisional and incomplete about them; they point to one another and both point to something in the future, something still to come, which will be the actual, real, and definitive event.

—Erich Auerbach, "Figura"

I.

On the morning of September 11, 2001, one of tens of thousands, from the corner of Bleecker Street and LaGuardia Place in Greenwich Village, I watched the towers burn, saw falling windows and small forms that even from that distance were unmistakably falling bodies, and saw the first of the two towers fall. I thought about many things as I compulsively watched. I thought, among other things, about Lot's wife.

In the afternoon of September 11, I was in line at a supermarket at the same corner. The line was long—people were hoarding—and I fell into conversation with the woman in front of me, a nurse just off her night shift. A woman standing in front of us with a boy heard us speaking. She told us she

had been inside one of the towers. She worked for Lehman Brothers on the thirty-fourth floor. The evacuation was orderly, she said, and things were surprisingly calm until people reached the lobby, when suddenly the extent of the chaos was visible. Someone leading her away from the building told her not to look behind her. There, in line in the supermarket, she said: "My first instinct was to look back." I borrowed a pen and wrote these words, as though I might forget them, on the back of a train ticket I had in my wallet. She said little about what she saw.

II.

Lot's wife is a grave from the moment she turns. Surely someone somewhere has remarked that this thing she becomes recalls the standing stones placed as memorials across the ancient Near East.[1] Scholars contend that these stones in various shapes—sometimes plain, sometimes inscribed—are an early ex- ample of Near Eastern aniconism: that is, of religious practices not based on anthropomorphic or mimetic images. Particularly resonant is one description of the orientation of many of these stones: they face "the rising sun, which is believed to radiate life, fertility, and strength."[2] Lot's wife appears a kind of negative imitation of these stones: transformed by the sight of the destruction of cities, changed from flesh to salt, a substance associated with the destruc- tion of fertility, she also unsettles the aniconic tradition.[3] Kiefer's painting without a figure recalls the enigmatic place of the figure in this transformation from the start: does this "pillar" represent a person? Does the translation of the human into a pillar without features reflect the impulse that led to the second commandment? (The French Bible simply translates the Hebrew word as "statue.") Or should one read the story as a fable about the radical reversal of anthropomorphization, the undoing of any human resemblance? The con- tinuing habit of pointing at this or another rock as Lot's wife suggests that despite any erasure of the human, this thing that is not a graven image cannot *not* become human again. To identify a rock as Lot's wife is to undo the force of the abstraction that has produced Lot's wife.

Lot's wife could be the focus of a history of Western iconoclasm. This is not such a history. But to recall the iconoclastic context of the story of Lot's wife suggests both a way to rethink its biblical context and the modern uses of it I have been tracing in this study. Artaud, the producers of film noir, and Kiefer all belong to a culture overwhelmingly saturated by the image. Indeed, this saturation of culture by images partly explains the continuing allure of the story of Lot's wife: a story about a destructive visual experience of the

destruction of cities resonates when most images, even images of intense suf-
fering, have lost some of their power. There is precisely no actual compulsion
to respond to any given image in any particular way. As Thomas Keenan
writes, "The responsibility of the viewer is coextensive with the lack of self-
evidence of the image: it dictates nothing, compels nothing."[4] That the Gene-
sis story about the power of images was always a myth should not disguise
the very different historical conditions that generate cultures of iconoclasm
and iconic extravagance. But to represent the story reveals faultlines in varying
strategies of representation. On the one hand, to represent the burning cities
was always the most obvious kind of disobedience, a transgression of the
commandment not to look back. On the other, one might say that such visual
representations were saved from the stigma of disobedience because they
knew they could not play—or could *only* play—at being a likeness; the artist
knew that such a work could not be a likeness, that there can be no question
of likeness because the image lacks the force of the event. Such a representa- *of great*
tion must, then, to some extent always be antimimetic. And yet that disavowal *destruction*
of mimesis may also suggest a desire for the overwhelming force an image
cannot duplicate.

At the very least, the return to the story of Lot's wife and the linking of the
second commandment to abstraction discussed in the previous chapter sug-
gest a desire for control over the production of images in a culture that manu-
factures them constantly. This desire for control is especially notable in times
of crisis when, in only partly predictable ways, new and various constraints
on the production and, more important, the circulation of images arise. The
virtual elimination of images of the dying on September 11, 2001, from the
press in the United States is a remarkable example of such constraints. These
constraints do not follow in some seamless way from the restrictions of the
second commandment; the story of Lot does, however, resonate with that
mixture of constraint and desire that surrounded those events. If spectators
are in danger of petrifaction at the sight of disaster, then cultures continue to
require restraints and ways to forbid looking back. But this requirement also
points to a certain identification, even a will to identify. Were there no com-
pulsion to put ourselves in the place of the dead, we would not shield our-
selves from them. Images of falling bodies vanish; stuffed animals become
the friendly surrogates of the "missing"; the mayor announces that because
rainstorms have destroyed popular memorials, he has ordered them swept
away by the Department of Sanitation; archivists scramble to save what they
can. It's time to get back to work.

As a contrast to that moment, no longer present and yet not yet past, I
follow my examples in turning to an example from an historical moment that

was officially iconoclastic. In a paradoxical monologue from the grave, a poem
in Thomas Jordan's *Piety, and Poesy* (1643) captures the monumental quality
of Lot's wife; it speaks to what was and what was not allowed in representa-
tions of September 11, 2001. An introductory section establishes the poem's
context, and the words of Lot's wife follow:

> But *God* whose *Mercy* would not let his *Ire*
> Punish thy *Crime*, as it did theirs, in fire;
> With his divine Compunction did consent
> At once to give thee *Death* and *Monument*:
> Where I perceive engraved on thy stone
> Are *lines* that tend to Exhortation:
> Which that by thy Offence, I may take heed,
> I shall (with sacred application) Read.

The Inscription.

> In this Pillar do I lie
> Buried, where no mortal Eye
> Ever could my Bones descry.
>
> When I saw great *Sodom* burn
> To this *Pillar* I did turn,
> Where my *Body* is my *Urn*.[5]

Jordan's poem is, first, a solution to the problem of Lot's wife as an image,
and this solution is peculiar to Reformation Europe. This God produces im-
ages like those the iconoclastic Reformers allowed: the monument must be
"engraved," must be made to speak, just as the paintings of the period were
marked by an abundance of written text, just as the walls of churches, once
remarkable for their images, were sometimes decorated with painted words.
Jordan's effacement of the body of Lot's wife recalls the effacement of features
of the sculptures in English churches, and the "Inscription" recalls the ways
in which the proper post-Reformation images were, to use Luther's phrase for
the sacraments, "visible words." As Joseph Koerner writes, "To Protestants,
this triumph of the verbal over the visual is a proper reformation of the
image."[6] Jordan ingeniously reads the transformation of Lot's wife as a merci-
ful punishment and the result of God's "Compunction." Rather than perish-
ing, like the Sodomites, by fire, Lot's wife receives a gift, simultaneous with
her conversion into a monument. This conversion is also a conversion into
language. Indeed, Jordan construes God's gift of legibility to Lot's wife as part

of God's mercy. How odd, one might have said, and one might still say, that in the Hebrew Bible her death is so tantalizing as to say almost nothing.

In saying nothing plainly the figure allows many to say much. Jordan's poem is particularly eloquent about the logic of incorporation that haunts the figure, a logic that the "Inscription" does not simply explain. Rendered most tellingly—or perhaps only most literal-mindedly—by the sequence in *Lot in Sodom* where the bodies of the dead of Sodom enter Lot's wife and she becomes their memorial in the process, many portray Lot's wife as the scene of phantasmatic incorporations. Jordan's poem accentuates these problems of incorporation through its canny uncertainty about how to imagine her interior: could some immortal eye see her bones? Are there any bones, or is her body an urn holding only ashes? This poem asks again what it is that Lot's wife becomes: she is body, urn, and pillar all at once. Jordan encourages the reader to see the transformation of Lot's wife as a kind of divine work of sculpture, or, instead—in jumping over resemblance into fragmentary architecture (Lot's wife as pillar)—as a negation of the mimetic work of sculpture. How Jordan imagines the appearance of the "pillar" is unclear not because the poem is a failed exercise in ekphrasis but precisely because language should replace image. In the transformation of Lot's wife into monument, readers should scan not only the meaning of Lot's wife's death, but also that of their own. As monument to herself, as monument to the death of that crowd of others of which she is the sole witness, Lot's wife recalls the connection between death and sculpture that Kenneth Gross has emphasized. "We are not just buried in our statues," Gross writes, "our statues are buried in us."[7] Like the story of Lot's wife, sculpture tends to attach itself to precisely those events that resist incorporation.

III.

To turn back from the early modern to the postmodern, then, a corollary to this early modern lesson in the resistance to incorporation is that people readily embrace works that ease the difficulties of incorporation. Such a corollary is especially legible in the recent history of a sculpture in lower Manhattan. The sculpture, J. Seward Johnson's *Double Check*, became famous in photographs after September 11, 2001: the bronze of a man scrutinizing his briefcase survived the rain of debris from the falling towers in Liberty Plaza, a square very near the site of the former World Trade Center. The sculptor's words capture some of the desires this sculpture evokes: "He is a survivor, and he is sort of, as a humanesque figure, an embodiment of those who didn't survive."[8] That awkward "humanesque" perfectly embodies the impossible work

this sculpture has been called to do, its mediation between the living and the dead. On the one hand, as Johnson stresses, the sculpture is like us: "He's a survivor. We all have the dust from 9/11 on us, and he personifies that feeling."[9] On the other hand, the power of the sculpture is supposed to lie in its embodiment of those others who cannot witness the sculpture's stubborn survival, those who died in the attacks. As an "unidentified male" volunteer at what would become known as "Ground Zero" told a reporter: "he represented the body of all the people who didn't have bodies."[10] The sculpture was always an icon to the idea of the aesthetic as a useful break from the world of work: the "double check" of the title referred both to the spectator's second glance to verify that this realist thing is indeed a sculpture and to the figure's perusal of his briefcase for that petrified document or calculator necessary to his work. A sly logic assured that those taking time to look at the sculpture would see a figure who was eternally never wasting a minute while in that space of freedom designed to provide a respite from work, Liberty Plaza.[11]

After September 11, *Double Check* was perceived as a memorial to those who died. In this, it was not so different from a great number of other sites, "humanesque" and otherwise, especially at Union Square and south of Fourteenth Street. Steadily garlanded with objects, it became, as a local reporter insisted, an "icon." The statue has returned, though it has been altered; the artist, Ronald Drenger reported in 2005, "plans to clean the sculpture and cover it with a grayish patina, to make it look as it did immediately after the terrorist attack."[12] But to what might this sculpture now be an icon? Before September 11, writes Drenger, *Double Check* "symbolized the mundane, the routine—the Everyman going about his business, easily lost among crowds of people much like him."[13] The addition of the "grayish patina" is no radical change, and, if anything, causes the sculpture more closely to resemble those of George Segal, the sculptor to whom Seward appears most indebted. A sculpture that suggested the ways moments of liberty are haunted by the specter of work has become something different: a memorial to those who died while going about their business.

Gross's insistence on sculpture's enactment of the vicissitudes of incorporation may explain why this return of *Double Check*—albeit with the patina of simulated dust—has escaped the controversy that has surrounded virtually every other sculptural project designed to memorialize the attacks.[14] If *Double Check* embodies the dead, it embodies them as though unchanged: the sculpture inspires visions of not-so-Elysian fields where the shades of the dead continue to go through the files they take with them. And this figure, as an object of identification and incorporation, erases the differences of gender,

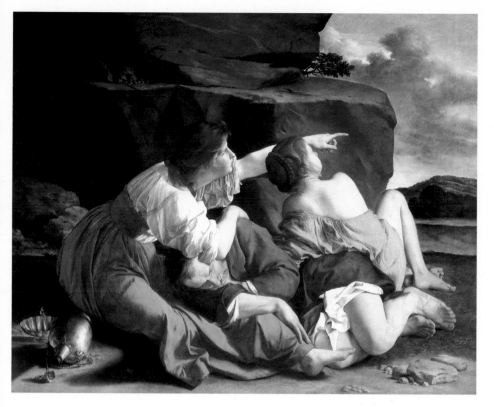

PLATE 1 The J. Paul Getty Museum Los Angeles, Orazio Gentileschi, *Lot and His Daughters* about 1622, oil on canvas 151.8 × 189.2 cm.

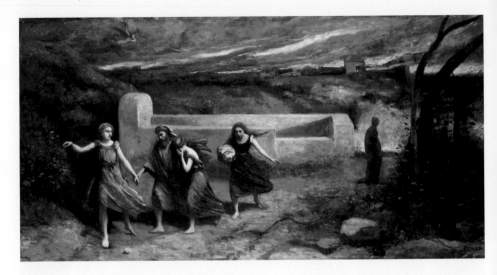

PLATE 2 Jean-Baptiste-Camille Corot (1796–1875), *The Destruction of Sodom*, 1843. Oil on canvas, 92.4 × 181.3 cm. H. O. Havemeyer Collection, Bequest of Mrs. H. O. Havemeyer, 1929, 29.100.18. Image copyright © The Metropolitan Museum of Art/Art Resource, NY.

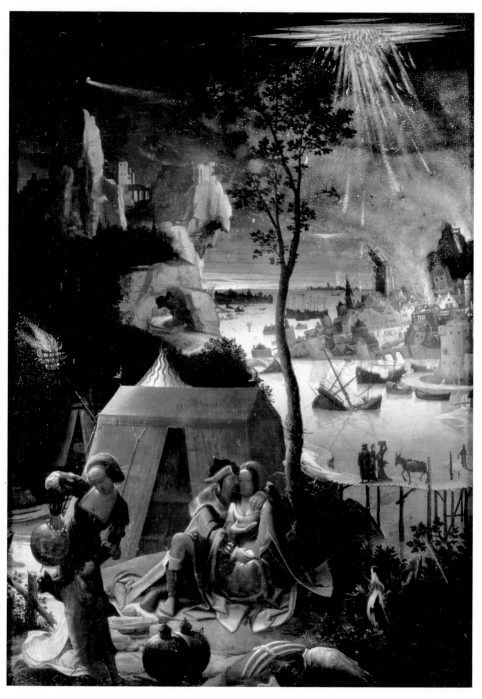

PLATE 3 Lucas van Leyden (1494–1538) (attributed to), *Lot and His Daughters*. Louvre, Paris, France. Photo Credit: Scala/Art Resource, NY.

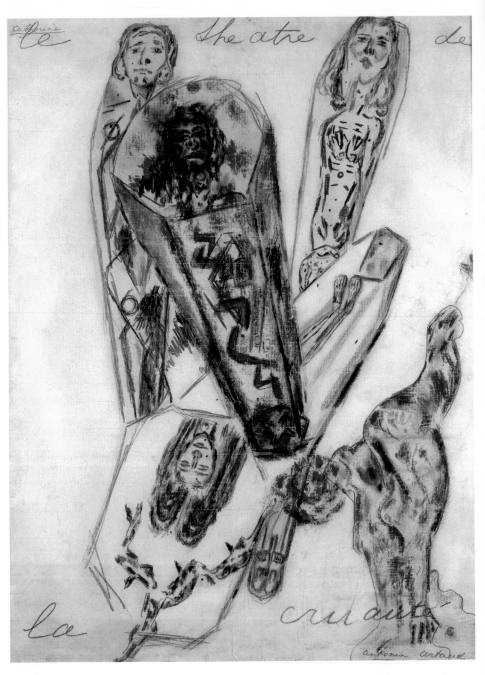

PLATE 4 Antonin Artaud (1896–1948), *Le théâtre de la cruauté* (*The Theatre of Cruelty*), c. March 1946. Graphite and wax crayon, 62 × 46 cm. Musée d'Art Moderne, Centre Georges Pompidou, Paris, France. Photo: Philippe Migeat. Photo Credit: CNAC/MNAM/Dist. Réunion des Musées Nationaux/Art Resource, NY © Artists Rights Society (ARS), New York/ADAGP, Paris.

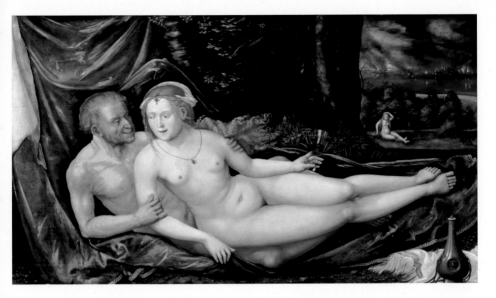

PLATE 5 Albrecht Altdorfer (1480–1538), *Lot and His Daughters*. Kunsthistorisches Museum, Vienna, Austria. Photo: Nimatallah/Art Resource, NY.

PLATE 6 Anselm Kiefer (b. 1945). *Lilith*, 1987–9. Oil, ash and copper wire on canvas, 380 × 560 cm. Tate Modern, London. © Tate, London, 2007.

PLATE 7 Anselm Kiefer (b. 1945), *Lot's Wife*, 1989. Mixed media; 350 × 410 cm. Image © The Cleveland Museum of Art, Leonard C. Hanna Jr., Fund 1990.8.

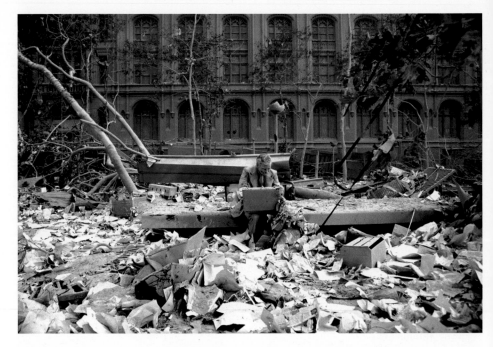

PLATE 8 *New York City/September 11, 2001: Sculpture in Park Near World Trade Center (Seward Johnson's* Double Check). Photo by Susan Meiselas/Magnum Photos.

profession, class, race, and posthumous income that separate the dead in their afterlives as they divided them while they lived. The difficulty of incorporating the dead does not arise; they are, so to speak, always already incorporated. If we could read the memo the figure consults, we would find that we know already what it says.

And yet *Double Check*—especially as captured in photographs—has gained an undeniable power. In Susan Meiselas's photograph taken in the afternoon of September 11 (plate 8), which is for me the iconic image of this "icon," *Double Check* is at the apex of a triangle formed by the blown-back plane trees to the left and the long scraps of metal or plastic hanging from branches to the right. The man rummaging through his briefcase, that is, seems an alternative epicenter to another explosion, as though a blast had radiated outwards from the spot where he sits—as though he were like Gabrielle, in *Kiss Me Deadly*, having opened the "great whatsit," from which an epochal explosion erupts. Meanwhile, the evidence of that other epicenter is everywhere. The blast, to the northwest of the petrified businessman, who faced north, crushed paper against his left side; in the foreground, a few pages with photo portraits, as if foreshadowing the "missing" posters that soon seemed to hang on every wall, are strewn about. Everyone will recall the paper that cascaded like a sick parody of victory confetti over lower Manhattan. And many will remember, too, that paper *was* at the center of the collapse of the towers and provided crucial fuel for the fires. "It would be simplifying things, but not by much," writes William Langewiesche, "to conclude that it was paperwork that brought the South Tower down."[15]

My reception of the photographs of *Double Check* after the attacks was always marked by my seeing it, as I had to see it, as a kind of mock Lot's wife. The sculpture's swerving from the modern fantasy that the spectator might be changed utterly by the sight of disaster seems to me in some ways a good thing; there are good reasons to abandon this myth. And yet the sculpture's preservation of a reassuring image of the everyday strikes me as an evasion of the masochism that looking back continues to require.

IV.

Many critics have been alert to the ways that American culture was prepared for events of September 11, 2001. The imagination of disaster that has for so long been a Hollywood staple; the constant stress on immediate threats to middle-class safety on the evening news; the preparation for a return to a Cold War economy that was always promised by the election of George W. Bush, and that now has its justification in that oxymoronic adventure, the

war on terrorism: these forces, and others, prepared us for the attacks. Mike Davis has been one of the more intriguing analysts of these forms of anticipation and cultural imagination. The archaeologist of fantasies of the apocalyptic destruction of Los Angeles turns his attention to September 11, 2001, by exhuming a history of anticipations of the events of that day, beginning with the particularly telling examples of H. G. Wells and Federico García Lorca. Symptomatically, Davis then turns to the more distant German expressionists of the period immediately preceding World War I. These expressionists, Davis writes, "were ablaze with clairvoyant images of murder victims, tumbling tenements, exploding cities and flying bodies." Davis quotes the painter and poet Ludwig Meidner writing in 1913: "My brain bled dreadful visions. I could see nothing but a thousand skeletons jigging in a row. Many graves and burned cities writhed across the plains."[16] The jigging skeletons are figures in the tradition of the Dance of Death, or *Totentanz*, and those "burned cities" writhing across the plains bring the reader to Sodom and Gomorrah. Why has Davis, of all unlikely suspects, invited us to read the destruction of the World Trade Center as having been prefigured by a vision inspired by the Bible?

We do not, to paraphrase Marx, make our visions of disaster as we please. As Davis knows, such vivid "clairvoyance" does not come from nowhere. Indeed, this passage from Meidner suggests why we should be suspicious of regarding such talk as clairvoyant at all, even should we understand that clairvoyance in the more narrow form of foreknowledge about the devastation of World War I. Davis offers this passage from Meidner not so much as an example of such clairvoyance about September 11 as one of a set of illustrations of "a permanent foreboding about urban space as potential Ground Zero."[17] In this formulation, "foreboding" becomes something much less than clairvoyance; it has moved into that category that Althusser insists has no history, ideology.

I concentrate on the example of Davis's reading of September 11 because it seems to me important to stress the difficulty in American culture of finding a language for the destruction of the World Trade Center towers that does not bear some trace of the stories of Sodom and Gomorrah. Analogous language on the right wing of American politics is all too readily at hand; the widely broadcast comments made by Jerry Falwell and Pat Robertson on September 13, 2001, were only the most visible attempt to place the attacks within the theological narrative that presents the catastrophic destruction of cities and towers as divine retribution for sin. Their text for the day was 2 Chronicles 7:14 (in the American Standard Version): "If my people, which are called by my name, shall humble themselves, and pray, and seek my face, and turn

from their wicked ways; then will I hear from heaven, and will forgive their sin, and will heal their land." The controversy inspired by Falwell's list of those who invited divine wrath—"the pagans, and the abortionists, and the feminists, and the gays and lesbians who are actively trying to make that an alternative lifestyle, the ACLU, People for the American Way, all of them who have tried to secularize America"—led to the now customary round of crafty apologies.[18] The "permanent foreboding" of the televangelists, their constant apprehension that large cities, and Sodom on the Hudson in particular, are always on a path to doom, means that the events of September 11 become, in an odd way, the fulfillment of a wish. Before September 11, 2001, such speakers had all the certainty of righteousness without the required evidence that, to use their language, God has lifted the curtain of protection from the United States; now they can feel confident of both. Figures have become facts; these facts satisfy the demands of myth.

My impatient response to this insistence on figural reading on the Right, and, to a lesser but still noteworthy extent, on the Left, is a desire to call for an end to it. The blindness that accompanies these apocalyptic figurations does damage us. To imagine the erasure of figuration as an answer to such thinking, however, is yet another unreal solution to a real problem.

V.

In one of the more haunting of the spectral moments in the writings of Adam Smith, Smith imagines that we might sympathize with the dead, and he speculates memorably on the inevitable failure and significant consequences of such sympathy:

> That our sympathy can afford them no consolation seems to be an addition to their calamity; and to think that all we can do is unavailing, and that, what alleviates all other distress, the regret, the love, and the lamentations of their friends, can yield no comfort to them, serves only to exasperate our sense of their misery. The happiness of the dead, however, most assuredly, is affected by none of these circumstances; nor is it the thought of these things which can ever disturb the profound security of their repose. The idea of that dreary and endless melancholy, which the fancy naturally ascribes to their condition, arises altogether from our joining to that change which has been produced upon them, our own consciousness of that change, from our putting ourselves in their situation, and from our lodging, if I may be allowed to say so, our own living souls in their inanimated bodies, and thence conceiving what

would be our imaginations in this case. It is from this very illusion of the imagination, that the foresight of our own dissolution is so terrible to us, and that the idea of these circumstances, which undoubtedly can give us no pain when we are dead, makes us miserable while we are alive. And from thence arises one of the most important principles in human nature, the dread of death, the great poison to the happiness, but the great restraint upon the injustice of mankind, which, while it afflicts and mortifies the individual, guards and protects the society.[19]

I would like to pair this long passage with a shorter, if also thought-provoking, one: "In perhaps its simplest formulation," writes Diana Fuss in *Identification Papers*, "identification is the detour through the other that defines a self."[20] These quotations are at once complementary and at odds. Smith's bleak picture of the lack of relation between the living and the dead maps Fuss's "detour" as a road that travels from the self all the way to the projections that self has cast onto the condition of the dead; this detour never reaches any "other" at all. Smith's description of the relation to the dead does not describe mourning so much as the illusory operation of a sympathy that must invent its object. We know that our lamentations do nothing, and that the dead are nothing like us, and that we cannot help them in any way, and yet we imagine that their existence is like ours, only marked by a much greater dreariness and an "endless melancholy." (They never stop consulting their briefcases.) That "endless melancholy" is in fact the result of a quasi-theatrical "lodging" of "our own living souls in their inanimated bodies"—we impersonate the dead, in every sense. This is something like the reverse of haunting: the living occupy the dead, and mourn themselves. Or it may be that such occupations are what mourning is.

It is the last turn in the passage from Smith that is, perhaps, the most remarkable. Having described something like the fictional status of a certain relation to the dead, he describes the real social consequences of this very fictional relation. The "dread of death"—a powerful force founded on epistemological error, on a mistaking of a fantasy of self for an other—guards and protects society. I have offered Smith's unsentimental reflections on death because we are surrounded at the moment by so much sentimentality on these questions. Catastrophic events pose peculiar problems of identification. The nation attacked, the nation mourns: what are we to do with these phrases? To think of the relation many imagine to the dead as a performance—a performance that works because the living imagine themselves playing the dead as if they were method actors "getting inside" the dead—might disrupt some of the forms of figuration that prevail at the moment. It might be that to

mourn is in fact just what a nation does, or that mourning is what *makes* a nation, as Benedict Anderson may be read to suggest.[21] But perhaps to bring Smith together with Anderson suggests one kind of imagining that makes a community, national foundation in perfect surrogation—surrogation where the replacement claims to occupy the place of the dead.[22]

It is here, I hope, that I can make sense of my own encounter with a surrogate of Lot's wife in line at a supermarket on the afternoon of September 11, 2001. In that strange moment of extraordinary panic and the absolutely ordinary, I felt I had encountered the surrogate of surrogates, the figure of my own experience and that of many other witnesses. Lot's wife's spectatorship turns her into a memorial of the destruction she witnesses; I was in a city of stunned memorials.

To tell the story in this way is to recapitulate the path of my own error. What seemed to me, on September 11, an uncanny confirmation of the structure I was inclined to use to understand my own experience of horrific spectatorship seems to me now a trace of my own frantic desire to produce meaning. Fear and panic found solace in figuration.

Nor was the idea that we had been destroyed an accurate one. I do not know if the woman whom I think of as Lot's wife was traumatized, and I make no claim to speak for her, still less for those who experienced far worse sights and sounds and smells. And I cannot speak for those who suffered far worse losses. Reading against my earlier compulsion, I now feel sure that Lot's wife is an image of what most of us, after September 11, are not. We are not dead embodiments of mourning; looking, however painful, has not destroyed us. Lot's wife works only as a reminder of the persistence of the power of a figurative reading that is only one of many ways that I fail to recognize recent history. To this extent, *Double Check* is an accurate "icon" of the double lives many lead. On the one hand, we got back to work, and erased—or tried to erase—images of the dying. (These carry on a quasi-pornographic life in the far and near electronic reaches of the "public sphere.") On the other hand, the culture implies that dwelling in trauma grants ethical authority: the families of the dead have a moral authority others do not. Any violation of the pact that decrees that we must identify with the dead—especially in the precincts of the World Trade Center site—becomes a scandal.

For many, September 11, 2001, becomes a metonymy for the demand for new models of identification, for a new ethical encounter with the other.[23] Critics have made compelling calls for forms of identification that escape the usual, those forms that tend to incorporate—and, by incorporating, to annihilate—the other. What such calls may miss is that a massive conversion of

identification, spectacular in every sense, had already altered everyday American life. The implicit context of this call for ethical identifications is a universe of forms of identification based on the incorporative annihilation they lament. Such incorporation of the dead tends to disguise forms of interpretation. One identifies with the dead; one speaks as the dead; finally—very often, with disturbing speed—one speaks *for* the dead. Now, as when Jordan spoke for Lot's wife, the dead are, it seems, consistently orthodox. Jordan's poem ends with this moment of ventriloquism:

> Councel then I give to those
> Which the path to blisse have chose,
> Turn not back, ye cannot lose.
>
> That way let your whole hearts lie,
> If ye let them backward flie
> They'll quickly grow *as hard as I*.

In Jordan's poem, the silent dead authorize a familiar ethics. Now, the silence of the dead authorizes a politics. And something like the fantasy of destructive spectatorship has become one basis for this lethal politics. The stricken living, having seen what they have seen, ventriloquize the vengeful monologue of the dead. The logic of destructive spectatorship presumes a self susceptible to instantaneous transformation by spectacle. Having witnessed mass death, the surviving Lot's wives testify through surrogation, claiming the place and the words of the dead. Now, however, the dread of death does not restrain the injustice of mankind, if it ever did.

So I must disavow my panicked identification of the woman in the supermarket with Lot's wife. She looked back; she went to buy groceries. The romance of destructive spectatorship produces an absence in the place that argument or protest should take. (It's what the dead want.) Do not look back means: Do not question the authority behind the destruction of cities you continue to witness.

PREFACE: LOOKING BACK ON LOT'S WIFE

1. Many of the details of my summary are open to challenge. Take, for instance, the claim that the men of Sodom plan to rape the disguised angels: John Boswell casts doubt on this translation, insisting that the men of Sodom simply want to know the angels, and that "the Hebrew word 'to know' . . . is very rarely used in a sexual sense in the Bible (despite popular opinion to the contrary)" (*Christianity, Social Tolerance, and Homosexuality*, 94). Meanwhile, the New English Bible translates the relevant passage as follows: "They called out to Lot and asked him where the men were who had entered his house that night. 'Bring them out,' they shouted, 'so that we can have intercourse with them'" (Gen. 19:5). As this debate concerns the supposed biblical foundations for the suppression of homosexuality, it is a consequential one.

2. Though I have consulted several translations, throughout this book I quote E. A. Speiser's translation of Genesis; quotations from other books of the Bible follow *The New English Bible*. Nahum A. Sarna's *JPS Torah Commentary* translates the passage similarly, but is exceptional in suggesting in its commentary that not to look backward means simply not to linger (137–38). Here, I follow most commentators and the story's popular reception in assuming that to look backward means to look backward.

3. See, for instance, Speiser's "Comment": "But true to the unwritten code, Lot will stop at nothing in his effort to protect his guests" (Speiser, *Genesis*, 143). On the common ancient motif of "entertaining angels unawares," see also Gaster, *Myth, Legend, and Custom in the Old Testament*, 156–57.

4. I suspect not. It would, however, be worth investigating parallels between classical metamorphoses and the story of Lot's wife. Immediately after Orpheus's backward glance kills Eurydice, for instance, Ovid compares Orpheus to a man who has become a statue: "The double death / Stunned Orpheus, like the man who turned to stone / At sight of Cerberus . . ." (*Metamorphoses*, 10.236).

5. Robert Alter develops this link between the story of Noah and that of Lot, and anticipates other aspects of my reading of the story, in his "Sodom as Nexus," 35. The

story of Lot's wife also resonates with the devastating story of the Levite's concubine in Judges 19 and 20, which includes a brutal parallel to Lot's offering of his daughters. For a reading of Judges, see Mieke Bal, "The Rape of Narrative and the Narrative of Rape." For a suggestive reading of a set of "allegories of resistance to the divine intention of sexuality in the service of lawful succession" in Genesis (206), see Leo Bersani's epilogue to *The Culture of Redemption*.

6. See Speiser's note to Gen. 19.1: "It is only in the light of the *sanwerim* [the angelic flash that blinds the men of Sodom] (11), that the 'men' (5, 8, 10) are revealed as angels (15). By thus viewing the action through the eyes of the actors, the spectator also is caught up in the unfolding drama, in spite of his advance knowledge." Abraham becomes a surrogate for the "spectator" Speiser imagines viewing this "drama." On the question of sight in the story of Lot, see also Alter, "Sodom as Nexus," 34.

7. On the ancient practice of sowing vanquished cities with salt, see Stanley Gevirtz, "Jericho and Shechem."

8. Speiser, *Genesis*, 143.

INTRODUCTION

1. A. E. Housman, *More Poems*, 52.

2. For a survey of theological responses to the story of Lot in early Jewish and Christian literature, as well as a philological account of the story, see Loader, *A Tale of Two Cities*. See also Robert Polhemus, *Lot's Daughters*, chap. 3; and Joshua Kind, "The Drunken Lot in Exegetical Literature," in "The Drunken Lot and His Daughters."

3. Auerbach, *Mimesis*, 15.

4. See Speiser's comment in this context: "As they are here portrayed, Lot and his two daughters had every reason to believe that they were the last people on earth. . . . The young women were concerned with the future of the race, and they were resolute enough to adopt the only desperate measure that appeared to be available. The father, moreover, was not a conscious party to the scheme. All of this adds up to praise rather than blame" (Speiser, *Genesis*, 145). There are a few fundamental objections to this logic. If all three believed they were the last of the living, why the drunkenness? And what about the village of Zoar, which is preserved? Did it have no inhabitants? Or perhaps a racial logic is at work, and Zoar simply had no inhabitants who were eligible sex partners. One of the more intriguing answers to these questions is that of J. R. Porter, who argues that it is possible that the story dates from a period during which "intercourse between a father and daughter was not considered shameful among the Israelites or neighboring groups such as the Moabites and the Ammonites" ("The Daughters of Lot," 128); ascribing the story to sinful others would then itself be a later addition.

5. There are many images of one or another geographical oddity someone claims for the remains of Lot's wife. For a rather baroque description of these formations— "pointed out variously as this pillar or that column or that salty cervix rising from the sea banks like a tiny dome, deckle-edged and lumpy"—see Sallie Tisdale, *Lot's Wife*, 73, a book which, despite its title, has little to do with the concerns of the present one.

For the work of the reputed salt remains of Sodom in one quirky Romantic imagination, see Charles J. Rzepka, "Slavery, Sodom, and De Quincey's 'Savannah-La-Mar,'" esp. 33–34. My favorite response to this pop-archaeological search for the remains of Lot's wife remains that reported to me by Paud Roche: an American farmer, visiting Jordan and shown a geographical feature reputed to be Lot's wife, exclaimed, "That can't be her! The cows would have licked her down to nothing by now!" I wonder whether Paul Kos, the American conceptual artist, had heard a similar anecdote; in any case, his wonderful *Lot's Wife*, a pillar of salt cubes in a cow pasture (p. 21), strikes me as a beautifully comic meditation on the story. Perhaps Roche's source and Kos both knew the legend, reported in the *Jewish Encyclopedia*, that "oxen used to consume every day the pillar of salt by licking it down to the toes, but it was restored by the morning" (s.v. "Lot" in *Jewish Encyclopedia*, available online at http://www.jewishencyclopedia.com). For a more solemn survey of the archeological record of Sodom, see van Hattem, "Once Again: Sodom and Gomorrah."

6. Theodor W. Adorno, "On Lyric Poetry and Society" (1957), in *Notes to Literature*, 1:44–45. While the coincidence of the word "glitter"—the German word, which "glitter" translates well, is *Glanz*—is a trivial part of what draws me to this passage, it is worth noting that it is precisely around this word that one can spot Adorno's "false glitter." (For the German, see Adorno's *Noten zur Literatur*, 58.) Above, I quote the text of Housman's poem in the first American edition; others, including a variorum edition, give Housman's phrase as "glistering token." To my ear, "glistering," striking a falsely poetic note, is the error; to one following in Housman's footsteps as textual scholar, "glittering" is the error. That one can see the "poeticizing" moment precisely in this word provides an example of Adorno's point. See *The Poems of A. E. Housman*, 136–37, for an annotated text of the poem, and the note on the poem by the editor, Archie Burnett, 450–51. Burnett also notes Housman's pencil marks next to this passage from the Apocrypha: "Of whose wickedness even to this day the waste land that smoketh is a testimony . . . and a standing pillar of salt is a monument of an unbelieving soul" (Wisd. of Sol. 10:7).

7. Adorno, "On Lyric Poetry and Society," 46.

8. This is not to say that I have not benefited from such studies. Two works on related themes that I have consulted with profit are Dora and Erwin Panofsky's *Pandora's Box* and Kenneth Gross's *The Dream of the Moving Statue*. In *Lot's Daughters*, Robert Polhemus stresses redemptive aspects of the Lot story. Emphasizing Christ's descent from Ruth, a Moabite, Polhemus detects an emancipatory potential in this genealogy that becomes the allegorical model for a series of "Lot's daughters" from Lear's daughters to Mia Farrow.

9. This book stresses the visual, and therefore scants the large number of uses of Lot's wife in poetry and prose. Particularly strange and compelling uses of the figure in prose, which I nevertheless neglect, appear in Vladimir Nabokov's *Speak, Memory*, 131; Marilynne Robinson's *Housekeeping*, 153; and Salman Rushdie's "Imaginary Homelands," 10. Similarly, I say nothing here about the poem called "Lot's Wife" by Anna Akhmatova (available in several translations), or in Wislawa Szymborska's *Sounds, Feelings, Thoughts*, 158–61, or Stevie Smith's *New and Selected Poems*, 44. This is a highly selective list.

10. Fried, "Art and Objecthood," in *Art and Objecthood*, 153. The other criterion for Fried's theatricality in this essay is that "it is concerned with the actual circumstances in which the beholder encounters literalist work" (153). This criterion—what came to be called "site-specificity"—is of varying importance in the works I consider; it is also of less importance to Fried's art-historical work.

11. Ibid., 50. The discrepancy between the argument about theatricality in Fried's seminal essay "Art and Objecthood" and his pursuit of similar issues in his art-historical trilogy on French painting—*Absorption and Theatricality* and his books on Courbet and Manet—bears emphasis.

12. See Bürger, *The Theory of the Avant-Garde*.

13. I have found Miriam Bratu Hansen's dialectical attention to both the "textual" codes that produce spectators and to histories of empirical spectators in *Babel and Babylon* an enlightening example. For a survey of a modern countertradition that emphasizes destructive aspects of vision, see Martin Jay's *Downcast Eyes*. Early in his book, Jay discusses the division between theories of spectatorship that assume spectatorial distance, and others that emphasize a specular collapse of the viewer with—or into—the object viewed (31). In the uses I trace here, Lot's wife belongs to both traditions. I should stress, however, that I use the terms "spectator" and "spectatorship" advisedly. In *Techniques of the Observer*, Jonathan Crary explains that he prefers the term "observer" to "spectator" because of the association of spectatorship with "one who is a passive onlooker at a spectacle, as at an art gallery or theater": "Though obviously one who sees, an observer is more importantly one who sees within a prescribed set of possibilities, one who is embedded in a system of conventions and limitations" (6). While by no means free of conventions or restraints, the spectator I discuss is marked precisely by distance. This distance is the problem. Artaud, for instance, desires a catastrophic intensification of the corporeal nature of observation Crary describes; spectatorial distance is the barrier to this intensification.

14. I use the feminine pronoun for the spectator advisedly, and not only because my model for the spectator here is Lot's wife. My conception of spectatorship also owes much to feminist scholarship that has emphasized the vicissitudes of women's film spectatorship. Along with Laura Mulvey's groundbreaking "Visual Pleasure and Narrative Cinema," Gaylyn Studlar's *In the Realm of Pleasure* has been especially important because of its emphasis on masochism in spectatorship.

15. Polhemus, for instance, begins his survey of the visual representations of the story with the image from the Nuremberg Chronicle (Polhemus, *Lot's Daughters*, 72 and plate 1). See also *The Sarajevo Haggadah*, 17; the image appears on the seventh unnumbered page of the facsimile.

16. Joshua Kind's thorough survey of the history of the representation of Lot and his daughters in painting from 1500 to 1650 ("The Drunken Lot and His Daughters") suggests the great range of works the biblical story inspired.

17. This painting, now at the Getty Museum, is one in a series Gentileschi executed with some differences in composition. Another version, now in the National Gallery of Canada, Ottawa, for instance, shows an untroubled sky (Christiansen and Mann, *Orazio and Artemisia Gentileschi*, 197). Yet another version, in the Gemäldegalerie, Berlin, significantly depicted "in the background the burning city of Sodom; this was

shown on an additional strip of the Berlin picture that has since been removed"
(Christiansen and Mann, *Orazio and Artemisia Gentileschi*, 183n2). "It is highly likely,"
writes Ward Bissell, "that this strip was a later, non-autograph addition." The inclu-
sion of a view of the burning city suggests frustration at Gentileschi's restraint—a
restraint by no means shared by other painters, as will become clear. Indeed, one
might imagine that Gentileschi responds in part to a tradition of painting that reveled
in showing the burning cities. And yet, as Bissell writes in a generously detailed per-
sonal communication, in an 1808 engraving of another version of the theme attributed
to Gentileschi, "the city appears with considerable clarity." This version is probably a
copy, but it is possible that this copy reflects a lost original. Bissell summarizes: "One
is strongly inclined to believe that Gentileschi would have preferred allusion to Sodom
to the more prosaic outright depiction of it. But there is always an outside chance that
on one occasion, in reduced scale, he inserted the city" (Bissell, letter to author, July
19, 2005).

18. Indeed, in another version of the same theme by Gentileschi, now in Bilbao,
Spain, "the standing daughter's gesture evokes not only the unseen city but also, in
the middle distance, a tiny, ghost-like figure of Lot's wife in the form of the pillar of
salt" (Ward Bissell, letter to author, July 19, 2005). For discussions and illustration of
the 1628 Bilbao version, see Christiansen and Mann, *Orazio and Artemisia Gentileschi*,
232–34, and Bissell, *Orazio Gentileschi and the Poetic Tradition in Caravaggesque Paint-
ing*, 51–52.

19. This tale of father and daughters makes it especially intriguing that Orazio
Gentileschi's daughter, Artemisia, also painted the theme of Lot and his daughters.
For a discussion of Artemisia's version, see Bissell, *Artemisia Gentileschi and the Au-
thority of Art*, 82–87 and figs. 163–68. On the visual relationship between the works of
father and daughter, Bissell concludes: "As [Mary] Garrard . . . notes, Orazio Gentile-
schi had also rejected blatant sexuality in his various interpretations of the theme from
the 1620s. Artemisia may have seen the version painted for Giovan Antonio Sauli in
her father's Roman studio, but compositionally her picture owes nothing to Orazio's
conception" (Bissell, *Artemisia Gentileschi and the Authority of Art*, 409n121). There
might be more to say about this way of owing nothing.

20. For Fried's discussion of absorption, see especially *Theatricality and Absorption*.

21. I allude in this sentence to David Freedberg's provocative *Power of Images*.

22. Quoted in Tinterow, Pantazzi, and Pomarède, *Corot*, 254.

23. In the Bilbao *Lot and His Daughters* by Orazio Gentileschi, Lot's wife appears
in this portion of the canvas (see n. 16, above). In Ruth Mellinkoff's economical and
excellent survey of images of Lot and his daughters, for instance, Lot's wife appears in
a similar position in paintings and drawings by Jan de Cock, Lucas Cranach, Lucas
van Leyden, Agostino Carraci, and Frans Floris. See the appendix to Mellinkoff, "Ti-
tian's Pastoral Scene," 851–57. I discuss the van Leyden below; it appears in the present
study as plate 3. For another economical survey built around a single work, in this
case a painting by Joachim Wtewael, see Anne W. Lowenthal, "Lot and His Daughters
as Moral Dilemma."

24. An engraving after the painting as exhibited in 1844 suggests that the earlier
version included two elements in the representation of Lot's wife that Corot revised as

he altered the painting: she does cast a shadow, and she gestures toward the city of Sodom. This gesture made her the antitype to the angel, whose gesture, in the engraving, was itself much more forceful than that of the final version. For the engraving, see Tinterow, Pantazzi, and Pomarède, *Corot*, 254, fig. 107. I also speculate that Corot might have revised his painting after having seen an image of the Dead Sea monolith associated with Lot's wife similar to the one I discuss below in chapter one (fig. 3).

25. John Boswell argues for the relative modernity of this association in *Christianity, Social Tolerance, and Homosexuality*. Boswell argues that early Christian condemnation of homosexual acts had little to do with the Bible; Boswell emphasizes that the crucial sin in Genesis 19, and in early Christian interpretations of the story, was inhospitality (92–99). See, however, n. 26, below.

26. On this question, Jonathan Goldberg's comments in his introduction to *Reclaiming Sodom* are compelling. On the one hand, Goldberg rejects the arguments of "Fundamentalist readers" who "have no doubt that homosexuality is the crime that brought Sodom down; such readers . . . assume a transhistorical homosexuality available anywhere at any time and always to be abominated." On the other hand, scholars such as Boswell who link the crimes of Sodom solely to failures of hospitality "have attempted to efface sexual matters entirely, and this is difficult to do, since, even if the Sodomites had not unambiguously sought sexual relations with the angels, Lot's offer of his daughters as a substitute is a far less equivocal act" (6–7). The violent revision of Genesis 19 in Judges 19 and 20 certainly suggests that the story was understood as one about sexuality.

27. Loader remarks that the Genesis story reflects the "anti-urban tendency" of a nomadic people (*A Tale of Two Cities*, 38; see also 43). Mike Davis's *City of Quartz*, *Ecology of Fear*, and "The Flames of New York" have all sharply provoked my thinking about the antiurban bias of a suburban people. Kenneth T. Jackson, arguing for the continuing importance of cities in a suburbanizing culture, has twice closed an op-ed piece for the *New York Times* with this quotation from Charles E. Merriam: "The trouble with Lot's wife was that she looked backward and saw Sodom and Gomorrah. If she had looked forward, she would have seen that heaven is also pictured as a city" (Jackson, "America's Rush to Suburbia," *New York Times*, June 9, 1996, and idem, "Once Again, the City Beckons," *New York Times*, March 30, 2001). One wonders: would she not have seen a cave in the mountains? See also two remarkable surveys of modernity and "urbicide": Stephen Graham's "Cities as Strategic Sites: Place Annihilation and Urban Geopolitics" and Ryan Bishop and Gregory Clancey's "The City-as-Target, or Perpetuation and Death," in *Cities, War, and Terrorism*, edited by Graham.

28. On Cain and the urban, see Karsten Harries, *The Ethical Function of Architecture*, chap. 16, "Mold and Ruins," and George Shulman, "The Myth of Cain."

29. Hal Foster, "Foreword: Mothertruckers," in Jeffrey Schnapp, *Staging Fascism*, xviii.

30. I refer here to Althusser's "Ideology and Ideological State Apparatuses." I am not arguing that many critics, if challenged, would claim that a single work might undo the effects of institutional interpellation. I do think, however, that something like this belief informs much recent criticism in its quest for the subversive entertainment that undoes ideology through guerilla subject-formation. The belief is, I think,

part of what John Guillory has called, after Althusser, "the spontaneous philosophy of the critics." See Guillory, "The Sokal Affair," 475. Part of the problem stems from a misunderstanding of the mirror stage: the *event* of subject-formation, as Jacques Lacan describes it, seems to promise a set of similar events in the future of the new subject. But the mirror stage is not *an* event but, precisely, a *stage* in (at least) the developmental sense of the word. For a particularly valuable discussion of the mirror stage, and especially of its temporality, see Kaja Silverman, *The Threshold of the Visible World*, 10–22.

31. The literature on this question is large. The succinct account in Laplanche and Pontalis is of great value; see the entry, "Masochism," in *The Language of Psychoanalysis*. Many important contributions are included in Hanly's *Essential Papers on Masochism*. Of special importance here are the observations of Jean Laplanche in "Aggressiveness and Sadomasochism," chap. 5 of *Life and Death in Psychoanalysis*; see esp. 97–102, on the origin of the masochistic drive; these pages culminate in a discussion of the role of fantasy in the turn to masochism.

32. Otto Fenichel, "The Clinical Aspect of the Need for Punishment," in Hanly, *Essential Papers on Masochism*, 313.

33. I return to the figure of the Angel of History in my chapter on Kiefer, below.

34. See Hartman, *The Unmediated Vision*. One might also see these modern Lot's wives as versions of the post-Enlightenment sublime. For an account of that sublime, which, not incidentally, owes much to Hartman, see Thomas Weiskel, *The Romantic Sublime*.

35. Adorno, *Minima Moralia*, 25.

36. Caruth, *Unclaimed Experience*, 5. I have removed a stray "is" after "each" in the first sentence of this passage.

37. Phelan, "Converging Glances," 34. Phelan writes in dialogue with Caruth's "Parting Words."

38. Phelan intriguingly understands trauma as an occasion for creative response. The "fort-da" game, she writes, "stages the eye's inevitable encounter with blindness and the I's encounter with incomprehensibility and unknowingness. The disappearance and return of the visual image is the oscillating beat that is the heart of seeing itself." This game "is necessarily creative" ("Converging Glances," 35). I would argue that trauma describes not those everyday experiences of loss that allow for creative response but those that resist that creativity and shut its possibility down. That the recognition of future loss—even, or especially, the loss of one's own being—produces enigmatic everyday forms of creativity seems, to me, right. But is this recognition traumatic, or a response to trauma? Phelan here points to a different understanding of trauma than the one most commonly encountered in literary studies. In her reading, "the catastrophe around which trauma theory orbits is at once more trivial and more profound than is usually admitted" (ibid., 37). Because trauma is foundational to the construction of vision and of the self, everyone struggles with this trauma, whether creatively or otherwise. Jean Laplanche similarly speaks of what he calls "the humanizing trauma," a trauma he associates with the self's originary encounters with an otherness that at once constitutes and threatens the self (Caruth, "An Interview with Jean Laplanche," para. 86). For Laplanche, "gross traumas, train accidents and

so on" involve problems of resymbolization of this originary trauma ("An Interview with Jean Laplanche," para. 47). *Forgetting Lot's Wife* is far more about ways of imagining the engaged witnessing of "gross traumas" than about the possible psychic basis of these traumas.

39. For a succinct critique of this claim, see Jill Bennett, *Empathic Vision*, 35.

40. Andreas Huyssen provides a timely critique of reading "the whole history of the twentieth century under the sign of trauma" in *Present Pasts*, 8–9.

41. In literary studies, the most influential source for such arguments is Shoshana Felman and Dori Laub's *Testimony*. That book's argument that the listener to testimony of traumatic events comes, in Laub's words, to "partially experience trauma in himself" (57) at once exaggerates the power of narration and underestimates the severity of trauma. For a skeptical comment on this notion of "secondary trauma" from a critic largely friendly to Felman and Laub, see Geoffrey Hartman, "Holocaust Testimony, Art, and Trauma," in *The Longest Shadow*, 165n10. For a much fiercer and controversial critique of accounts of the transmission of trauma in the work of Caruth and Felman and Laub, see Ruth Leys, *Trauma: A Genealogy*, esp. 268–69 and 284–92. A background for the debate, I would stress, is that modernists such as Artaud claimed that a true work of art would possess the power to traumatize. My emphasis on the spectator's distance suggests my focus: not those who have been directly traumatized by horrific historical events, but those who have the responsibility to look back at them.

42. Jean-Paul Sartre, "Manhattan: The Great American Desert," in *The Empire City*, 456–57. I first encountered this quotation in David Reid and Jayne L. Walker's "Strange Pursuit" (71): see also the relevant pages in this essay on the mid-twentieth-century imagination of Manhattan apocalypses (69–72), as well as Mike Davis, "The Flames of New York," his preface to *Dead Cities*.

43. To quote Richard Halpern, writing in a related context, "This book is about the ways in which an older, sodomitical thematic persists even into the modern regime of sexual identities, when its cultural supports might seem to have fallen away" (*Shakespeare's Perfume*, 10).

44. Dylanologists may recall "Trouble in Mind," still available only as the b-side of various singles, including most notably "Slow Train Coming," the hit that announced Dylan's conversion to Christianity. In "Trouble in Mind," he sings, "Ask Lot what he thought when his wife turned to stone." One might also recall "She Belongs to Me": "She's got everything she needs, / She's an artist, she don't look back." In *Chronicles*, Dylan describes Sun Records recordings in a figure that combines Lot's wife and Orpheus: "If you were walking away and looked back at them, you could be turned into stone" (216).

CHAPTER ONE: ARTAUD, SPECTATORSHIP, AND CATASTROPHE

1. On Lucretius's shipwreck, see David Marshall's discussions in *The Figure of Theater*, 207–10, and *The Surprising Effects of Sympathy*, 23 and passim; Marshall's work on spectatorship has informed my own. See also Hans Blumenberg's discussion of the philosophical tradition of Lucretius's figure in his resonant *Shipwreck with Spectator*.

2. Among the many works on this large issue, I have found especially compelling George Mosse's *The Nationalization of the Masses* and work by Jeffrey T. Schnapp, "18 BL: Fascist Mass Spectacle," and, even more useful for its synoptic view of the problem of mass spectacle in the 1930s, "Border Crossings: Italian/ German Peregrinations of the Theater of Totality." Schnapp's demonstration in "Border Crossings" of the interconnected lineage of avant-garde and fascist attempts at a true *Gesamtkunstwerk* in the 1930s is especially fascinating, rich, and troubling. See also Schnapp's related *Staging Fascism*, his account of a fascist mass spectacle staged in Florence in 1934. On the German context, see also Rainer Stollman's excellent "Fascist Politics as a Total Work of Art." Robert Jan van Pelt stresses Nazi attempts at fabricating ritual in his valuable chapter, "Apocalyptic Abjection," in the volume *Architectural Principles in the Age of Historicism*, edited by van Pelt and Carroll William Westfall.

3. Walter Benjamin, "The Work of Art in the Age of Its Technological Reproducibility: Third Version," in idem, *Selected Writings*, 4:269.

4. See Moretti, "From *The Waste Land* to the Artificial Paradise." Eliot himself became a participant in this theatrical and political struggle over the "sacred" when he turned to theater in such plays as *Murder in the Cathedral* (1935) and to protofascist social criticism in *After Strange Gods* (1934). On the question of Artaud's failure, Philippe Sollers comments: "To speak of Artaud's 'failure' in the theater is senseless. That failure is inevitable (given our society, our culture), but the fact that this theater can be described makes a great deal of sense, since the undertaking it stands for concerns every person's life" (Sollers, "Thought Expresses Signs," 91).

5. An editorial note appended to a reprinting of "La Mise en Scène et la Métaphysique," which, to my knowledge, first reproduced the painting in the company of Artaud's essay, for instance, points out that Artaud "reinvents the work he discusses and audaciously discovers details that don't appear in it at all" (Artaud, "La Mise en Scène et la Métaphysique," *L'Arc*, 85; my translation). On the question of the misattribution of the painting to van Leyden, see Elise Lawton Smith, *The Paintings of Lucas van Leyden*, 181–84. Leyden did, in fact, engrave a print on the theme of Lot and his daughters; see discussion and illustration in Ellen S. Jacobowitz and Stephanie Loeb Stepanek, *The Prints of Lucas van Leyden and His Contemporaries*, 238–39.

6. Antonin Artaud, *The Theater and Its Double*, 33; further references will appear in parentheses in the text. In places, I quote Artaud's French; quotations follow his *Œuvres Complètes* (hereafter OC), followed by volume and page numbers. Artaud's notion that the Louvre's *Lot and His Daughters* is a model for a superior theater is clear in his first writing about it, in a letter to Jean Paulhan dated September 6, 1931 (OC 5:55).

7. Jane Goodall has suggested that Lot's wife is "the figure whose occluded presence hovers in the subtext of 'La Mise en scène et la Métaphysique,'" but she leaves it for others to suggest how this occlusion might work. See Goodall, "Artaud and Painting," 111. Lot's wife, for Goodall, is an example of a failed gnostic, who obeys the "naive impulse to 'turn round'" to the old "known and accepted paths of understanding" (111) rejected by Artaud in *The Theater and Its Double*. This implies that Artaud would reject Lot's wife and joins in her punishment; as I will argue, his treatment of

her is in fact more ambivalent. Goodall also points out the compositional importance of the tree at the center of the canvas, which I mention below.

8. Davis McCallum suggested in conversation that this crowd may be the men of Sodom, surrounding the house of Lot. If so, the double time of the painting, which puts the destruction of the cities on the Plain beside the incest of Lot and his daughters, becomes instead a triple time; the crowd of men are part of the scene of the destruction their demands help bring on. I thank Jennifer Whiting, as well, for her close observations of the painting.

9. The irony of this refusal of linguistic codes is that Artaud, in the end, relies on linguistic tropes to describe the antilinguistic theater he desires. See, for a now-classic discussion of this, Jacques Derrida's "La parole soufflée," esp. 190–95.

10. Sontag, "Approaching Artaud," 30; this essay reprints Sontag's introduction to Artaud, *Selected Writings*. "Approaching Artaud" remains one of the best general discussions of Artaud's aesthetic, and is especially valuable for its pages on Artaud's theater (30–51).

11. Artaud oscillates around the question of whether his theater is homeopathic, or whether actual violence may sometimes be a part of it. This ambiguity survived to Artaud's final days. In one of Artaud's last letters, after a bureaucrat's dismaying decision not to allow the transmission of his compelling radio broadcast, *To Have Done with the Judgment of God*, he wrote (in verse form, which I will not reproduce) to Paule Thévenin, the friend he had chosen as his literary executor: "I am through with Radio and from now on will devote myself exclusively to the theater as I conceive it, a theater of blood, a theater which with each performance will have done something *bodily* to the one who performs as well as to the one who comes to see others perform, but actually the actors are not performing, they are doing" (Artaud, *Selected Writings*, 584–85). The crucial phrases here reflect just the power and vagueness that typically mark Artaud's formulations about his theater. It is hard to know what to make of a theater "of" blood. One does not know whether this is a theater that has its basis not in language but in the body, or a theater that in fact draws blood.

12. Plato, *Republic*, 317; §514b.

13. According to an editor's note (OC 4:344), Artaud probably wrote the preface after a journey to Mexico in 1936, five years after he first delivered "Metaphysics and the *Mise en Scène*" as a lecture at the Sorbonne in December 1931. In Mexico, Artaud traveled among the Tarahumara, and these travels inform the preface; in a text about his journeys, Artaud describes an Ovidian landscape where every metamorphic rock appears to be a sort of petrified being: "The land of the Tarahumara is full of signs, forms, and natural effigies which in no way seem the result of chance, as if the gods, whom one feels everywhere here, had chosen to express their powers by means of these strange signatures in which the figure of man is hunted down from all sides." These "natural effigies," the signatures of the gods, take the form of tortured human forms Artaud sees everywhere. See "The Mountain of Signs," in Artaud, *Selected Writings*, 379.

14. Jean Paulhan, editor of the *Nouvelle Revue Française* and of *The Theater and Its Double*, and a friend to Artaud, wrote an intriguing answer to a questionnaire: "I am no enemy on principle of catastrophes." See Hollier, ed., *The College of Sociology*, 64.

The affinities between the project of the College and that of Artaud are numerous. Especially notable is Bataille's dream of recreating the sacred, which is well documented in his essays collected in *The College of Sociology*, esp. "The Sorcerer's Apprentice," 12–24.

15. For *Van Gogh, the Man Suicided by Society*, see Artaud, *Selected Writings*, 483–512.

16. Herbert Blau, *The Audience*, 119.

17. Hugo Ball, *Flight Out of Time*, 163. Ball's diary also contains a related reflection on Lot's wife: "The enjoyment of every excess, and hence of war too, is based on a revenge against culture. Let us regard it as beneath our dignity to enjoy ourselves in that way. But let us also forbid ourselves to stop halfway and to turn into a pillar of salt like Lot's wife, that is, to turn into a bitter monument" (184).

18. *The Interpreter's Bible*, 1:630. The note also states: "The woman caught in the whirlwind of fire from doomed Sodom because she was still too reluctant to leave the wicked city has become proverbial: 'Remember Lot's wife' (Luke 17:32)." This seems to me badly to misread Jesus' injunction. In Luke, Jesus significantly refrains from judging Lot's wife as these commentators do. The activities Jesus lists as common in Lot's days—"they ate and drank; they bought and sold; they planted and built" (Luke 17:28)—are most remarkable for their sheer ordinariness. The everyday world Jesus imagines on the brink of destruction contrasts with homophobic discourse that has used the story of Lot for scriptural justification.

19. I owe this formulation to correspondence with Margaret Bruzelius.

20. For a recent exception, see Edward Scheer's introduction to his *Antonin Artaud: A Critical Reader*, 4.

21. Shaw and Brecht revised the story of Joan of Arc in *Saint Joan* and *Saint Joan of the Stockyards*. Brecht turns to the plot of the story of Lot, too, in *The Good Person of Szechuan*; the opening scenario of the story, in which angelic figures seek hospitality, echoes and lampoons the biblical story.

22. It is not the case, however, that Artaud consistently distinguishes desirable "signs" from degraded "forms," even in the preface. He writes, for instance, of the "cultivated 'civilized' man . . . who thinks in forms, signs, representations" (8).

23. Denis Hollier, "The Death of Paper, Part Two."

24. Jacques Lacan, "The Function and Field of Speech and Language in Psychoanalysis," in *Écrits*, 43, and Guy Scarpetta, "Artaud Écrit ou La Canne de Saint Patrick," 67. On the same page, Scarpetta reveals that Artaud's hated "Doctor L." was Lacan. Lacan treated Artaud at an asylum and later urged his students not to interest themselves in a case he gave a resonant name: "la passion d'Antonin Artaud." For a fine discussion of Artaud and madness, see Louis Sass, "'The Catastrophes of Heaven.'" For a superb discussion of issues of self-alienation and the self as statue in Lacan, see Mikkel Borch-Jacobsen's chapter, "The Statue Man," in his *Lacan: The Absolute Master*: "The 'ego-world' is a statue: as hard as stone, as cold as ice, it is *standing in front of* the ego that is petrified there—that is, in the ego-world, it both gazes at and petrifies itself" (60). Also relevant here is Kenneth Gross's meditation on a fantasy he relates to Lot's wife and other figures: that the statue is "the relic of a

metamorphosis" that turned a living thing into "stone or bronze or plaster" (*The Dream of the Moving Statue*, 15).

25. For a reading of Artaud's resistance to repetition and to derivation of any kind, see Leo Bersani, "Artaud, Defecation and Birth," in his *A Future for Astyanax*.

26. This image invites and has received autobiographical readings. There are clues to this reading in the discussion of the drawing in a catalogue of Artaud's drawings, *Antonin Artaud: Œuvres sur papier*, 140, and Stephen Barber has written a more elaborated account. The image, he asserts, depicts "a group of warrior girls whom Artaud, in the isolation and sterility of his internment, had elaborated as the embodiment of [Artaud's] desired liberation. He named them his 'daughters of the heart to be born.'" This fantasy group included women Artaud knew and admired as well as his grandmothers who "were genealogically inverted, to become feral, erotic children ready to battle for Artaud's release" (Barber, *Artaud: The Screaming Body*, 55). That Artaud considered these figures "daughters" and that this fantasy involved such inversion also links *Le Théâtre de la cruauté* to the context of representations of the Lot story.

27. Baudelaire's poem, "Une Charogne," about the "disgusting corpse" with "its legs in the air like a lewd woman [*comme une femme lubrique*]," may inform Artaud's use of the word. Baudelaire's poem ends with an invocation to the beloved who "will come to resemble that offal." I quote from the "plain" prose translation and the French in Francis Scarfe's bilingual edition (*Baudelaire*, 47–49).

28. Prevel, *En Compagnie d'Antonin Artaud*, 94.

29. Ibid., 83.

30. As Allen Weiss has recently stressed, the notion of the body without organs elaborated by Deleuze and Guattari in *Anti-Oedipus* derives from Artaud's *To Have Done with the Judgment of God*; see Weiss, "Radio, Death, and the Devil," 307n36. For another recent discussion of Artaud from a Deleuzian perspective, see Peggy Phelan's "Performing Talking Cures: Artaud's Voice."

31. I also suspect that then, as now, illustrations of this pillar circulated in the press. At any rate, according to his friend and editor, Paule Thévenin, Artaud studied the *Dictionnaire de la Bible* closely in 1933 and took notes from it while working on his *Heliogabalus, or the Anarchist Crowned*; "he had added three pen drawings reproducing some illustrations of the work he had consulted" ("The Search for a Lost World," in Jacques Derrida and Thévenin, *The Secret Art of Antonin Artaud*, 9). I have chosen to use the Bible edited by L'Abbé J.-B. Glaire in part because the appendices to this Bible are also by Vigouroux.

32. Rainer Friedrich, "The Deconstructed Self in Artaud and Brecht," 284. Friedrich's examples from Brecht are the *Lehrstücke*; he excepts Brecht's later work from his indictment. Friedrich also lists Artaud's affinities with antisemitism and fascism, in examples that range from a dream in which the Action Française rescues him from "a Jewish-controlled police force," to the dedication of a book to Hitler in 1943, to genocidal fantasies. Friedrich claims not that these examples demonstrate any coherent political allegiance, but that they show a "close affinity" between Artaud's irrationalism and "those strands in German expressionism and irrationalist philosophy that prepared the other type of totalitarianism" (288).

33. W. H. Auden, "Musée des Beaux Arts," in his *Collected Poems*, 146–47.

34. For a far more extensive reading of the relation between Bruegel's painting, Auden's poem, and contemporary politics, see Alexander Nemerov, "The Flight of Form." Nemerov focuses on the figure of the ploughman, whom he sees as a complicated figure for the role of the intellectual in 1938.

CHAPTER TWO: HOLLYWOOD SODOM

1. Lauren Berlant has been an especially incisive critic of this scene of the witnessing of suffering and the attendant problems of testimony. See, for instance, her essays "Poor Eliza" and "Trauma and Ineloquence."

2. Berger, "The City of Sodom," in *The Sense of Sight*, 77.

3. For an especially provocative analysis of the politics of spectacle surrounding September 11th, see Retort, *Afflicted Powers*, esp. chap. 1.

4. A tornado smashes the Hollywood sign in Roland Emmerich's *The Day after Tomorrow* (2004).

5. Sontag, "The Imagination of Disaster," 212.

6. On these ruins, see Kenneth Anger, *Hollywood Babylon*, 6, and Robert Sklar, *Movie-Made America*, 64; see also the splendidly evocative photographs in Anger (7 and 12–13).

7. Sodom lies on Anger's map, but as part of a more variegated geography. Describing scandal sheets, Anger writes: "for the *GraphiC* & Co there was No Badder Place than Hollywood—Reborn BABYLON, with Santa Monica-Sodom and Glendale-Gomorrah for suburbs" (Anger, *Hollywood Babylon*, 189). The disturbing lineaments of such depictions of Hollywood as Sodom are especially clear in Max Knepper's forgotten *Sodom and Gomorrah: The Story of Hollywood*, a screed published in 1935, a representative of the kind of anti-sodomitical jeremiad the films I will discuss complicate. Anti-Semitic, marked by intense misogyny, and full of muckraking self-righteousness, Knepper, like Anger, compiles a dossier of gossip; unlike Anger, Knepper believes this gossip serves the cause of normative virtue.

8. Michael Warner, "New English Sodom," 20. My understanding of Sodom in this chapter also owes much to the argument of Jonathan Goldberg in *Sodometries*, especially to its fourth chapter, "The Transvestite Stage: More on the Case of Christopher Marlowe."

9. Sontag, "The Imagination of Disaster," 215.

10. The other renditions appear in a 1922 *Sodom and Gomorrah* directed by Michael Curtiz in Austria before he came to Hollywood, and in Robert Aldrich's 1962 film of the same title, which I discuss in the conclusion to this chapter. I have been able to see only a drastically cut and mediocre video transfer of Curtiz's film, so I reserve consideration of this work for another time. On Curtiz's film, see Nikolaus Wostry, "*Sodom and Gomorrah*: Notes on a Reconstruction."

11. For general discussions of the work of Watson and Webber, see Lucy Fischer, "The Films of James Sibley Watson, Jr., and Melville Webber," and Lisa Cartwright, "U.S. Modernism and the Emergence of 'The Right Wing of Film Art.'" For reminiscences by participants, see James Sibley Watson Jr. et al., "The Films of J. S. Sibley Watson, Jr., and Melville Webber: Some Retrospective Views."

12. See, for instance, Cartwright, "U.S. Modernism and the Emergence of 'The Right Wing of Film Art,'" 178n23, where she puts *Lot in Sodom* in the company of the work of Kenneth Anger, among others. Barbara Hammer's appropriation of outtakes from *Lot in Sodom* in her film *Nitrate Kisses* registers the uneasiness of dubbing *Lot in Sodom*, as Sally Willis does in her introduction to an interview with Hammer, the "first gay film in America" (Hammer, "Uncommon History," 8).

13. Marianne Moore, "Lot in Sodom," 310. This review first appeared in *Close Up* 10 (December 1933): 318–19. Moore was friendly with both Watson, one of the film's directors, and Hildegarde Watson, his wife and star. (Watson, not incidentally, shared ownership of the *Dial* with Scofield Thayer.) Indeed, Moore tries out passages that end up in her review in a letter to Hildegarde. See "To Hildegarde Watson," September 3, 1933, in Marianne Moore, *Selected Letters*, 314–15. To my mind, this friendship does not mitigate the review's interest, which in any case expresses a certain *desire* for a modernist cinema.

14. My only clue about the identity of this third actress: "It was Steve [Kraskiewicz] who brought us our leading Sodomites, two uninhibited and extremely handsome young men from the Polish community; also, from the same source, the beautiful girl who appears repeatedly in different guises in the sequence where Lot cajoles the Sodomites with a description of the delights of married life" (James Sibley Watson Jr., "The Films of J. S. Watson, Jr., and Melville Webber: Some Retrospective Views," 76–77).

15. Herman G. Weinberg, "'Lot in Sodom,'" 267.

16. Moore, "Lot in Sodom," 311.

17. Ibid., 311–12.

18. Writing of his "first entertainment film" with Webber, an adaptation of Poe's *The Fall of the House of Usher*, James Sibley Watson Jr. writes of Hildegarde Watson: "At the start of *Usher*, she plays a silent star of the twenties" (Watson, "The Films of J. S. Watson, Jr., and Melville Webber: Some Retrospective Views," 74; 77). She continues to play the star in *Lot in Sodom*.

19. In this section, page numbers refer to Rossen et al.'s shooting script of *The Strange Love of Martha Ivers*. Where discrepancies exist between the script and the finished film, I use the spoken dialogue in the film.

20. It is also possible, however, that this is not a momentary economy at all, but an importation of a military barter system stateside. What are these elemental possessions but a soldier's things? Sam is, among other things, something of a reluctant war hero, and the film is one of many noir inversions of Preston Sturges's *Hail the Conquering Hero*. Here, the true war hero, with what a private investigator calls "a war record few can equal," gets a vicious welcome from his home town.

21. The question of the genre of *Strange Love* reflects the complexities surrounding the whole question of whether film noir is a genuine genre, a series of films, or a style. For a fine survey of this now-extensive debate, see James Naremore, *More than Night*.

22. Alain Silver and Elizabeth Ward, introduction to *Film Noir: An Encyclopedic Reference to the American Style*, 2. For another account of this post–World War II context, see Paul Schrader's section on "War and post-war disillusionment" in his seminal "Notes on *Film Noir*," in Silver and Ursini, *Film Noir Reader*, 54–55.

23. For a general discussion of the missing family and deracination in the film noir, see Sylvia Harvey, "Woman's Place."

24. Schrader, "Notes on *Film Noir*," 58.

25. A scene shot on what appears to be precisely the same set appears in another noir of 1946, also concerning a returning soldier, and also from Paramount, *The Blue Dahlia*. The edifice I take to be the Chateau Marmont is again visible in the upper-right of the frame. *The Blue Dahlia* is explicitly set in Los Angeles. I thank Laura Saltz for pointing out this parallel scene to me.

26. In 1946, the year of the release of *Strange Love*, fast-growing Hollywood was itself having its most successful year to date, the boom before the bust. See Sklar, *Movie-Made America*, 269.

27. Edward Dimendberg compares the rubble of European cities destroyed In World War II with the "deteriorating infrastructures" of New York and Los Angeles, a "result of years of depression and military conflict"; further, he stresses that "urban renewal" was to bring "a spatial disfiguration that solicits comparison to the campaigns accompanying World War II" (Dimendberg, *Film Noir and the Spaces of Modernity*, 8–9).

28. One might see the film as part of the massive reassertion of patriarchy many have spotted in noir narratives after World War II; Martha would then be the apotheosis of the women who became part of the work force during the war, not Rosie the Riveter but herself Boss. I am not convinced, however, that the problem with capitalist America for *Strange Love*—or for many another film noir—is that it is feminized. Indeed, in the ferocity of its picture of postwar culture as taking part in the corruption and barbarism of the defeated Axis, one might compare the Hollywood film noir to such post–World War II German work as Wolfgang Koeppen's novel *Death in Rome*, with its delineation of continuities between Nazi and postwar power. For that matter, one might compare it to the work of a critic who would have never been able to recognize the force of film noir, Adorno. (For Adorno's judgment of a noir television show directed by none other than Robert Aldrich, see Bill Krohn's "Adorno on Aldrich.")

29. On Aldrich's debts to Milestone, see Arnold and Miller, *The Films and Career of Robert Aldrich*, 7–8.

30. Sontag, "The Imagination of Disaster," 214. She observes of science fiction disaster movies: "Neither do these sequences differ in aesthetic intention from the destruction scenes in the big sword, sandal, and orgy spectaculars set in biblical and Roman times—the end of Sodom in Aldrich's *Sodom and Gomorrah*, of Gaza in de Mille's *Samson and Delilah* . . ." (214). I would argue that this coincidence suggests the ways biblical narratives continue to inform our pleasure in watching the destruction of cities.

31. See the section "Ritual and Liturgical Uses of Salt in the Bible," in Pierre Laszlo, *Salt: Grain of Life*, 144–45.

32. Krohn, "*Sodom and Gomorrah*," 5–6.

33. Borde and Chaumeton, "Towards a Definition of *Film Noir*," 25.

34. In "Strange Pursuit," David Reid and Jayne L. Walker provide a particularly suggestive survey of the relationship between the film noir and the often apocalyptic

views of the American city in the postwar period (see esp. 57–72). On film noir and postwar ideas of urban space, see also Dimendberg, *Film Noir and the Spaces of Modernity*. See also Mike Davis's fascinating discussion of the politics of *Kiss Me Deadly* in *Dead Cities* (136–38).

35. On the reconstruction of the film, and for a wonderful set of stills reproducing the restored ending, see Alain Silver, "So What's with the Ending of *Kiss Me Deadly*?" and, for more detail on the reconstruction, Glenn Erickson, "The Kiss Me Mangled Mystery." Aldrich himself commented: "I have never seen a print without, repeat, without Hammer and Velda stumbling in the surf. That's the way it was shot, that's the way it was released; the idea being that Mike was left alive long enough to see what havoc he had caused, though certainly he and Velda were both seriously contaminated" (Edwin T. Arnold and Eugene L. Miller, *The Films and Career of Robert Aldrich*, 245n37).

36. Lucretius, *The Nature of the Universe*, 60, opening to book 2.

37. In the collage of scenes of atrocities and war that forms "Inferno," the first part of his *Notre Musique* (2004), Godard uses the scene of Velda and Mike looking back. The scene's combination of complicity and endangered distance may explain its inclusion: the sequence is the single staging of witnessing in an intense montage that requires that viewers contemplate the conditions of their own spectatorship.

38. Neil Hertz, *The End of the Line*, 166.

39. Alain Silver and James Ursini, *What Ever Happened to Robert Aldrich?*, 179.

40. Ibid.

41. Scorcese describes the ending of *Kiss Me Deadly* and mentions the invocation of Lot's wife in his idiosyncratic survey of American film; see Scorcese and Michael Henry Wilson, *A Personal Journey*, 120. Lot's wife surfaces also in Scorcese's *Alice Doesn't Live Here Anymore* (1974). Alice, leaving town with her son by car, warns him: "Don't look back: you'll turn into a pile of shit." Her son replies: "The whole state is shit." And Alice responds: "Don't talk dirty, Tommy. How many times do I have to tell you?"

42. Artaud, *The Theater and Its Double*, 42.

43. Thanks to David Hoover for bringing my attention to this phenomenon, described by various websites. See, for instance, the entry on Las Vegas history on the Yahoo UK and Ireland Travel site, available at http://uk.holidaysguide.yahoo.com/ p-travelguide-131365-las_vegas_history-I : "In the early 1950s a new kind of entertainment was born: watching the atomic testing. . . . A famous *Life* magazine photo captured one of the mushroom clouds rising above the waving cowboy, 'Vegas Vic' of Fremont Street. In fact, the opening of the now closed Desert Inn was timed to coincide with one of the blasts."

CHAPTER THREE: ANSELM KIEFER'S *LOT'S WIFE*: PERSPECTIVE AND THE PLACE OF THE SPECTATOR

1. Sebald, *After Nature*, 86–87.

2. For a particularly compelling treatment of problems of generational memory in post–World War II Germany, see Eric Santner, *Stranded Objects*.

3. Kurt Vonnegut anticipates Sebald's imagining of Lot's wife as a spectator of the destruction of Dresden in *Slaughterhouse Five*. Like Sam Masterson, Vonnegut reads his Gideons' Bible "for tales of great destruction"; also like Sam, he associates himself with Lot's wife. *Slaughterhouse Five*, writes Vonnegut, "is a failure, and had to be, since it was written by a pillar of salt" (19). For a poem that also associates the place of the writer among ruins with Lot's wife, see Zbigniew Herbert's "About Troy," in *Elegy for the Departure*, 9–10.

4. One might argue that Sebald avoids naming Sodom or the figures in the Lot story in keeping with his resistance to mythical explanations of catastrophe. Referring directly to "images such as those of burning cities and Lot's wife in [Sebald's] *The Rings of Saturn*," Amir Eshel writes that Sebald's use of such images "is not the result of a mythicizing interpretative endeavor, but rather the attempt to present images of and in relation to the catastrophic—images that only mirror the narrator's inability to deliver a cohesive, meaning-generating account of the 'radical contingency' inherent in the catastrophic, indeed, in history" (Eshel, "Against the Power of Time," 91). But might images not provide a kind of coherence without generating cohesive meaning? (I have not found Lot's wife in *The Rings of Saturn* and suspect Eshel might be thinking of *After Nature*.)

5. Caruth, *Unclaimed Experience*, 11.

6. In German, these lines are clipped, colloquial, and perhaps still more marked by an alienation of experience: "[sie] weiß aber heut nicht mehr, / wie die brennende Stadt aussah / und was für Gefühle sie / bei ihrem Anblick bewegten" (*Nach der Natur*, 67–68). The enjambment divides her from the feelings that move her, and these feelings seem scarcely to be hers at all.

7. This critique appears in Leys's seventh chapter, especially in a section called "Defending the Science of the Literal I: Trauma as Icon" (245–54). Leys's linking of Caruth to this theory of trauma as icon does not seem to me fair.

8. Leys, *Trauma*, 250.

9. Wood, *Albrecht Altdorfer and the Origins of Landscape*, 267. In keeping with the redemptive strain of his book, Robert Polhemus points out that a cross is visible in the ruby-red wineglass in the painting: "As the wine of lechery could be transmuted into the symbol of salvation, so the incest of Lot and his daughters might be redeemed by new modes of bonding between fathers and daughters for the future benefit of both" (*Lot's Daughters*, 84).

10. Freud, "Disturbance of Memory," 245.

11. For a remarkable survey of this topic, see Freedberg, *The Power of Images*.

12. Koerner, *Caspar David Friedrich*, 20.

13. Ulrich Baer's account, in *Spectral Evidence*, of the ways certain photographs of the landscapes of former death camps also resist Koerner's paradigm for the landscape has influenced this paragraph.

14. The caption is also available online at the Tate Modern website, at www .tate.org.uk.

15. It is significant that Kiefer rarely if ever signs his works; every viewer of his work knows his writing—or, at least, the loopy script he uses in his paintings—but I do not recall seeing his signature.

16. Huyssen, *Twilight Memories*, 236.

17. On Arminius, see also Simon Schama's chapter, "*Der Holzweg*: The Track through the Woods," in *Landscape and Memory*, which concludes with a discussion of Kiefer.

18. Huyssen, *Twilight Memories*, 233.

19. Ibid., 220.

20. Bishop and Clancey, "The City-as-Target," in *Cities, War, and Terrorism*, ed. Stephen Graham, 62. Here and elsewhere in this chapter, I have also benefited from conversation with Patrick Deer and from reading his forthcoming *Culture in Camouflage: War, Empire, and Modern British Literature*, which is rich in observations about contrasting perspectives—on the ground and from the air —during wartime.

21. Sebald, *On the Natural History of Destruction*, 26.

22. In a sentence that perhaps helps to explain why he does not scrutinize the code name that gives his book his title, Gordon Musgrove writes: "As a great port Hamburg was a natural avenue for spies entering or leaving the Continent, and much information was passed on by sailors. After this attack the sin emporia of the Reeperbahn were in ruins, so the purveyors of secret information had to find a new rendezvous at which to transact their business" (Musgrove, *Operation Gomorrah*, 47). That new venue, according to rumor, was a zoo. Bishop and Clancey also note this codename and remark: "As in the Old Testament, all cities become potential 'cities on the plains,' with few fitting another typology found in the Pentateuch: 'cities of refuge'" ("The City-as-Target," 57).

23. Sebald, *On the Natural History of Destruction*, 26–28. Sebald draws on Hans Erich Nossack's remarkable memoir of the destruction of Hamburg, *The End*, which begins by stressing the vicissitudes of spectatorship: "For me the city went to ruin as a whole, and my danger consisted in being overpowered by seeing and knowing the entirety of its fate" (1).

24. "Operation Gomorrah" is not alone in this mixing of apocalyptic religion and air war. The raid on Cologne, in May 1942, was called "Operation Millennium," nominally because it was the first such raid in which the R.A.F. used more than a thousand bombers. In a strange echo of this thinking of Germany through Genesis 19, Stephen Spender, following a postwar tour through Germany in search of its remaining intelligentsia, writes: "From this point of view we can regard Germany as Sodom. If we can find ten good Germans, we can save the spiritual life of Germany. That is to say, if we can put ten Germans whom the Germans can respect as being not only Germans, but men accepted and listened to by the outside world, into touch, through every possible means of freedom of movement and publicity, with the German people, and with the outside world, we shall have shown the Germans the path which leads them up from despair and darkness, the path which also leads them into the European community" (Spender, "Rhineland Journey," 412). In the remarkable and neglected *European Witness*, which includes much of the material from this article, Spender does not include the comparison of Germany to Sodom.

25. See my discussion of the phantasmagorical in *Scare Quotes from Shakespeare*, esp. 96–97.

26. Rosenthal provides a complete list (*Anselm Kiefer*, 156n36).

27. Saltzman, *Anselm Kiefer and Art after Auschwitz*, 42.

28. Bersani, *The Culture of Redemption*.

29. For some, the names are too much. Names are, for instance, part of what earned Kiefer the scorn of Arthur Danto, who dismisses him in a scathing—and challenging—1989 review as a portentous, pretentious dealer in cheap symbolism and sentimental redemption (Danto, "Art: Anselm Kiefer").

30. This is not to say that Saltzman disregards the place of the spectator. See, for instance, her comments on Adorno and the avoidance of a fetishistic relationship to the aesthetic object (*Anselm Kiefer and Art after Auschwitz*, 20).

31. Bal and Bryson, "Semiotics and Art History," 205.

32. My approach is closest to that of Matthew Biro. In a pair of readings of Kiefer's *Iron Path*, for instance, Biro has stressed the ways the painting "presents the spectator with the opportunity to identify with the subject position of the victimizer. . . . Through his deployment of an emphatically drawn perspectival space, Kiefer makes each and every spectator party to his own, highly critical existential questioning" ("Representation and Event," 134). Biro notes the ways this painting "produces disturbingly redemptive readings" (ibid.). Biro also discusses *Iron Path* in *Anselm Kiefer and the Philosophy of Martin Heidegger*, 87–93 and 98–100.

33. Andreas Huyssen, *Twilight Memories*, 247.

34. For Buchloh's comments, see "A Note on Gerhard Richter's *October 18, 1977*," 100–103; for Danto, "Art: Anselm Kiefer," 27, 28. See also Gerhard Richter's fierce account of an exhibition of Kiefer's work (*The Daily Practice of Painting*, 120).

35. Daniel Arasse, *Anselm Kiefer*, 150.

36. As Bal and Bryson's association of perspective with "scientific pursuit" and then with "fascist tendencies" suggests, James Elkins's distinction between perspective as technique and perspective as metaphor breaks down very quickly in readings of Kiefer. For this distinction, see James Elkins, *The Poetics of Perspective*, esp. chap. 1. For a related account and summary of arguments about the ideological function of perspective, see Victor Burgin, *In/Different Spaces*, 142–44. Lacan's section on "Of the Gaze as *Objet Petit a*" in *The Four Fundamental Concepts of Psychoanalysis* has been crucial to much of this work on perspective: see, for instance, Jean-Louis Baudry's "Ideological Effects of the Basic Apparatus" in the anthology edited by Philip Rosen, *Narrative, Apparatus, Ideology*. See also Peggy Phelan's discussion of perspective and "the potential annihilation of the looker" (Phelan, *Unmarked*, 25).

37. Damisch, *The Origin of Perspective*, 268.

38. Ibid., 28; see also 86. Anthony Vidler also notes this passage in his *Warped Space* (8); Vidler's emphasis in *Warped Space* on the relationship between challenges to the perspectival regime and the placement of the subject in contemporary art and architecture has been helpful to me.

39. Though I am indebted to Benjamin H. D. Buchloh's fierce denunciation of the mythical content in the work of Kiefer and other German painters in his "Figures of Authority, Ciphers of Regression," my own sense of the place of the mythical in Kiefer's work is closer to that of Huyssen, who stresses throughout his work on Kiefer that engagement with mythical content differs from a myth-making project.

40. Huyssen, *Twilight Memories*, 222. For other accounts that emphasize the contrast between perspective and the painted surfaces of Kiefer's paintings, see Barbara Rose, "Kiefer's Cosmos," and Peter Schjeldahl, "Our Kiefer," 118.

41. Clendinnen, *Reading the Holocaust*, 4.

42. See the illustration in Mellinkoff, "Titian's Pastoral Scene," 848.

43. For details in this paragraph, I am indebted to Tom E. Hinson's account of the materials in and the making of *Lot's Wife* in "Anselm Kiefer: *Lot's Wife.*"

44. Ibid., 183. Hinson implicitly links this mark and coil to the painted name (182–83).

45. For distinctly varied discussions of *The Ambassadors*, see Karsten Harries, *Infinity and Perspective*, 93–95, and Lacan, *The Four Fundamental Concepts of Psychoanalysis*, 85–90. For a fine explication of Lacan's reading, see Kaja Silverman, *The Threshold of the Visible World*, 175–79.

46. See, for instance, part of Damisch's extended reading of the inauguration of perspective in the experiments of Brunelleschi: "Brunelleschi's sky is no longer that of medieval philosophers, nor is it the rarefied domain of the spheres so dear to philosophers and cosmographers; it is, rather, a meteorological site through which clouds move, pushed by the wind, and which thus escapes the measurements of geometry and perspective itself, here deliberately restricted to the *physical* components of the visible" (Damisch, *Origin of Perspective*, 153).

47. For discussions of these matters of translation and much else, I thank Karsten Harries and Lisa Harries-Schumann.

48. Luther, *Lectures on Genesis: Chapters 15–20*, 298.

49. Another, more distant possibility is that Kiefer means to recall Sütterlin, a style of handwriting taught in German schools from the late nineteenth-century until 1941, when it was banned by the Nazis. In Sütterlin, the "u" does have a line over it. This line, is, however, most often curved, and other aspects of Kiefer's "handwriting" do not recall the shapes of the letters in Sütterlin.

50. See Crain's exemplary reading of Ed Ruscha's *F House* in the epilogue to her *The Story of A*, 211–16.

51. T. J. Clark, *Farewell to an Idea*, 336.

52. I am grateful to participants in a seminar at the 2004 American Comparative Literature Association for emphasizing the importance of this strip.

53. A tantalizing comment from Damisch has informed this paragraph. Speaking of his training with Merleau-Ponty, Damisch describes a planned project on darkness and Goya: "It would be, then, a matter not of narrating history but of seeing it. What would a phenomenology of the perception of history be? You have to remember that we were just emerging from the war. It was extremely important to me, the idea that I had perceived history" (Bois, Hollier, and Krauss, "A Conversation with Hubert Damisch," 4).

54. Lisa Saltzman makes a crucial contribution to the discussion of Kiefer's relationship to the second commandment in "'Thou Shalt Not Make Graven Images': Adorno, Kiefer, and the Ethics of Representation," the first chapter of her *Anselm Kiefer and Art after Auschwitz*.

55. Claude Lanzmann, whom Miriam Hansen calls "the most radical proponent of this critique," claims that had he found documentary footage of the gassing of Jews in Auschwitz, he would have destroyed it (Hansen, "*Schindler's List* Is Not *Shoah*," 301).

56. Ibid., 301–2.

57. For two approaches to understanding the Holocaust in light of the Lot story, see Rachel Feldhay Brenner's essay "Re-reading the Story of Sodom and Gomorrah in the Aftermath of the Holocaust" and Daniel Mendelsohn's *The Lost*, a moving experiment that combines memoir and biblical commentary, esp. 445–48.

58. For a brilliant and painstaking account of the logic of the second commandment through the work of, and the philosophical contexts surrounding, Benjamin and Adorno, see Rebecca Comay, "Materialist Mutations of the *Bilderverbot*."

59. Ibid., 343.

60. Cornelia Brink and Susan Sontag—both citing Hannah Arendt—point out that the large archive of photographs taken immediately after the liberation of the camps falsifies the events they supposedly represent. When the machinery of genocide was functioning, there were, for instance, no piles of corpses: the crematoria destroyed them. Such photographs, then, falsify a process designed to leave no trace that a photograph might capture. Or, that is, these traces would not include corpses. The problem of how to locate the human body as the absent object of representation becomes, for Kiefer, a problem of how to place or locate the body of the audience. On the problem of the archive of Holocaust photographs, see Brink, "Looking at Photographs," esp. 141–42, and Sontag, *Regarding the Pain of Others*, 84. For a discussion of photography that treats the Holocaust after the event, see Ulrich Baer, *Spectral Evidence*.

61. Benjamin, *Illuminations*, 257.

62. Matthew Biro has made the most historically alert comments about this series that I have seen (*Anselm Kiefer and the Philosophy of Martin Heidegger*, 210–14). Here, as elsewhere, Biro's treatment of spectatorship overlaps with my own.

63. On Klee's painting, which Benjamin owned for a time, see especially Scholem, "Walter Benjamin and His Angel," and O. K. Werckmeister, "Walter Benjamin's Angel of History."

64. For discussion of the historian's identification with the angel, see Werckmeister, "Walter Benjamin's Angel of History." The association of the angel with destruction, Werckmeister shows, was clearer in earlier drafts of the "Theses": see esp. 261–63.

65. Heiner Müller, "The Luckless Angel," in *Germania*, 99; "Der Glücklose Engel," in *Werke I: Die Gedichte*, 53.

66. Adorno, *Aesthetic Theory*, 67.

CODA: LOT'S WIFE ON SEPTEMBER 11, 2001; OR, AGAINST FIGURATION

1. On these stones, see Tryggve Mettinger's *No Graven Image?*, Theodore Lewis's review of Mettinger, which provides a fine introductory survey of the scholarship, as well as the provocative comments of David Freedberg in "The Myth of Aniconism," the fourth chapter of idem, *The Power of Images*.

2. Uzi Avner, "Ancient Cult Sites in the Negev and Sinai Deserts," *Tel Aviv* 11: 115–31, quoted in Mettinger, *No Graven Image?*, 33.

3. On sowing the sites of ruined cities with salt, see Gevirtz, "Jericho and Shechem." I should stress that Gevirtz takes part in a debate about the symbolic force of salt in the ancient world; he does not assume that salt always signified infertility.

4. Keenan, "Publicity and Indifference," 114. For salient comments on the political issues raised by a superfluity of images of suffering, see also Keenan's "Live from . . ."

5. Jordan, *Piety, and Poesy*, n.p.

6. Koerner, *Reformation of the Image*, 46; I take the quotation from Luther from ibid., 43. See also Ernest B. Gilman, *Iconoclasm and Poetry in the English Reformation*.

7. Gross, *Dream of the Moving Statue*, 33.

8. Ronald Drenger, "Can 9/11 Icon Come Home?," *Tribeca Trib*, February 4, 2004, available online at http://www.tribecatrib.com/newsfeb04/911-icon.htm.

9. Ronald Drenger, "Iconic Survivor of Sept. 11 Will Return to Park Home," *Tribeca Trib*, June 3, 2005, available online at http://www.tribecatrib.com/newsjune05/iconicsurvivor.htm.

10. Jeanne Moos, "Story of Statue that Gained in Stature When Trade Center Came Tumbling Down," "rush transcript" of broadcast aired December 12, 2001, *Mornings with Paula Zahn*, available at http://transcripts.cnn.com/TRANSCRIPTS/0112/12/ltm.04.html.

11. Adorno's essay "Free Time," in idem, *Critical Models*, informs this last sentence. It is a small but piquant irony that upon its reopening, Liberty Plaza has been rechristened Zuccotti Park, after the U.S. Chairman of Brookfield Properties, which owns this public space.

12. Drenger, "Can 9/11 Icon Come Home?"

13. Ibid.

14. The record suggests that we want our sculptures to remain the same. The restoration of Fritz Koenig's abstract *Sphere for Plaza Fountain*, 1968–71, the sculpture once in the center of the World Trade Center's brutalist public space, has also been uncontroversial. Now installed in damaged form in Battery Park, on the southern tip of Manhattan, it has become a memorial site. *Double Check* has returned, along with a huge red abstraction in steel by Mark DiSuvero called *Joie de Vivre* in the opposite corner. (Earlier, *Joie de Vivre* was installed in one of Manhattan's most joyless and lifeless public spaces, the so-called Hudson Square, a plaza surrounded by traffic from the incoming tube of the Holland Tunnel.) By contrast, the most prominent case of artistic controversy post–September 11 remains that of Eric Fischl's "Tumbling Woman," which was removed a week after its installation at Rockefeller Center.

15. Langewiesche, *American Ground*, 58–59.

16. Mike Davis, "The Flames of New York," in *Dead Cities*, 7. For Davis's reading of visions of the destruction of Los Angeles, see his *Ecology of Fear*, especially the chapter, "The Literary Destruction of Los Angeles."

17. Davis, "The Flames of New York," in *Dead Cities*, 6.

18. Texts of the dialogue between Robertson and Falwell on Robertson's *700 Club* appear on several websites. See, for example, "Partial transcript of comments from the September 13, 2001, telecast of the *700 Club*," ACT UP New York, available at http://www.actupny.org/YELL/falwell.html.

19. Adam Smith, *The Theory of Moral Sentiments*, 13.

20. Diana Fuss, *Identification Papers*, 2.

21. On death and nationalism, see Benedict Anderson, *Imagined Communities*, 9–12. For a related discussion of disaster as a key form for the foundation of modern publics, see Michael Warner, "The Mass Public and the Mass Subject," in *Publics and Counterpublics*, 176–79. See also David Simpson's *9/11*, esp. chap. 3, "Framing the Dead."

22. I am here working with the term "surrogation" in the sense Joseph Roach gives it in his *Cities of the Dead*.

23. See, for instance, the conclusion to Marianna Torgovnick, *The War Complex*, and the argument about identification in the introduction to Jill Bennett, *Empathic Vision*. For early and compelling critical responses to September 11, see the short pieces edited by David Román in "A Forum on Theatre and Tragedy." Una Chaudhuri's contribution to this forum, which links September 11 to Artaud, has been especially important to me (97–99).

Adorno, Theodor W. *Aesthetic Theory*. Ed. and trans. Robert Hullot-Kentor. Theory and History of Literature, vol. 88. Minneapolis: University of Minnesota Press, 1997.

———. *Critical Models*. Trans. Henry Pickford. New York: Columbia University Press, 1999.

———. *Minima Moralia: Reflections from Damaged Life*. Trans. E. F. N. Jephcott. London: NLB, 1974.

———. *Noten zur Literatur*. Ed. Rolf Teidemann. Frankfurt am Main: Suhrkamp, 1981.

———. *Notes to Literature*. 2 vols. Ed. Rolf Tiedemann. Trans. Shierry Weber Nicholsen. New York: Columbia University Press, 1992.

Alice Doesn't Live Here Anymore. Dir. Martin Scorcese. Screenplay Robert Getchell. Perf.: Ellen Burstyn, Alfred Lutter, Kris Kristofferson, Harvey Keitel, Diane Ladd, Jodie Foster. Warner Brothers, 1974.

Alter, Robert. "Sodom as Nexus: The Web of Design in Biblical Narrative." In *Reclaiming Sodom*. Ed. Jonathan Goldberg. New York: Routledge, 1994.

Althusser, Louis. "Ideology and Ideological State Apparatuses." In *Lenin and Philosophy and Other Essays*. Trans. Ben Brewster. New York: Monthly Review Press, 1971.

Anderson, Benedict. *Imagined Communities: Reflections on the Origin and Spread of Nationalism*. Rev. ed. London: Verso, 1991.

Anger, Kenneth. *Hollywood Babylon*. New York: Dell, 1975.

Arasse, Daniel. *Anselm Kiefer*. New York: Abrams, 2001.

Arnold, Edwin T., and Eugene L. Miller. *The Films and Career of Robert Aldrich*. Knoxville: University of Tennessee Press, 1986.

Artaud, Antonin. "La Mise en Scène et la Métaphysique." *L'Arc: Cahiers Méditerranéens* 3, no. 10 (Spring 1960).

———. *Antonin Artaud: Œuvres sur papier*. Marseille: Musées de Marseille, 1995.

————. *Œuvres Complètes.* 26 vols. Paris: Gallimard, 1956.

————. *Selected Writings.* Trans. Helen Weaver. Ed. and introduction, Susan Sontag. Notes by Sontag and Don Eric Levine. Berkeley: University of California Press, 1988.

————. *The Theater and Its Double.* Trans. Mary Caroline Richards. New York: Grove, 1958.

Auden, W. H. *Collected Poems.* Ed. Edward Mendelson. New York: Random House, 1976.

Auerbach, Erich. "Figura." In *Scenes from the Drama of European Literature.* Theory and History of Literature 9. Minneapolis: University of Minnesota Press, 1984.

————. *Mimesis: The Representation of Reality in Western Literature.* Trans. Willard R. Trask. Intro. Edward W. Said. Princeton: Princeton University Press, 2003.

Baer, Ulrich. *Spectral Evidence: The Photography of Trauma.* Cambridge, Mass.: MIT Press, 2002.

Bal, Mieke. "The Rape of Narrative and the Narrative of Rape: Speech Acts and Body Language in Judges." In *Literature and the Body: Essays On Populations and Persons.* Ed. Elaine Scarry. Selected Papers from the English Institute, 1986. Baltimore: The Johns Hopkins University Press, 1988.

Bal, Mieke and Norman Bryson. "Semiotics and Art History." *Art Bulletin* 73, no. 2 (June 1991): 174–208.

Ball, Hugo. *Flight Out of Time.* Trans. Ann Raimes. Ed. John Elderfield. The Documents of Twentieth-Century Art. New York: Viking, 1974.

Barber, Stephen. *Artaud: The Screaming Body.* London: Creation Books, 1999.

Baudelaire, Charles. *Baudelaire.* Ed. Francis Scarfe. The Penguin Poets. Harmondsworth: Penguin, 1961.

Baudry, Jean-Louis. "Ideological Effects of the Basic Apparatus." In *Narrative, Apparatus, Ideology.* Ed. Philip Rosen.

Benjamin, Walter. *Illuminations.* Trans. Harry Zohn. New York: Schocken, 1969.

————. *Selected Writings: Volume 4, 1938–1940.* Trans. Edmund Jephcott et al. Ed. Howard Eiland and Michael W. Jennings. Cambridge, Mass.: Belknap Press of Harvard University Press, 2003.

Bennett, Jill. *Empathic Vision: Affect, Trauma, and Contemporary Art.* Stanford: Stanford University Press, 2005.

Berger, John. *The Sense of Sight.* New York: Vintage, 1993.

Berlant, Lauren. "Poor Eliza." *American Literature* 70, no. 3 (September 1998): 635–68.

————. "Trauma and Ineloquence." *Cultural Values* 5, no. 1 (January 2001): 41–58.

Bersani, Leo. "Artaud, Defecation and Birth." In *A Future for Astyanax: Character and Desire in Literature.* London: Marion Boyars, 1978.

————. *The Culture of Redemption.* Cambridge, Mass.: Harvard University Press, 1990.

Biro, Matthew. *Anselm Kiefer and the Philosophy of Martin Heidegger.* Cambridge: Cambridge University Press, 1998.

————. "Representation and Event: Anselm Kiefer, Joseph Beuys, and the Memory of the Holocaust." *Yale Journal of Criticism* 16, no. 1 (2003): 113–46.

Bissell, R. Ward. *Artemisia Gentileschi and the Authority of Art: Critical Reading and Catalogue Raisonné.* University Park: Pennsylvania State University Press, 1999.

————. *Orazio Gentileschi and the Poetic Tradition in Caravaggesque Painting.* University Park: Pennsylvania State University Press, 1981.

Blau, Herbert. *The Audience.* Baltimore: The Johns Hopkins University Press, 1990.

Blumenberg, Hans. *Shipwreck with Spectator: Paradigm of a Metaphor for Existence.* Trans. Steven Rendall. Cambridge, Mass.: MIT Press, 1997.

Bois, Yve-Alain, Denis Hollier, and Rosalind Krauss. "A Conversation with Hubert Damisch." *October* 85 (Summer 1998): 3–17.

Borch-Jacobsen, Mikkel. *Lacan: The Absolute Master.* Stanford: Stanford University Press, 1991.

Borde, Raymond, and Étienne Chaumeton. "Towards a Definition of *Film Noir*." In Silver and Ursini, *Film Noir Reader.*

Boswell, John. *Christianity, Social Tolerance, and Homosexuality: Gay People in Western Europe from the Beginning of the Christian Era to the Fourteenth Century.* Chicago: University of Chicago Press, 1980.

Brenner, Rachel Feldhay. "Re-Reading the Story of Sodom and Gomorrah in the Aftermath of the Holocaust." In *Peace, In Deed: Essays in Honor of Harry James Cargas.* Ed. Zev Garber and Richard Libowitz. South Florida Studies in the History of Judaism, no. 162. Atlanta: Scholars Press, 1998.

Brink, Cornelia. "Looking at Photographs from Nazi Concentration Camps." *History and Memory* 12, no. 1 (Spring–Summer 2000): 135–50.

Buchloh, Benjamin H. D. "A Note on Gerhard Richter's *October 18, 1977.*" *October* 48 (Spring 1989): 88–109.

————. "Figures of Authority, Ciphers of Regression: Notes on the Return of Representation in European Painting." *October* 16 (Spring 1981): 39–68.

Bürger, Peter. *The Theory of the Avant-Garde.* Trans. Michael Shaw. Theory and History of Literature, vol. 4. Minneapolis: University of Minnesota Press, 1984.

Burgin, Victor. *In/Different Spaces: Place and Memory in Visual Culture.* Berkeley: University of California Press, 1996.

Cartwright, Lisa. "U.S. Modernism and the Emergence of 'The Right Wing of Film Art': The Films of James Sibley Watson, Jr., and Melville Webber." In *The First American Film Avant-Garde, 1919–1945.* Ed. Jan-Christopher Horak. Madison: University of Wisconsin Press, 1995.

Caruth, Cathy. "An Interview with Jean Laplanche." *Postmodern Culture* 11, no. 2 (January 2001). Online. August 7, 2006.

————. "Parting Words: Trauma, Silence and Survival." *Cultural Values* 5, no. 1 (January 2001): 7–26.

————. *Unclaimed Experience: Trauma, Narrative, and History.* Baltimore: The Johns Hopkins University Press, 1996.

Christiansen, Keith, and Judith W. Mann. *Orazio and Artemisia Gentileschi.* New York: Metropolitan Musuem of Art, 2001.

Clark, T. J. *Farewell to an Idea: Episodes from a History of Modernism.* New Haven: Yale University Press, 1999.

Clendinnen, Inga. *Reading the Holocaust.* Cambridge: Cambridge University Press, 1999.

The College of Sociology. Trans. Betsy Wing. Ed. Denis Hollier. Theory and History of Literature, vol. 41. Minneapolis: University of Minnesota Press, 1988.

Comay, Rebecca. "Materialist Mutations of the *Bilderverbot.*" In *Sites of Vision: The Discursive Construction of Sight in the History of Philosophy.* Ed. David Michael Levin. Cambridge, Mass.: MIT Press, 1999.

Copjec, Joan, ed. *Shades of Noir: A Reader.* London: Verso, 1993.

Crain, Patricia. *The Story of A: The Alphabetization of America from* The New England Primer *to* The Scarlet Letter. Stanford: Stanford University Press, 2000.

Crary, Jonathan. *Techniques of the Observer: On Vision and Modernity in the Nineteenth Century.* Cambridge, Mass.: MIT Press, 1990.

Damisch, Hubert. *The Origin of Perspective.* Trans. John Goodman. Cambridge, Mass.: MIT Press, 1994.

Danto, Arthur. "Art: Anselm Kiefer." *Nation,* January 2, 1989: 26–28.

Davis, Mike. *City of Quartz: Excavating the Future in Los Angeles.* New York: Vintage, 1992.

———. *Dead Cities and Other Tales.* New York: New Press, 2002.

———. *Ecology of Fear: Los Angeles and the Imagination of Disaster.* New York: Metropolitan Books, 1998.

Deer, Patrick. *Culture in Camouflage: War, Empire, and Modern British Literature.* Oxford: Oxford University Press, forthcoming.

Derrida, Jacques. "La parole soufflée." In *Writing and Difference.* Trans. Alan Bass. Chicago: University of Chicago Press, 1978.

Derrida, Jacques, and Paule Thévenin. *The Secret Art of Antonin Artaud.* Trans. and with a preface by Mary Ann Caws. Cambridge, Mass.: MIT Press, 1998.

Dimendberg, Edward. *Film Noir and the Spaces of Modernity.* Cambridge, Mass.: Harvard University Press, 2004.

Don't Look Back. Dir. D. A. Pennebaker. Perf.: Bob Dylan. Independent, 1967.

Dylan, Bob. *Chronicles.* New York: Simon and Schuster, 2004.

———. "Trouble in Mind." B-side of "Gotta Serve Somebody." Columbia 1–11072. 45 rpm record.

Elkins, James. *The Poetics of Perspective.* Ithaca: Cornell University Press, 1994.

Erickson, Glenn. "The Kiss Me Mangled Mystery: Refurbishing a Film Noir." *Images: A Journal of Film and Popular Culture* 3 (1997), available at http://www.imagesjournal.com.

Eshel, Amir. "Against the Power of Time: The Poetics of Suspension in W. G. Sebald's *Austerlitz.*" *New German Critique* 88 (Winter 2003): 71–96.

Felman, Shoshana, and Dori Laub. *Testimony: Crises of Witnessing in Literature, Psychoanalysis, and History.* New York: Routledge: 1992.

Fenichel, Otto. "The Clinical Aspect of the Need for Punishment." In Hanly, *Essential Papers on Masochism.*

Fischer, Lucy. "The Films of James Sibley Watson, Jr., and Melville Webber: A Reconsideration." *Millennium Film Journal* 19 (Fall–Winter 1987–88): 40–49.

Foster, Hal. "Foreword: Mothertruckers." Foreword to Schnapp, *Staging Fascism.*

Freedberg, David. *The Power of Images: Studies in the History and Theory of Response.* Chicago: University of Chicago Press, 1989.

Freud, Sigmund. "A Disturbance of Memory on the Acropolis." In *The Standard Edition of The Complete Psychological Works of Sigmund Freud*. Vol. 22. Ed. James Strachey. London: Hogarth Press and the Institute of Psycho-Analysis, 1964.

Fried, Michael. *Absorption and Theatricality: Painting and Beholder in the Age of Diderot*. Chicago: University of Chicago Press, 1980.

———. *Art and Objecthood: Essays and Reviews*. Chicago: University of Chicago Press, 1998.

———. *Courbet's Realism*. Chicago: University of Chicago Press, 1990.

Friedrich, Rainer. "The Deconstructed Self in Artaud and Brecht: Negation of Subject and Antitotalitarianism." *Forum for Modern Language Studies* 26, no. 3 (1990): 282–97.

Fuss, Diana. *Identification Papers*. New York: Routledge, 1995.

Gaster, Theodor H. *Myth, Legend, and Custom in the Old Testament: A Comparative Study with Chapters from Sir James G. Frazer's Folklore in the Old Testament*. New York: Harper and Row, 1969.

Gevirtz, Stanley. "Jericho and Shechem: A Religio-Literary Aspect of City Destruction." *Vetus Testamentum* 23, no. 1 (1963): 52–62.

Gilman, Ernest B. *Iconoclasm and Poetry in the English Reformation*. Chicago: University of Chicago Press, 1986.

Goldberg, Jonathan. *Sodometries: Renaissance Texts, Modern Sexualities*. Stanford: Stanford University Press, 1992.

Goodall, Jane. "Artaud and Painting: The Quest for a Language of Gnosis." *Paragraph* 12, no. 2 (July 1989): 107–23.

Graham, Stephen, ed. *Cities, War, and Terrorism: Towards an Urban Geopolitics*. Malden, Mass.: Blackwell, 2004.

Gross, Kenneth. *The Dream of the Moving Statue*. Ithaca: Cornell University Press, 1992.

Guillory, John. "The Sokal Affair and the History of Criticism." *Critical Inquiry* 28, no. 2 (Winter 2001): 470–508.

Halpern, Richard. *Shakespeare's Perfume: Sodomy and Sublimity in the Sonnets, Wilde, Freud, and Lacan*. Philadelphia: University of Pennsylvania Press, 2002.

Hammer, Barbara. "Uncommon History: An Interview with Barbara Hammer." By Holly Willis. *Film Quarterly* 47, no. 4 (Summer 1994): 7–13.

Hanly, Margaret Ann Fitzpatrick, ed. *Essential Papers on Masochism*. New York: New York University Press, 1995.

Hansen, Miriam Bratu. *Babel and Babylon: Spectatorship in American Silent Film*. Cambridge, Mass.: Harvard University Press, 1991.

———. "*Schindler's List* Is Not *Shoah*: The Second Commandment, Popular Modernism, and Public Memory." *Critical Inquiry* 22, no. 2 (Winter 1996): 292–312.

Harries, Karsten. *The Ethical Function of Architecture*. Cambridge, Mass.: MIT Press, 1997.

———. *Infinity and Perspective*. Cambridge, Mass.: MIT Press, 2001.

Harries, Martin. *Scare Quotes from Shakespeare: Marx, Keynes, and the Language of Reenchantment*. Stanford: Stanford University Press, 2000.

Hartman, Geoffrey H. *The Longest Shadow: In the Aftermath of the Holocaust.* Bloomington: Indiana University Press, 1996.

———. *The Unmediated Vision: An Interpretation of Wordsworth, Hopkins, Rilke, and Valery.* New Haven: Yale University Press, 1954.

Harvey, Sylvia. "Woman's Place: The Absent Family of Film Noir." In Kaplan, *Women in Film Noir.*

Herbert, Zbigniew. *Elegy for the Departure and Other Poems.* Trans. John and Bogdana Carpenter. New York: Ecco, 1999.

Hertz, Neil. *The End of the Line: Essays on Psychoanalysis and the Sublime.* New York: Columbia University Press, 1985.

Hinson, Tom E. "Anselm Kiefer: *Lot's Wife.*" *Bulletin of the Cleveland Museum of Art* 80, no. 4 (April 1993): 180–85.

Hollier, Denis. "The Death of Paper, Part Two: Artaud's Sound System." *October* 80 (Spring 1997): 27–37.

Housman, A. E. *More Poems.* New York: Knopf, 1936.

———. *The Poems of A. E. Housman.* Ed. Archie Burnett. Oxford: Clarendon Press, 1997.

Huyssen, Andreas. *Present Pasts: Urban Palimpsests and the Politics of Memory.* Stanford: Stanford University Press, 2003.

———. *Twilight Memories: Marking Time in a Culture of Amnesia.* New York: Routledge, 1995.

The Interpreter's Bible. Ed. George Arthur Buttrick et al. 12 vols. New York: Abingdon-Cokesbury, 1951.

Jacobowitz, Ellen S., and Stephanie Loeb Stepanek. *The Prints of Lucas van Leyden and His Contemporaries.* Washington, D.C.: National Gallery of Art, 1983.

Jay, Martin. *Downcast Eyes: The Denigration of Vision in Twentieth-Century French Thought.* Berkeley: University of California Press, 1994.

Jordan, Thomas. *Piety, and Poesy.* London: Printed for Robert Wood, 1643.

The JPS Torah Commentary: Genesis. Commentary by Nahum M. Sarna. Philadelphia: The Jewish Publication Society, 5749/1989.

Kaplan, E. Ann, ed. *Women in Film Noir.* New ed. London: British Film Institute, 1998.

Keenan, Thomas. "Live from . . ." In *Back to the Front: Tourisms of War.* Ed. Elizabeth Diller and Ricardo Scofodio. F.R.A.C. Basse Normandie, 1994.

———. "Publicity and Indifference (Sarajevo on Television)." *PMLA* 117, no. 1 (January 2002): 104–16.

Kind, Joshua Benjamin. "The Drunken Lot and His Daughters: An Iconographic Study of the Uses of This Theme in the Visual Arts from 1500–1650, and its Bases in Exegetical and Literary History." Ph.D. diss., Columbia University, 1967.

Kiss Me Deadly. Dir. Robert Aldrich. Perf.: Ralph Meeker, Albert Dekker, Maxine Cooper, Gaby Rodgers. United Artists, 1955.

Knepper, Max. *Sodom and Gomorrah: The Story of Hollywood.* Los Angeles: Sponsored by the End Poverty League, 1935.

Koerner, Joseph Leo. *Caspar David Friedrich and The Subject of Landscape.* New Haven: Yale University Press, 1990.

————. *The Reformation of the Image*. Chicago: University of Chicago Press, 2004.

Krohn, Bill. "Adorno on Aldrich." *Screening the Past* 10 (June 2000). Online. July 8, 2005.

————. "*Sodom and Gomorrah*: The Auteur and the Potboiler." *Screening the Past* 10 (June 2000). Online. July 8, 2005.

Lacan, Jacques. *Écrits*. New York: Norton, 1977.

————. *The Four Fundamental Concepts of Psychoanalysis*. Trans. Alan Sheridan. New York: Norton, 1981.

Langewiesche, William. *American Ground: Unbuilding the World Trade Center*. New York: North Point Press, 2002.

Laplanche, Jean. *Life and Death in Psychoanalysis*. Trans. Jeffrey Mehlman. Baltimore: The Johns Hopkins University Press, 1985.

Laplanche, Jean, and J.-B. Pontalis. *The Language of Psychoanalysis*. Trans. Donald Nicholson-Smith. New York: Norton, 1973.

Laszlo, Pierre. *Salt: Grain of Life*. Trans. Mary Beth Mader. New York: Columbia University Press, 2001.

Lewis, Theodore J. "Divine Images and Aniconism in Ancient Israel." *Journal of the American Oriental Society* 118, no. 1 (January–March 1998): 36–53.

Leys, Ruth. *Trauma: A Genealogy*. Chicago: University of Chicago Press, 2000.

Loader, J. A. *A Tale of Two Cities: Sodom and Gomorrah in the Old Testament, Early Jewish and Early Christian Traditions*. Contributions to Biblical Exegesis and Theology, vol. 1. Kampen: J. H. Kok, 1990.

Lot in Sodom. Dir. James Sibley Watson Jr. and Melville Webber. Perf.: Hildegarde Watson, Friederick Haak. Independent, 1933.

Lowenthal, Anne W. "Lot and His Daughters as Moral Dilemma." In *The Age of Rembrandt: Studies in Seventeenth-Century Dutch Painting*. Ed. Roland E. Fleischer and Susan Scott Munshower. Papers in Art History from The Pennsylvania State University, vol. 3. 1988.

Lucretius. *On the Nature of the Universe*. Trans. Ronald Latham. Harmondsworth: Penguin Books, 1952.

Luther, Martin. *Lectures on Genesis: Chapters 15–20. Luther's Works*. Vol. 3. Ed. Jaroslav Pelikan. St. Louis: Concordia Publishing House, 1961.

Marshall, David. *The Figure of Theater: Shaftesbury, Defoe, Adam Smith, and George Eliot*. New York: Columbia University Press, 1986.

————. *The Surprising Effects of Sympathy: Marivaux, Diderot, Rousseau, and Mary Shelley*. Chicago: University of Chicago Press, 1988.

Mellinkoff, Ruth. "Titian's Pastoral Scene: A Unique Rendition of Lot and His Daughters." *Renaissance Quarterly* 51, no. 3 (Autumn 1998): 828–63.

Mendelsohn, Daniel. *The Lost: A Search for Six of Six Million*. New York: HarperCollins, 2006.

Mettinger, Tryggve N. D. *No Graven Image? Israelite Aniconism in Its Ancient Near Eastern Context*. Coniectanea Biblica Old Testament Series, vol. 43. Stockholm: Almqvist and Wiksell, 1995.

Moore, Marianne. "Lot in Sodom." In *The Complete Prose of Marianne Moore*. Ed. Patricia C. Willis. New York: Penguin, 1987, 310–12.

———. *The Selected Letters of Marianne Moore*. Ed. Bonnie Costello with Celeste Goodridge and Cristanne Miller. New York: Knopf, 1997.

Moretti, Franco. "From *The Waste Land* to the Artificial Paradise." In *Signs Taken for Wonders*. London: Verso, 1983.

Mosse, George. *The Nationalization of the Masses: Political Symbolism and Mass Movements from the Napoleonic Wars through the Third Reich*. New York: Howard Fertig, 1975.

Müller, Heiner. *Germania*. Trans. Bernard and Caroline Schütze. New York: Semiotext(e), 1990.

———. *Werke I: Die Gedichte*. Frankfurt am Main: Suhrkamp, 1998.

Mulvey, Laura. "Visual Pleasure and Narrative Cinema" and "Afterthoughts on 'Visual Pleasure and Narrative Cinema' Inspired by *Duel in the Sun*." In *Feminism and Film Theory*. Ed. Constance Penley. New York: Routledge, 1988.

Musgrove, Gordon. *Operation Gomorrah: The Hamburg Firestorm Raids*. London: Jane's, 1981.

Naremore, James. *More than Night: Film Noir in its Contexts*. Berkeley: University of California Press, 1998.

Nemerov, Alexander. "The Flight of Form: Auden, Bruegel, and the Turn to Abstraction in the 1940s." *Critical Inquiry* 31, no. 4 (Summer 2005): 780–810.

The New English Bible with the Apocrypha. Gen. ed. Samuel Sandmel. 2d ed. New York: Oxford University Press, 1972.

Nitrate Kisses. Dir. Barbara Hammer. 1992.

Nossack, Hans Erich. *The End: Hamburg 1943*. Trans. Joel Agee. Photographs by Erich Andres. Chicago: The University of Chicago Press, 2004.

Notre Musique. Dir. Jean-Luc Godard. Perf.: Godard, Sarah Adler, Nade Dieu. 2004.

Ovid. *Metamorphoses*. Trans. Rolfe Humphries. Bloomington: Indiana University Press, 1955.

Panofsky, Dora, and Erwin Panofsky. *Pandora's Box: The Changing Aspects of a Mythical Symbol*. 2d, rev. ed. New York: Harper, 1965.

Phelan, Peggy. "Converging Glances: A Response to Cathy Caruth's 'Parting Words.'" *Cultural Values* 5, no. 1 (January 2001): 27–40.

———. "Performing Talking Cures: Artaud's Voice." In *Language Machines: Technologies of Literary and Cultural Production*. Ed. Jeffrey Masten, Peter Stallybrass, and Nancy J. Vickers. Essays from the English Institute. New York: Routledge, 1997.

———. *Unmarked: The Politics of Performance*. London: Routledge, 1993.

Plato. *The Republic*. Trans. Desmond Lee. 2d ed. Harmondsworth: Penguin, 1974.

Polhemus, Robert. *Lot's Daughters: Sex, Redemption, and Women's Quest for Authority*. Stanford: Stanford University Pres, 2005.

Porter, J. R. "The Daughters of Lot." *Folklore* 89, no. 2 (1978): 127–41.

Prevel, Jacques. *En Compagnie d'Antonin Artaud*. New ed. by Gérard Mordillat and Jérome Prieur, based on the edition of Bernard Noël. Paris: Flammarion, 1994.

Reid, David, and Jayne L. Walker. "Strange Pursuit: Cornell Woodrich and the Abandoned City of the Forties." In Copjec, *Shades of Noir*.

Retort. *Afflicted Powers: Capital and Spectacle in a New Age of War.* London: Verso, 2005.

Richter, Gerhard. *The Daily Practice of Painting: Writings and Interviews.* Trans. David Britt. Ed. Hans-Ulrich Obrist. Cambridge, Mass.: MIT Press, 1995.

Roach, Joseph. *Cities of the Dead: Circum-Atlantic Performance.* New York: Columbia University Press, 1996.

Robinson, Marilynne. *Housekeeping.* New York: Farrar, Straus and Giroux, 1980.

Román, David, ed. "A Forum on Theatre and Tragedy in the Wake of September 11, 2001." *Theater Journal* 54.1 (March 2002): 96–138.

Rose, Barbara. "Kiefer's Cosmos." *Art in America* (December 1998): 70–73.

Rosen, Philip. *Narrative, Apparatus, Ideology.* New York: Columbia University Press, 1986.

Rosenthal, Mark. *Anselm Kiefer.* Chicago and Philadelphia: Art Institute of Chiacgo and Philadelphia Museum of Art, 1987.

Rossen, Robert, Robert Riskin, and John Patrick. *The Strange Love of Martha Ivers (1946): Shooting Script.* Alexandria, Va.: Alexander Street Press, 2003. Online through American Film Scripts, available at www.alexanderstreet.com.

Rushdie, Salman. "Imaginary Homelands." In *Imaginary Homelands: Essays and Criticism, 1981–1991.* London and New York: Granta Books/Viking, 1991.

Rzepka, Charles J. "Slavery, Sodom, and De Quincey's 'Savannah-La-Mar': Surplus Labor in Urban Gothic." *Wordsworth Circle* 27, no. 1 (1996): 33–37.

La Sainte Bible. Trans. L'Abbé J.-B. Glaire. New ed. with introduction, notes, and appendices by F. Vigouroux. Paris: A. et R. Roger et F. Chernoviz, 1905.

Saltzman, Lisa. *Anselm Kiefer and Art after Auschwitz.* Cambridge: Cambridge University Press, 1999.

Santner, Eric L. *My Own Private Germany: Daniel Paul Schreber's Secret History of Modernity.* Princeton: Princeton University Press, 1996.

———. *Stranded Objects: Mourning, Memory, and Film in Postwar Germany.* Ithaca: Cornell University Press, 1990.

Sarajevo Haggadah. Facsimile. Text by Cecil Roth. Beograd: "Jugoslavija," 1966.

Sartre, Jean-Paul. "Manhattan: The Great American Desert." In *The Empire City.* Ed. Alexander Klein. New York: Rinehart, 1955.

Sass, Louis. "'The Catastrophes of Heaven': Modernism, Primitivism, and the Madness of Antonin Artaud." *Modernism/Modernity* 3, no. 2 (May 1996): 73–91.

Scarpetta, Guy. "Artaud Écrit ou La Canne de Saint Patrick." *Tel Quel* 81 (Autumn 1979): 66–85.

Schama, Simon. *Landscape and Memory.* New York: Vintage, 1996.

Scheer, Edward, ed. *Antonin Artaud: A Critical Reader.* London: Routledge, 2004.

Schjeldahl, Peter. "Our Kiefer." *Art in America* (March 1988):116–27.

Schnapp, Jeffrey T. "Border Crossings: Italian/German Peregrinations of the Theater of Totality." *Critical Inquiry* 21, no. 1 (Autumn 1994): 80–123.

———. "18 BL: Fascist Mass Spectacle." *Representations* 43 (Summer 1993): 89–125.

———. *Staging Fascism: 18BL and the Theater of Masses for Masses.* Stanford: Stanford University Press, 1996.

Scholem, Gershom. "Walter Benjamin and His Angel." In *On Walter Benjamin: Critical Essays and Recollections*. Ed. Gary Smith. Cambridge, Mass.: MIT Press, 1988.

Schrader, Paul. "Notes on *Film Noir*." In Silver and Ursini, *Film Noir Reader*.

Scorcese, Martin, and Michael Henry Wilson. *A Personal Journey with Martin Scorcese Through American Movies*. New York: Miramax Books/Hyperion, in association with the British Film Institute, 1997.

Sebald, W. G. *After Nature*. Trans. Michael Hamburger. New York: Random House, 2002.

———. *Nach der Natur: Ein Elementargedicht*. Frankfurt: Fischer, 1995.

———. *On the Natural History of Destruction*. Trans. Anthea Bell. New York: Random House, 2003.

Shulman, George. "The Myth of Cain: Fratricide, City Building, and Politics." *Political Theory* 14, no. 2 (May 1986): 215–38.

Silver, Alain. "So What's with the Ending of *Kiss Me Deadly*?" *Images: A Journal of Film and Popular Culture* 2 (1996), available at http://www.imagesjournal.com.

Silver, Alain, and Elizabeth Ward, ed. *Film Noir: An Encyclopedic Reference to the American Style*. Rev. ed. Woodstock, N.Y.: Overlook Press, 1988.

Silver, Alain, and James Ursini. *What Ever Happened to Robert Aldrich?: His Life and Films*. New York: Limelight Editions, 1995.

———, eds. *Film Noir Reader*. New York: Limelight Editions, 1996.

Silverman, Kaja. *The Threshold of the Visible World*. New York: Routledge, 1996.

Simpson, David. *9/11: The Culture of Commemoration*. Chicago: University of Chicago Press, 2006.

Sklar, Robert. *Movie-Made America: A Cultural History of American Movies*. Rev. ed. New York: Vintage, 1994.

Smith, Adam. *The Theory of Moral Sentiments*. Ed. D. D. Raphael and A. L. Macfie. Indianapolis: Liberty Fund, 1982.

Smith, Elise Lawton. *The Paintings of Lucas van Leyden: A New Appraisal, with Catalogue Raisonné*. Columbia: University of Missouri Press, 1992.

Smith, Stevie. *New and Selected Poems*. New York: New Directions, 1972.

Sodom and Gomorrah. Dir. Robert Aldrich. Perf.: Stewart Granger, Anouk Aimée, Pier Angelli. Twentieth Century-Fox, 1963.

Sollers, Philippe. "Thought Expresses Signs." In *Writing and the Experience of Limits*. Ed. David Hayman. Trans. Philip Barnard with Hayman. New York: Columbia University Press, 1983.

Sontag, Susan. "Approaching Artaud." In *Under the Sign of Saturn*. New York: Farrar, Straus and Giroux, 1980.

———. "The Imagination of Disaster." In *Against Interpretation*. New York: Octagon, 1982.

Speiser, E. A., ed., trans., and commentary. *Genesis*. In *The Anchor Bible*. Garden City, N.Y.: Doubleday, 1964.

Spender, Stephen. *European Witness*. New York: Reynal and Hitchcock, 1946.

———. "Rhineland Journey." *Horizon* 72 (December 1945): 394–413.

Stollman, Rainer. "Fascist Politics as a Total Work of Art: Tendencies of Aestheticization of Political Life in National Socialism." *New German Critique* 14 (Spring 1978): 41–60.

The Strange Love of Martha Ivers. Dir. Lewis Mileston. Prod. Hal Wallis. Screenplay, Robert Rossen. Perf.: Barbara Stanwyck, Van Heflin, Lizabeth Scott, Kirk Douglas. Paramount, 1946.

Studlar, Gaylyn. *In the Realm of Pleasure: Von Sternberg, Dietrich, and the Masochistic Aesthetic.* Urbana: University of Illinois Press, 1988.

Szymborska, Wislawa. *Sounds, Feelings, Thoughts: Seventy Poems by Wislawa Szymborska.* Trans. Magnus J. Krynski and Robert A. Maguire. Princeton: Princeton University Press, 1981.

Tierney, Hanne. *Salome.* New York: Artgalaxy, 1983.

Tinterow, Gary, Michael Pantazzi, and Vincent Pomarède. *Corot.* New York: Metropolitan Museum of Art, 1996.

Tisdale, Sallie. *Lot's Wife: Salt and the Human Condition.* New York: Henry Holt, 1988.

Torgovnick, Marianna. *The War Complex: World War II in Our Time.* Chicago: University of Chicago Press, 2005.

van Hattem, Willem C. "Once Again: Sodom and Gomorrah." *Biblical Archeologist* 44, no. 2 (Spring 1981): 87–92.

van Pelt, Robert Jan. "Apocalyptic Abjection." In *Architectural Principles in the Age of Historicism.* Ed. Carroll William Westfall and van Pelt. New Haven: Yale University Press, 1991.

Vidler, Tony. *Warped Space: Art, Architecture, and Anxiety in Modern Culture.* Cambridge, Mass.: MIT Press, 2000.

Vigouroux, F., ed. *Dictionnaire de la Bible: contenant tous les noms de personnes, de lieux, de plantes, d'animaux mentionnés dans les Saintes Ecritures, les questions théologiques, archéologiques, scientifiques, critiques relatives a l'Ancien et au Nouveau Testament et des notices sur les commentateurs anciens et modernes.* 5 vols. Paris: Letouzey et Ané, 1895–1912.

Vonnegut, Kurt. *Slaughterhouse Five, or The Children's Crusade, a Duty-Dance with Death.* New York: Delacorte, 1969.

Warner, Michael. "New English Sodom." *American Literature* 64, no. 1 (March 1992): 19–47.

———. *Publics and Counterpublics.* New York: Zone Books, 2002.

Watson, James Sibley, Jr, Herbert Stern, Alec Wilder, and Lewis Whitbeck Jr. "The Films of J. S. Sibley Watson, Jr., and Melville Webber: Some Retrospective Views." *The University of Rochester Library Bulletin* 28, no. 2 (Winter 1975): 74–86.

Weinberg, Herman G. " 'Lot in Sodom.' " *Close Up* (September 1933): 266–68.

Weiskel, Thomas. *The Romantic Sublime: Studies in the Structure and Psychology of Transcendence.* Baltimore: The Johns Hopkins University Press, 1986.

Weiss, Allen S. "Radio, Death, and the Devil: Artaud's *Pour en Finir avec le Jugement de Dieu.*" In *Wireless Imagination: Sound, Radio, and The Avant-Garde.* Ed. Douglas Kahn and Gregory Whitehead. Cambridge, Mass.: MIT Press, 1992.

Werckmeister, O. K. "Walter Benjamin's Angel of History, or the Transfiguration of the Revolutionary into the Historian." *Critical Inquiry* 22, no. 2 (Winter 1996): 239–67.

Westermann, Claus. *Genesis 12–36: A Continental Commentary.* Trans. John J. Scullion. Minneapolis: Augsburg-Fortress Press, 1995.

Wood, Christopher S. *Albrecht Altdorfer and the Origins of Landscape.* Chicago: University of Chicago Press, 1993.

Wostry, Nikolaus. "*Sodom and Gomorrah*: Notes on a Reconstruction, or Less is More." *Moving Image* 3, no. 2 (2003): 19–39.

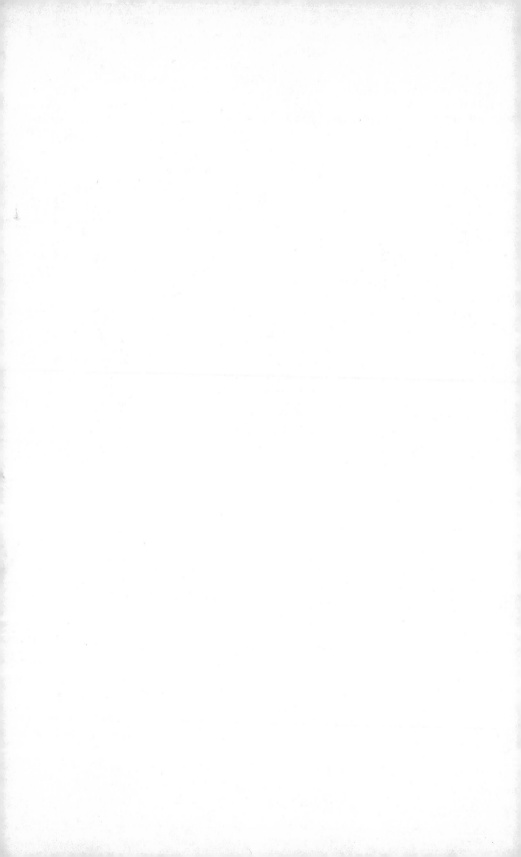